HOW TO TAKE BETTER TRAVEL PHOTOS

Lisl Dennis

Publisher: Bill Fisher
Editor-in-Chief: Carl Shipman; Editor: Theodore DiSante
Art Director: Don Burton; Book Design: Kathy Olson
Typography: Connie Brown, Cindy Coatsworth, Kris Spitler

cover photos: Beach Scene—Ostende, Belgium
Soldier—Istanbul, Turkey
Fruit & Scale—Charlotteville, Tobago

ISBN 0-912656-97-2
Library of Congress Catalog Card: 79-63101
©1979, Fisher Publishing, Inc. P.O. Box 5367, Tucson, AZ 85703, 602/888-2150
Printed in U.S.A.

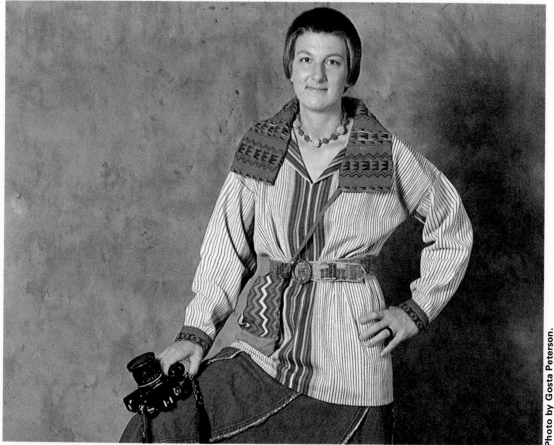

Photo by Gosta Peterson.

Lisl Dennis has been traveling and photographing continuously since high school. Professionally, she first concentrated on New England as a staff photographer for the *Boston Globe* newspaper. Today she is a New York based freelancer traveling six months a year on assignments around the world.

Lisl's photographs have appeared in many magazines, including: *Travel/Holiday, Town and Country, Essence, Fortune, Travel & Leisure, Réalités, GEO, Saturday Review* and *Popular Photography.*

Lisl also does assignments for travel-related organizations, such as hotels and national government tourist offices. Her photographs regularly appear in travel advertisements and promotional brochures.

With her husband, writer Landt Dennis, Lisl has written two books. They are: *Collecting Photographs—A Guide to the New Art Boom* and the award-winning *Catch the Wind: A History of Windmills and Windpower.*

Lisl is a member of the Society of American Travel Writers, the New York Travel Writers Association and the American Society of Magazine Photographers. Her photos are available through The Image Bank, an international picture agency headquartered in New York City.

PREVIEW

When you finish reading this book, you will have covered a million miles of armchair travel in the flight pattern of a professional freelance travel photographer—me, Lisl Dennis. You will have recorded many photogenic faces and overcome your timidity in photographing people.

You'll have been alone in a United States National Park, off season, making foul-weather photos. You'll also have enjoyed offbeat outdoor adventures such as a mule safari in Switzerland and a covered-wagon trip in Kansas.

You will have photographed an Ashanti durbar in Ghana, hiked through Hawaii's Haleakala crater, recorded Holland's windmills and seen some of the globe's loveliest landscapes. And you will have solved many problems common to all travel photography.

On the technical side, you will have assembled an effective slide show for friends. And learned how to salvage a camera from a salt water dunking. You will have learned more about interior lighting and how to make broader use of your lenses. Speaking of lenses, you'll have learned what I think is the best gear for travel photography.

You'll have made strong photographics for home or office walls. You'll understand the important difference between color and b&w photography within a travel context.

On the professional side, you'll know how the travel industry operates and how photographers like me become a part of it. In fact, you'll hear the saga of my photo-

graphic life—how I became a pro and how you can become a pro too. Scattered throughout the chapters are tips and bits of information which will help you get professional results even if you have no thought of becoming a professional photographer.

It's important to state, however, that this book is not primarily technical. I assume you have basic familiarity with camera operation and common photo terminology. This book is a first-person-singular sharing of my most memorable and instructive travel experiences and how I handled them photographically. This book is personal, and I hope inspirational, in its guidance to better travel photographs—not impersonal and technical.

Because I've worked very hard to

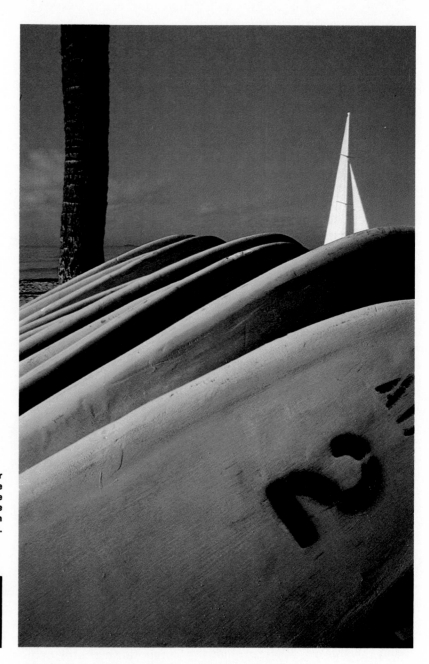

Waikiki, Hawaii—Photographs that suggest or imply are often more interesting than those showing everything in a scene. The composition of stacked surfboards, blue sky and sail indicates ocean activities in an indirect way.

get most of the images that illustrate this book, I will be demanding a lot of you as a photographer as well. Edward Steichen once said, "Photography is a medium of formidable contradictions. It is ridiculously easy and almost impossibly difficult."

If you're an amateur, you're probably already making the ridiculously easy photographs. I hope I'll help you make the impossibly difficult ones too. I don't use the word *amateur* in a negative sense at all. Throughout this book I've kept in mind the true meaning of the word. *Amateur* is Latin for *lover*, in this case a lover of photography. As a pro, I love photography too. Therefore, my thoughts and advice aren't handed *down*; they are handed *over*—to you.

1 GETTING READY

If you are sufficiently interested in photography that you would plan a vacation around the camera, here are some tips to help you get to fertile photographic ground. Heeding these tips amounts to some *homework*. It is the best way to familiarize yourself with the photographic possibilities of a destination, avoid being in the right place at the wrong time, or even the wrong place altogether.

RESEARCH BEFORE THE TRIP

The first question to ask yourself is exactly what kind of photographs you want to make on your next trip. This helps determine where to go by narrowing down the possibilities suited to your tastes. If I were an architecture buff, I wouldn't go to the Caribbean unless I was specifically interested in the remnants of Caribbean Georgian structures. If I wanted people pictures, I wouldn't return to Hong Kong where I was pelted with nuts and shooed away while photographing in the street markets.

You must decide what you're after and set about researching destinations you think will provide the desired subject matter and working environment.

The first step is to go to the nearest public library and locate the Index to the *National Geographic* magazine. Chances are it has a story about the place you're thinking of going. What may frustrate you is that all the supplements may not be available. The Index stops in 1976. To solve this problem, order your own copy of the Index and all supplements from the National Geographic Society, 17th and M Sts., N.W., Washington DC 20036. Then you'll have them on hand whenever you need them. Go to the library to read the magazine articles and take notes of photogenic people, places and things.

Don't leave the library yet because step two is also done there. Look up the country or place that interests you in the *Reader's Guide to Periodic Literature.* Read the referenced articles that promise information you're after. Again, note interesting towns, festivals and crafts.

The third step is to visit or write to the national government tourist office to get illustrated brochures on the destination under consideration. Be sure to ask if anything special will happen while you expect to be there. A worldwide and state-wide list of these offices is in the Appendix.

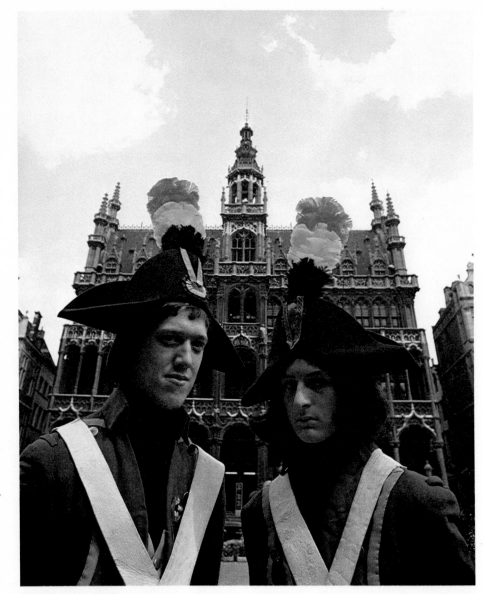

I'm reluctant to suggest that your travel agent might be helpful in tailoring a photographic vacation. Most agents are familiar only with the well-beaten path of travel and usually don't know about photogenic nooks and crannies. However, an agent may know about photo-tour operators. The best known is *Through The Lens Photographic Adventures.* Travel agents do have brochures from all parts of the world, and although brochure photography is sometimes unflattering to the country, you may get some ideas from them.

Continue with your vacation research. Browse the travel section of book stores. They contain many picture books about the U.S. and foreign countries and will give you good insight into your proposed destination.

One of the best research methods is to talk to people who've been where you're thinking of going. Your questions must be very specific! A simple, "Is it beautiful?" has elicited a *yes* about places I later found photographically uninspiring. Change the style of questioning. For example, the island of Dominica in the Caribbean is beautiful, but it is also solid green. I don't like solid-green photographs. What you need to ask about Dominica is, "Is the topography varied?"; "Is there agriculture to checker the landscape?"; "Are the beaches white or black sand?" Be specific!

One time I did not do my homework. I became very excited about getting fantastic people pictures in the Kumasi market in Ghana. I was told by friends that it was one of the largest open-air markets in West Africa and very colorful. Indeed it was large, the people were wonderful and it was colorful, but the majority of people were not in native dress at all. What I should have asked my friends was, "How much honest-to-goodness native dress will I find in the Kumasi market?"; not "Is it colorful?"

The moral of this story is *probe* when talking to people who have been to a place before you. Have an idea of what *you* want to know because non-photographer friends sometimes have no sense of what interests *you* photographically.

RESEARCH DURING THE TRIP

Homework should continue even after you've arrived at your chosen destination. When you get to your hotel, always ask the desk clerk if anything special is happening in the area. There may be a festival you haven't uncovered in your at-home research. Local newspapers and tourist-information publications in hotels are a good source too.

As you research, keep in mind that smaller, local events are sometimes more interesting and authentic than large publicized ones designed for tourists. They are often easier to photograph too.

While you're traveling either at home or abroad, always chat with other travelers. Often they will have been somewhere ahead of you and can alert you to photographic possibilities. I once met an Israeli student traveler over yogurt and fresh fruit in Panajachel, Guatemala on Lake Atitlan. He told me about the mountain town Nebaj and the extraordinary native dress worn there. The village was tough to get to, but it was worth every bump. A photo from that day appears on page 66.

Homework or no homework, there are certain places in any country where you can always count on good picture possibilities. These include markets, waterfronts, craft shops, fairs, festivals, parks, gardens and colorful local industries. Yes, industries! Think of tulip fields in Holland, Indonesian batik production or rug weaving in Iran. Even quilt-making in America is a cottage industry.

You might seriously consider developing a theme for your vacation photography. It could be children, flowers or architecture. Whatever the theme, it need not exclude other kinds of subject matter, but can be developed along with your general coverage. I make this suggestion because having a specific subject keeps you alert. The demands of a theme give focus to your photography. You don't drift around shooting here and there indiscriminately. Furthermore, realizing your objective builds photographic confidence.

Chartres, France—If you want to see cathedrals, go to France! Germany, Belgium, England and Italy also contain lovely cathedrals that make fascinating photo subjects.

7

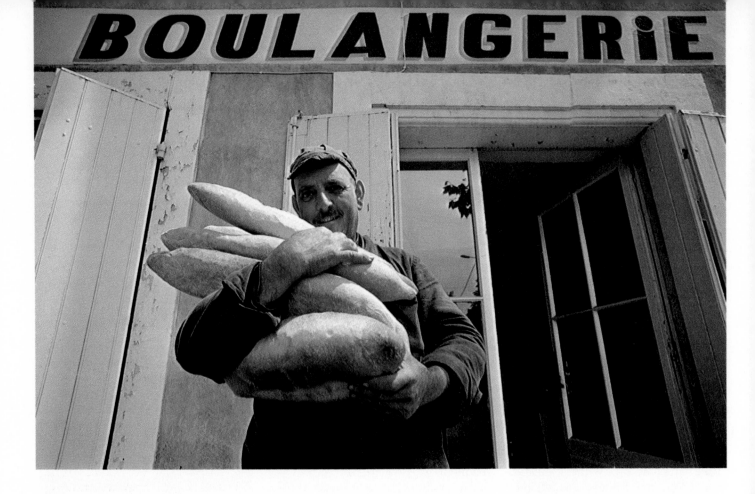

GET YOURSELF READY

All of your research and planning serves to familiarize you with your destination and inspire you to make a photographic record of your travels. Some careful planning will help you fit into your destination better and enjoy all of what it has to offer. But sometimes when you've made plans to go someplace really photogenic, you also resolve to get the best pictures you've ever made. Then anxiety creeps in. You wonder if you'll be able to feel at home, away from home, to get the wonderful travel photographs you want. Will language barriers throw you? Will you feel comfortable with the people? Will you be able to relax in your new surroundings?

I face these questions every time I confront a foreign environment with my camera. However, having worked on assignments around the world, I've learned to deal with this silly internal conspiracy. I do it by priming myself for photography and engaging all my senses and specific states of mind.

When I'm in an unfamiliar destination, my senses quicken in the new environment. The unfamiliar cadence of foreign languages and soothing cathedral bells engage my ears. The smells of freshly baked French bread, aromatic Caribbean spices, and incense in Eastern temples drift into my nostrils. To my taste, foods everywhere are good.

I can't resist feeling the fabric of foreign lands. In Guatemalan markets I've sunk my hands deep into bags of grain. In Ghana I've been body-to-body with Ashanti tribesmen during the durbar festival you'll read about in Chapter 6. I've felt the touch of children the world over reaching for my hand or grabbing my cameras for a peek through the lens.

My eyes wake up and become aggressive in a totally fresh surrounding. They have seen much of this world and are anxious to see the rest.

When all five senses have been brought to attention, you are ready for picture taking. Your mind and body are open to all the sensory impressions the new environment offers, and you are able to respond to them photographically. It is easy to assume that photographs derive from visual response alone. *Good* travel photography results from a *total* sensory response to the environment.

Beyond engaging your five senses, there are states of mind that will greatly enhance the "at home" feeling in your travels.

You must be keenly appreciative of your surroundings. This will quickly tune you in to the local atmosphere. Curiosity makes you interested in and open to people who have answers to your questions. By being honest and natural, you will fit in with everyone the world over. Even beyond naturalness is friendliness. With this quality you will never feel like a stranger for very long. Neither will you see foreigners all around you. They will be friends.

With these attitudes you stand a better chance of meeting some of the world's wonderful people.

EQUIPMENT FOR TRAVEL PHOTOGRAPHY

You have done your photo-holiday homework, and all systems are "go" with respect to reservations and itinerary. Now you must decide what photo gear to take along. Selecting a camera and accessories and packing them for travel is an individual matter. Before suggesting the basic, minimum equipment serious amateurs should take on trips, I'll tell you what I put in my camera bag and how and why I put it there. You must remember I'm a professional photographer standing 5'6" and weighing 120 pounds. Although I usually have my husband's shoulders to help, I only take what I can get to the airport and onto the plane alone. So far my equipment has met the requirements of all travel assignments.

I use the Nikon system, but this does not mean you must use it too. There are many camera manufacturers today producing quality gear. Furthermore, the points I make in this book are applicable to any camera format.

I use three Nikon F2 bodies. The F2 does not have a built-in metering system. For me the meters add unnecessary weight because I've been judging light for 10 years. I use a hand-held meter when in doubt, and as most professionals do, I bracket exposures for insurance.

In my choice of cameras I've stated my preference—not a recommendation. Some cameras with built-in meters weigh less than my F2 models. Many people, including professionals, prefer the convenience of cameras with built-in metering. You can develop an inventory of equipment that suits your needs and personal preferences, as I have done. You can do that with virtually any brand and type of camera.

On these three bodies I install my three most-used lenses. Around my neck hangs the 55mm macro, on my right shoulder is the 80-200mm zoom, and on the left shoulder is the 28-45mm zoom. I wear both of the shoulder cameras turned around with the lens toward my hip. This way they conform to my body better. I always get nervous when seeing someone with a long lens pointing outward. It could get amputated in a revolving door, and wide-angle lenses may get their eyes poked out when facing the world.

Remaining in my bag, which is much lighter by now, is a 24mm and an 18mm ultrawide-angle lens. The bag shares my left shoulder with the camera and 28-45mm zoom. Because weight is evenly distributed in this fashion, I can carry the gear for some time.

Traveling light requires traveling gadget-free. I use no filters except UV filters, which protect each lens from rain, dust, dogs' noses and fingerprints. They also cut down on ultraviolet light, thus reducing a bluish cast in color films. The only extras in my bag are a cable release for frequent use with a tripod, the hand-held meter, a small can of compressed air, lens tissue and sometimes a small flash unit.

This is the basic equipment I used for the photos in this book. It suits my specific way of working. Many different brands and models exist so you can select equipment that serves your photographic needs.

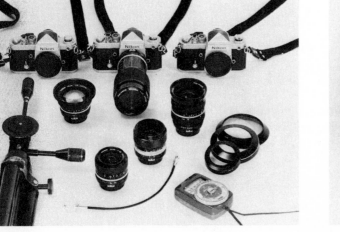

With this camera bag, the bodies fit on top of the lenses and all go into the bag. I carry my tripod with a shoulder strap.

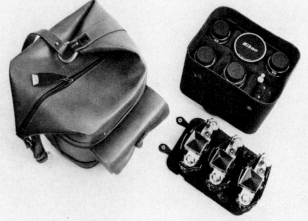

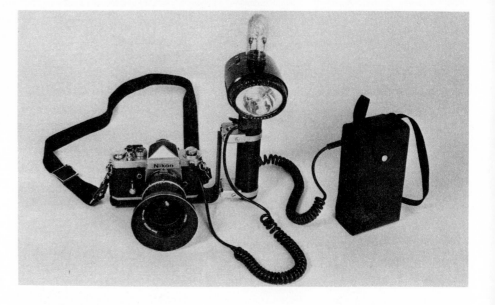

This is the flash unit I usually use. The barebulb on the head of the flash is a custom conversion done for me by Honeywell. The box on the right is the power pack. Sometimes I use a smaller flash that attaches directly to the camera.

HOW I PACK MY GEAR

No two photographers have identical gear. Therefore, showing how I pack my camera bag can only give you an example of how one person solved the problem of putting cameras and lenses in the smallest space, at the minimum weight, and with maximum accessibility and protection for each piece.

MINIMUM GEAR

With three bodies and five lenses, I have instant access to nearly every focal length from 18mm to 200mm. Nevertheless, if you ask me, "What should I have?" I'd probably suggest you buy two bodies and three lenses. "Which lenses?" is the next question I answer frequently for friends. You need a broad lens range. But for as light a load as possible, you can achieve this range with only three lenses. They should be wide-angle, normal and telephoto focal lengths.

Here's my suggestion which may blow your budget: To achieve the greatest range, get wide-angle and long-focal-length zooms and use a 55mm macro as your normal lens, so you can also do close-up photography. Needless to say, these more sophisticated lenses are more costly than a standard 50mm lens and fixed-focal-length wide-angle and telephoto lenses. However, your investment will surely be repaid by the greater flexibility of the macro and zoom lenses.

To get the most from this equipment you should also have a tripod and a flash unit. The tripod lets you use the long shutter speeds of your camera with the minimum of camera shake. It is also useful for photographing with long-focal-length lenses.

The flash unit lets you cope with dark interiors, some nighttime scenes and other difficult lighting situations. A small flash is probably all you'll need as long as you don't want to light any large areas with it.

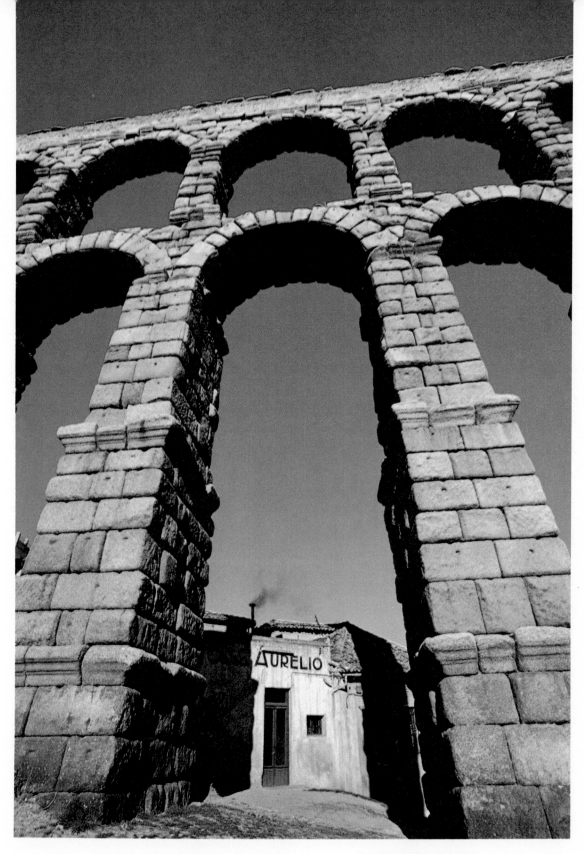

Segovia, Spain—By using an 18mm ultrawide-angle lens pointed
up, I created dramatic distortion.

USING
LENSES

2

To help you decide what kinds of lenses to use in travel shooting, I'll show you particular uses of six lenses, ranging from 18mm to 400mm. Because no one lens is used for all situations, there are different applications of the various focal lengths. There may be some ideas here to open your mind to applications of your own lenses which you've never considered before. And you can bring these ideas into play in your travels.

ULTRAWIDE-ANGLE LENSES

The 18mm ultrawide-angle lens would probably be considered a luxury, offbeat item for most amateurs. Like all tools it has special applications, and you should know what it does best. What the 18mm lens does best is distort! Nonetheless, its effective use requires some thought. The trick with ultrawide lenses is to use the distortion to esthetic advantage.

For example, the ancient aqueduct in Segovia, Spain is a mammoth piece of architecture. Its drama cannot be conveyed with a normal 50mm or 35mm lens because you have to back so far away to photograph all of it. The best way to find strong angles on any subject is to check them from all directions. As I walked around the aqueduct looking for an effective angle, I discovered the arches were most dramatic as I looked up at them from a nearby vantage point.

As I stood beneath an arch at close range, I discovered that only my 18mm lens would take it all in. Aiming up at the aqueduct with the 18mm lens caused much distortion, but the close vantage point enabled me to contrast the grandeur of the structure with the humble little building beyond. I also emphasized the shadows inside the arch which enhance the design of the photograph. With the 18mm lens I have the entire structure on film in a dramatic fashion. And distortion becomes an integral and acceptable part of the drama.

If you need to use a wide-angle lens for something formal, such as architectural photography, and wish to control the perspective distortion, or *fall-off*, keep the camera's film plane parallel with the subject. This is often impossible. Any focal-length lens is capable of producing fall-off, but the effect is more exaggerated with a wide-angle and even more so with an ultrawide-angle lens. Some wide-angle lenses are made with a perspective control built in. They are called *PC lenses*.

Something else to look for with ultrawide-angle lenses is extreme lateral distortion at the edges of the frame. This is caused by the optical limitations of recording three dimensions onto two dimensions. With the 18mm lens, any part of the subject at the edge of the frame on the short side will suffer a lateral magnification of about 40%. If you're using an 18mm lens to photograph a friend, place the subject in the center of the frame. Otherwise, the lens will produce a shorter, fatter-looking head in the image than the subject actually has.

The treatment of the aqueduct shot shows one way of getting a large subject in the viewfinder by using the 18mm lens. Next is an example of another application of the same ultrawide distortion effect.

In Portugal I fell in love with the subtle pale green of a house and its deeper green window trim accented with white. I knew the 18mm lens would allow me to emphasize these color contrasts through distortion. Because wide-angle lenses can have extensive depth of field, I knew I could move in close to the deepest green corner and still get a sharp image from one foot to ten feet. So I stopped down to *f*-22 to achieve this depth of field.

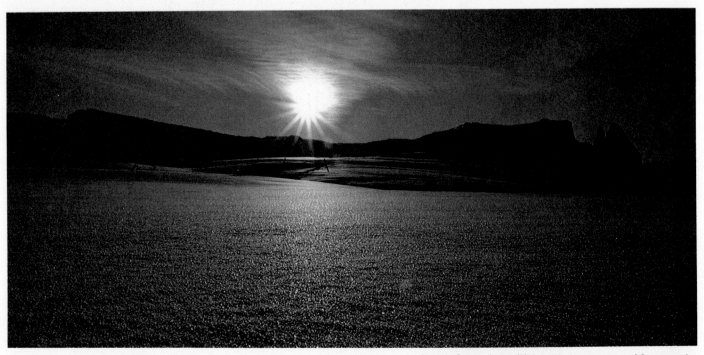

Alpe de Suisse, Italy—Wide-angle lenses are good for capturing expansive views. Sometimes, shooting from a low angle creates more dramatic effects than standing up straight would.

Opposite Page
North Adams, Massachusetts—Wide-angle lenses let you get really close and still include background subjects!

WIDE-ANGLE LENSES

Let's move on to the 24mm lens, which also distorts, but not as drastically as the 18mm lens. I had a 24mm lens in my fanny pack while skiing late one afternoon in the Alpe de Suisse, a magical mountain meadow in northern Italy's Val Gardena. It is walled in by a variety of mountain peaks.

Scanning the snow bowl, I spotted downhill and cross-country skiers, jingling horse-drawn sleighs and sturdy Germans hiking briskly. Rustic little huts emitted aromatic wood smoke while people sun bathed and sipped hot chocolate on the porches.

Before the sun set, I decided the 24mm lens would capture the wide-angle landscape. I wanted a shot of the sinking sun, glistening snow and the silhouette of the low-lying hill. To capitalize on wide-angle distortion in this picture, I knelt and shot with the 24mm lens close to the sparkling snow to emphasize it. By stopping the lens down to f-22, I achieved the star effect which results from shooting directly into sun at a small aperture.

A frequent problem when using a wide-angle lens for scenic photos is that they can include too much distracting detail. Many a spectacular mountain view is disappointing in a photo due to improper selection of lens and location. Therefore, use the tightest field of view possible to frame scenic subjects. If you're without the optimum lens, try to move closer. Sometimes, simply moving a quarter mile down the road will do the trick.

Let's shift from an Italian landscape to an American poppy and see how the 24mm lens applies to close-ups. Many amateurs assume that wide-angle lenses are only good for landscape shots. This is not so.

I had a dream-come-true assignment—photographing the entire state of Massachusetts for the Division of Tourism. One terribly muggy day, the kind in which cricket music and earthy smells hang in the air, I happened upon some oversized poppies. The 24mm lens isolated one of them against a nearby barn perfectly. The lens was no more than a foot away from the flower, and this exaggerated its size to give a poster-like effect.

This strong effect is achieved with many subjects by isolating them from their surroundings and moving in close with a wide-angle lens. What results from this treatment is essentially a wide-angle close-up shot or an environmental close-up. My close-up poppy picture still shows some surroundings. What I'm really stressing here is that close-up photos are not always made with macro lenses and landscapes are not always made with wide-angle lenses.

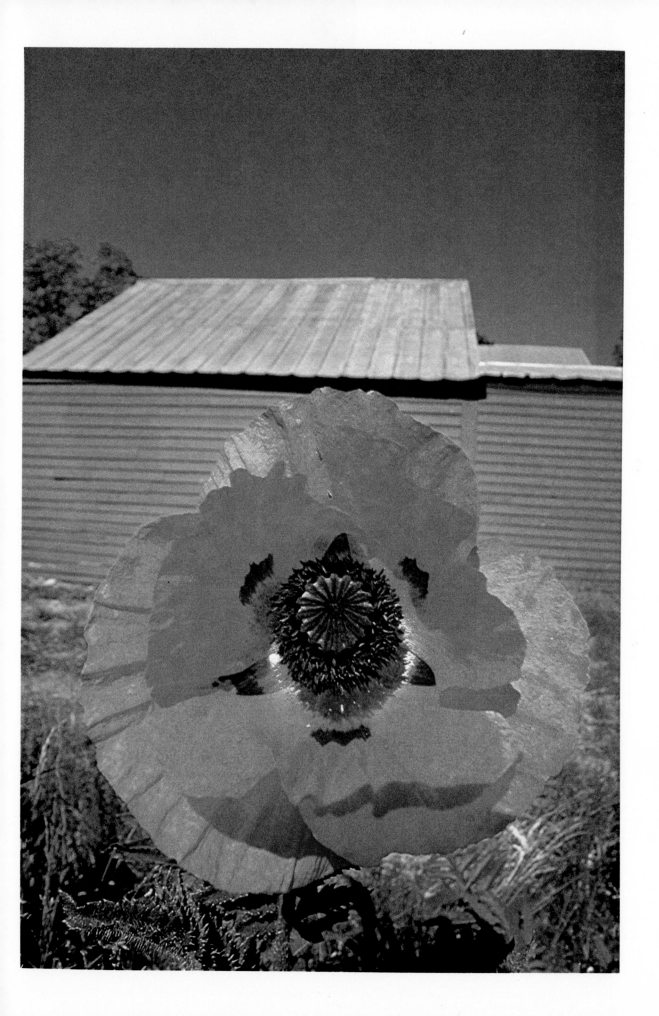

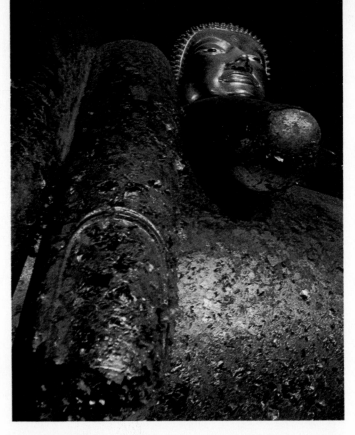

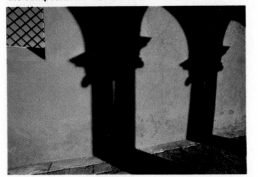

Venice, Italy—I had to work very fast to make this shot, and the wide-angle zoom allowed me to achieve the composition I wanted in the minimum of time.

Ayutthaya, Thailand—I use a wide-angle zoom to compose and crop without changing position.

WIDE-ANGLE ZOOM

I often use a handy 28-45mm zoom. It eliminates a couple of fixed-focal-length lenses, thus reducing the overall weight of my gear. The primary advantage of zooms is that you don't have to keep switching lenses all the time.

Another benefit is the ability to use any focal length between the two extremes of the lens. For example, best composition of a subject may need a 40mm setting for which there is no fixed-focal-length lens. Zooms allow precision framing. You might ask, "Why not stick with fixed-focal-length lenses and change the distance from the subject?" Sometimes this is impossible.

For example, when I photographed a statue of Buddha in Ayutthaya, the ancient capital of Thailand, there was only one spot to be in to achieve the composition I wanted. I had to jam my tripod into a tight space between a pillar and the base of the Buddha to get an unusual angle of the index finger resting on his crossed leg. I was bored with straight-on, all-encompassing photos of Buddhas I'd seen before.

With the 28-45mm lens I could play with the framing of the Buddha. I decided on a tight composition. Just as I prepared to shoot, the cleaning crew turned on one bare light bulb which hung from the ceiling in front of the Buddha. This illuminated the gold leaf better, and I captured the scene with a time exposure.

Once when I was in Venice, the 28-45mm zoom enabled me to work fast before getting kicked out of a cloister I had sauntered into accidentally on purpose. A guard started to object to my presence in the male sanctuary, but he was distracted by my husband, Landt, who engaged him in polite conversation. I was then able to frame quickly without changing lenses and get several shots of the arch's shadows before obediently leaving the cloister. Having to change a lens would have heightened the tension and absorbed valuable time.

Some people cling to the objecttion that zooms are not as sharp as fixed-focal-length lenses. In recent years top camera and lens manufacturers have improved zoom optics to the point that this argument is no longer valid.

St. Kitts, British West Indies—A super-sharp macro lens records details very well. The texture of the painted wood makes the subject appear more three-dimensional.

MACRO LENS

The next lens in my arsenal is the 55mm macro. Nikon calls it a *micro* lens. I use it as a substitute for the so-called normal lens which generally comes with the purchase of any 35mm SLR camera. The macro is suitable for any use a normal lens may have. Because it also functions as a close-up lens, its optics are super sharp.

For example, in Guatemala I used the 55mm macro lens for a mother and daughter portrait. They caught my eye primarily because they were the only people of Spanish descent I had seen working in the markets I went to. Everyone else was Indian. I also liked the contrast of their black and white clothing against the colorful materials they were selling.

The macro lens is an important part of my equipment because I use it so often for in-tight, detail shots. Rarely do I use the limit of its close-up capabilities. Most macro lenses have a built-in maximum magnification of 1/2, but you can get higher magnifications by adding extension rings or a bellows unit to your system.

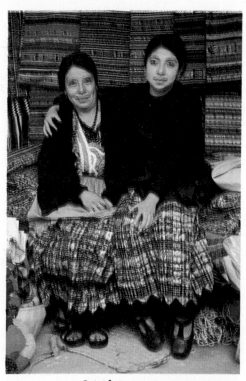

Sololá, Guatemala—I often use the macro lens as a "normal" 55mm lens.

17

LONG-FOCAL-LENGTH LENSES

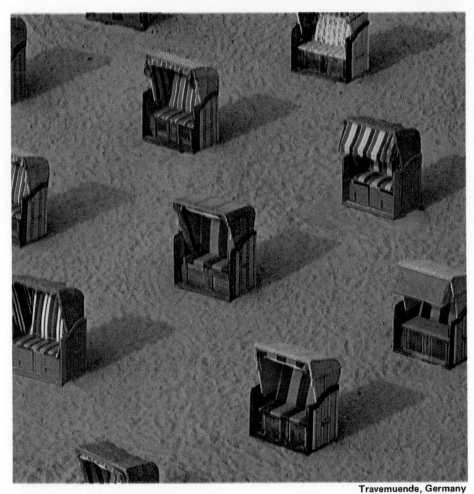

Travemuende, Germany

To continue this focal-length rundown, let's consider some shots taken with a borrowed 400mm telephoto. Besides the perspective-compression capability of telephotos, the ability to bring near and far elements visually closer together, they do other things. One is to bring a singular, faraway subject closeup, as in the photo of the German beach resort Travemuende. The beach was covered with colorful, two-person wind/sun houses, and I was able to shoot the beach from my hotel room.

You should use a tripod or other firm support with long-focal-length telephotos because of their extra weight and bulk. As a general rule, don't hand-hold these long-focal-length lenses for exposures longer than 1/500 second.

If you've installed a 400mm on a tripod on a windy day, watch out! Don't assume you can shoot at 1/60 second in the breeze. You can't and still avoid camera motion. You may need a 1/250 second shutter speed, or faster, to offset shutter and wind vibrations.

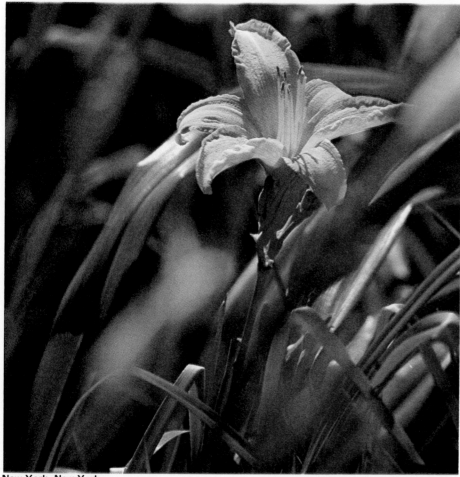

New York, New York

Another trick to try with telephotos, such as the 400mm, is to use shallow depth of field.

At the New York Botanical Garden I took a 400mm shot of a day lily. By opening the lens to f-3.5, I achieved a soft, out-of-focus foreground and background. This technique enabled me to isolate the flower from its surroundings and create an impressionistic photo.

It was possible to hand-hold the camera because with the f-3.5 aperture setting I needed a shutter speed of 1/500 second. This eliminated

blur due to any possible camera movement or flower motion caused by a breeze. But I did have to be sure focus was correct due to the limited depth of field.

You may be wondering why I don't own a 400mm telephoto. The reason is simple. I don't see enough long distance things I want to record to make the investment worthwhile. As you will notice from my work in this book, I'm severely prejudiced toward moving in close and getting an intimate view with a wide-angle or close-up lens.

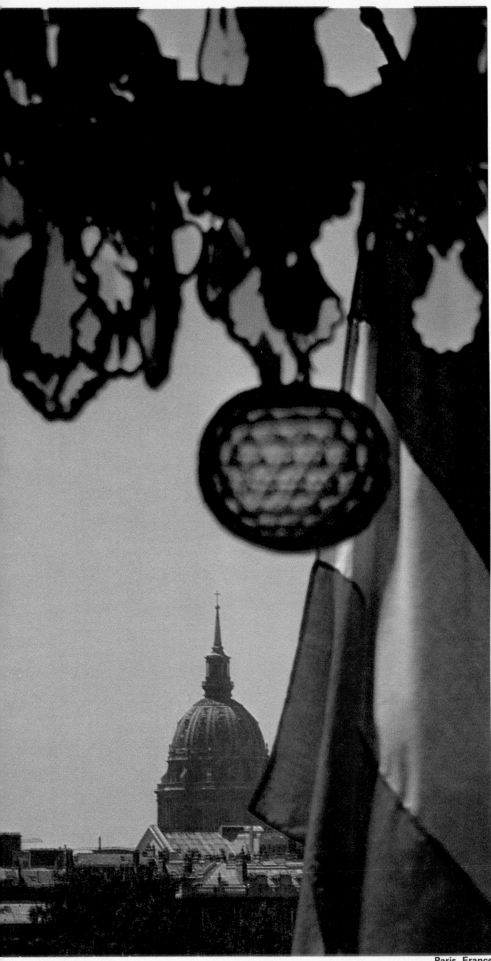

Paris, France

LONG-FOCAL-LENGTH ZOOM

I've already mentioned that zooms are ideal for precision framing and for eliminating the weight of several fixed-focal-length lenses. When it comes to long-focal-length zooms, you get these benefits plus the perspective compression of telephoto lenses. It seems to bring near and far objects closer together.

In Paris, I took advantage of this characteristic of my 80-200mm zoom. I was staying in a famous old-world hotel, the Crillon on the Place de la Concorde. The hotel's exterior was festooned with French flags to impress a visiting Arab chief of state. While wandering around the hotel one day, I noticed I could see from the ballroom to the dome of Les Invalides, Napoleon's tomb, a mile away. The composition problem was a crane to the right of the tomb and some new buildings under construction.

At that point, another thing came to my attention. My husband pointed to the chandeliers in the ballroom. He wanted me to include one of them in a shot of Les Invalides.

Immediately I assumed there was an insolvable depth-of-field problem and that the crane and construction would ruin the entire image anyway. But when I wandered out on the balcony, I spotted one of the French flags in a bracket. It was accessible and removable, and I was determined to put all these elements together to make the shot work.

No one was around to stop us from rearranging the scene, so I helped myself to a big, round table and set up a tripod on it. Then I stood on the table and began aligning the lens to exclude what I didn't want. Having done so, I asked Landt to remove the flag from its bracket. He stood on the balcony and held it to block the crane.

With the lens set at f-32 for maximum depth of field, I made exposures at 1/15 and 1/8 second. I got an acceptably sharp photo of

the foreground elements and a very sharp Les Invalides. The depth-of-field span was from about 15 feet to infinity. The telephoto zoom compressed the crystals, the flag and the tomb into a harmonious composition.

Usually when people purchase long-focal-length zoom lenses, they want the ability to keep their distance and zoom in on a subject. I was grateful for this capability one day when photographing a Queen's guard at St. James Palace in London.

I felt so sorry for this chap whom I wanted to photograph. It must be a very big bore to stand under a furry hat for hours on end, unable to flinch when tourists gawk, poke or take photos. My initial instinct was to go for a 55mm macro close-up portrait, but I couldn't bring myself to take photographic advantage of a totally defenseless person from mere inches away. So I stood back and zoomed in on him with the 80-200mm lens cropped tight and shot away with only a minimum amount of guilt.

EXPLOIT FOCAL LENGTH

I think it's important to be photographically fluent with as wide a range of lenses as possible. As you see in this chapter, each lens can solve certain problems. And if your eye is flexible and open to new angles, you will discover occasions to use a variety of lenses. Remember, you should not begin with hardware in mind thinking, "I have a brand new 24mm lens. I must go out and see 24mm perspective." Instead, begin with the subject or the concept and then decide which lens should be used to best express your sense of it.

After all, a painter doesn't paint a whole picture around an effect achieved by a particular brush. He may use a special brush to achieve a special effect. The same holds for photographers; subject first, hardware second.

Whether you travel with three lenses or thirteen, play your lens range for all it's worth. A pianist plays all the keys on the piano. He doesn't have a favorite note. Photographers should also try to be impartial and use all their lenses.

London, England

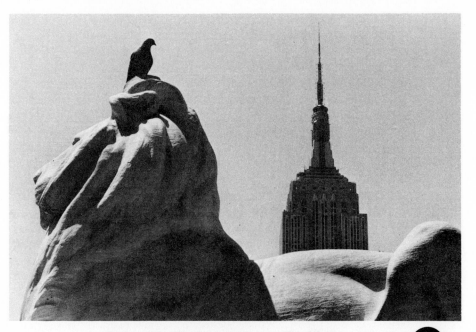

New York, New York—While looking for an unusual way to shoot the Empire State Building, I discovered this perspective from the steps of the Public Library.

EXPERIENCES IN 3 TRAVEL PHOTOGRAPHY

When thinking of travel, do you mentally pack bags and take a fantasy flight to a faraway place? You don't have to cover great distances to travel. It is basically a state of mind and an attitude to have toward wherever you may be. The true traveler is one who continually sees his surroundings with a fresh eye and can absorb the stimulus and atmosphere of the locale.

With this attitude, local and familiar places also qualify as travel destinations for you and your camera. It's easy to become passive when on familiar ground, but a good travel photographer should never let it happen. There are photographic opportunities wherever you may be. After all, when foreigners come to America, they often photograph what Americans might ignore as commonplace.

TRAVEL PHOTOGRAPHY IN YOUR OWN BACKYARD

Let's assume that you live in a city and want to open your mind to possibilities for some Saturday or Sunday shooting. You already know about the obvious things, but have you actually taken advantage of them?

For example, do you live in New York City but have never been to the Statue of Liberty? Or in Boston and have never been to Little Italy? Or in San Diego and never been to the famous zoo?

If you have photographed the obvious sights, how do you learn about the less obvious photo subjects? Drop by your city's Visitors and Convention Bureau to pick up literature about interesting locations and upcoming events. Many major metropolitan papers also list these happenings. The Friday paper usually lists all the weekend activities. Go to a book store or library and

look at guide books to your city. Authors of guides have devoted months to ferreting out information for travelers. Picture books may also give you some ideas, and almost all big cities now have a magazine devoted to their issues and events.

MY CITY

I happen to live in New York City so let's take it as an example and see how many places and happenings suitable for photography are in my backyard.

The Museum of the City of New York schedules walking tours through areas of historic and architectural interest. There are also tours through Harlem and Bedford-Stuyvesant neighborhoods. At one time the inner city *was* the city. Historic vestiges remain that are great for photographs. The Harlem tour offered by Penny Sightseeing, for example, includes a stop at the 18th century Jummel Mansion. Washington slept there, and it was one of his headquarters during the Revolution. "Bed-Stuy" has the

New York, New York—I used a 400mm lens to capture the spirit of the Art-Deco motif of the Chrysler Building.

New York, New York— Tours through Harlem visit Sunday-morning gospel services.

New York, New York—With a 24mm lens and a vertical viewpoint, I made an abstract view of the twin towers of the World Trade Center past a stainless steel sculpture.

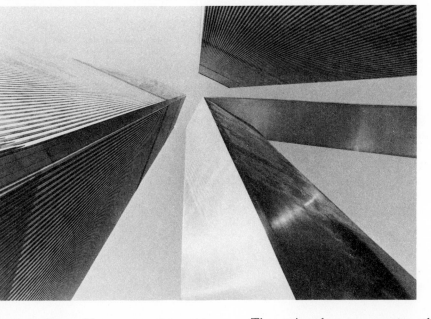

greatest diversity of architectural styles in New York City and has been undergoing a remarkable face-lift by the Bedford-Stuyvesant Restoration Corporation. You can call them for tour information.

While on assignment to photograph the area, I walked around with a writer and had nothing but pleasant encounters. But if you are nervous about low-income neighborhoods, take a tour with a group. Guided tours provide as many photo opportunities in New York as there are in low-income areas of Paris and Rome.

You can find many ethnic atmospheres in New York. Visit Orchard Street on Sunday to catch the dry goods market. The area is an Orthodox Jewish enclave. There's also a China Town, Little Italy and more.

For old-world atmosphere, the South Street Seaport with its four-masted schooners and other vessels from yesteryear is a fun place. Many fairs and concerts are

put on there. You may not want to get caught in a crowd on a hot summer's day, but remember where there are people, there are always pictures!

Furthermore, New York City has an ongoing schedule of parades, fairs, festivals and contests which entertain. The Macy's Thanksgiving Day parade is definitely photogenic. Not as well known is the West Indian Festival held every Labor Day in Brooklyn. Modeled after the Trinidad Carnival, the event features calypso, limbo dancers and steel bands. Also, there's a parade of floats and costumes made by West Indian people living in New York. It's probably the summer's best event. But even though the carnival grows in size each year, it's still not well-known. To see some of my shots of the West Indian Festival and learn more about shooting carnivals and parades, see Chapter 6.

There is also no greater thrill than Central Park in summer. It's really the place to see everyman à la New York City from the most sophisticated to the truly weird. Photographic opportunities include bike races, running marathons, horseback riding, yoga, kite flying, Frisbee throwing, miniature-boat sailing and martial-arts demonstrations. You name it; it's there. Central Park has photo opportunities unparalleled by any other park I've ever seen.

New York City also has stupendous architecture. Skyscrapers and landmark buildings abound with a variety of styles, and it's even fun to photograph the most famous. I did so one weekend. I wanted to make diverse architectural shots showing different approaches to photographing buildings.

23

You may be thinking at this point, "But New York City is different. My city isn't a smorgasbord of picture potential." I concede New York is a photographic cornucopia. I pick it simply to illustrate how you can probe into your own urban area.

Even if you live in the country, you may discover photogenic community events on bulletin boards. The nearest Chamber of Commerce will be up to date on area activities, and the local newspaper and state magazine should be helpful. Maybe you'll spot something unusual in an upcoming events column.

Would you see interesting travel photographs in a pumpkin-carving contest? If you had a house guest from overseas, wouldn't you take him to it, and wouldn't he be delighted to photograph it to show friends back home? Yes he would! So try thinking like a traveler. You'll be astonished how many more photographs you'll see if you do.

Another fun thing to consider if you are a country dweller is a picture story on your community or county. Photograph it with your new-found traveler's eye. You may even get yourself a picture page in the local paper or an exhibit at the Town Hall. Someone may be writing a history of the area, and your shots could illustrate it. Become photographically enthusiastic about your surroundings. You never know what might come of it.

With this fresh attitude of a traveler in your own backyard, you'll sharpen your skills and probably be a very busy photographer from now on.

THE UNITED STATES

If you are committed to travel photography, you may wish to plan a photo trip for a weekend or longer. I bet there's someplace you've been longing to go with your camera. Is time stopping you? If so, ask yourself how important photography is to you. If it is high on your list of interests, you'll be able to make necessary adjustments in your schedule and get away for a few days of shooting.

During the Bicentennial Year, many Americans discovered their own country. They celebrated by vacationing at home and found that becoming photographically aware of a state or region in America can be as gratifying as going to exotic places. You don't have to be in the summer crush at the Grand Canyon either. Try a serene journey through

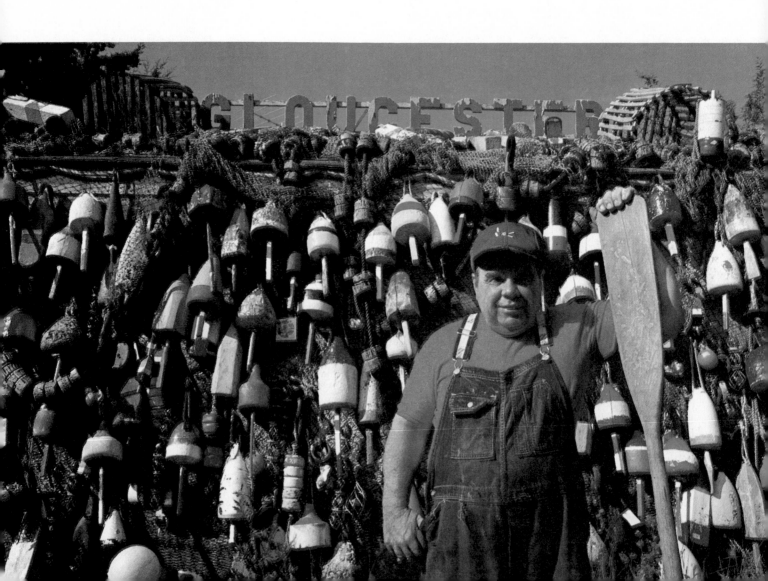

southern Ohio, the mountains of West Virginia, the Arkansas Ozarks, or along the Oregon coast. Some of our less-traveled states are where you can get in touch with grass-roots America.

For the Bicentennial Year, I became photographically involved with Massachusetts. I covered it from top to bottom for the Massachusetts Division of Tourism. I can look at just one of my photos from that assignment and recall the entire experience. All 45 days of it return to memory—from the cool piney smell of the Berkshire Mountains and the tunes of Tanglewood to the Cape Cod National Seashore with its beautiful sands. This is what a successful travel photograph does; it stirs up sights, sounds and aromas from our memory.

Opposite Page
Gloucester, Massachusetts—An environmental portrait should indicate the subject's relationship to his surroundings. There is no doubt that this man is a fisherman.

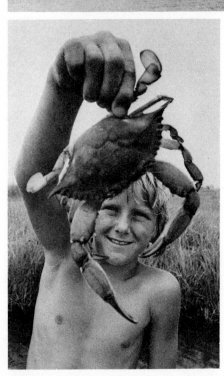

Tangier Island, Virginia—Crabbing is the principal industry on Tangier Island.

Tangier Island, Virginia—This boy jumped off the bow of the boat a number of times for me until I got the shot I wanted.

Virginia—If I were to suggest a dandy weekend trip for those in the Philadelphia-Baltimore-Washington, D.C. region, it would be Tangier Island in the Chesapeake Bay. You take the ferry from Crisfield, Maryland to this small, flat island, which is supported by the soft-shell-crab industry. While the island geography is no spectacle, the way of life is fascinating. It is crowded with tourists in the summer, so I recommend you go in the off season.

Tangiermen, as they are called, are God-fearing, family-loving, hard-working folk. They are descendants of early English colonists who settled in the Chesapeake in the 17th Century. To this day insularity has preserved traces of Elizabethan English. It's a joy listening to Tangiermen talk!

I had an especially enjoyable time on the island because a troop of small boys took a liking to me, so I photographed their antics and explorations. The soft-shell crab pens interested me, and there are snatches of the unusual lifestyle to be recorded too. For instance, the Tangierman buries his kin in his front yard. Grave stones are apt to be on the right side and a vegetable garden on the left.

On Tangier I jumped right into the community by going to church my first night there. I don't remember the denomination; I went for local color and to get in tune with the island people. Furthermore, I'd seen photographs of Ma Parker in a *National Geographic Magazine* article about the island. One was a shot of her holding up an apple pie she had just baked. The other was of her testifying at church. Having seen these, I thought it would be fun to catch a glimpse of her myself and possibly meet her at the church. We did meet, and she was every bit as delightful as her pictures indicated.

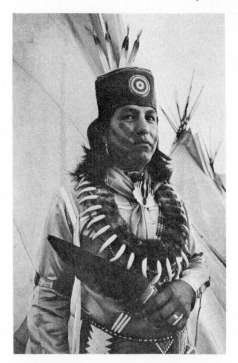

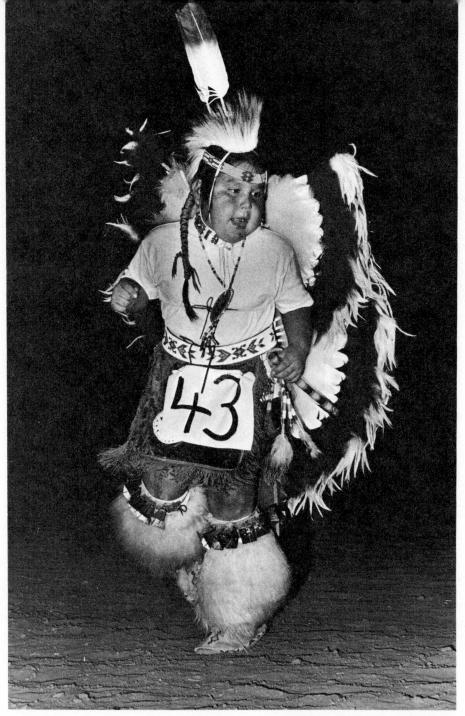

Anadarko, Oklahoma—I used a flash to
freeze fancy footwork contestant #43.

Oklahoma—All American states have annual affairs great for photographs. One of the more extraordinary events I have attended was the Anadarko Indian Festival in Oklahoma. Every August thousands of American Indians from all over the country convene here. The festival is mainly an exposition of Indian dances to heighten cultural awareness among tribes and pass the dances down to the next generation. Besides watching dancing at night under stadium floodlights, I walked through the encampment by day and met the Indians.

I made many photographs at Anadarko, including this portrait of Chief White Cloud's great-great grandson wearing his great-great grandfather's bearclaw necklace. It was a gratifying final shot after two sweaty days.

26

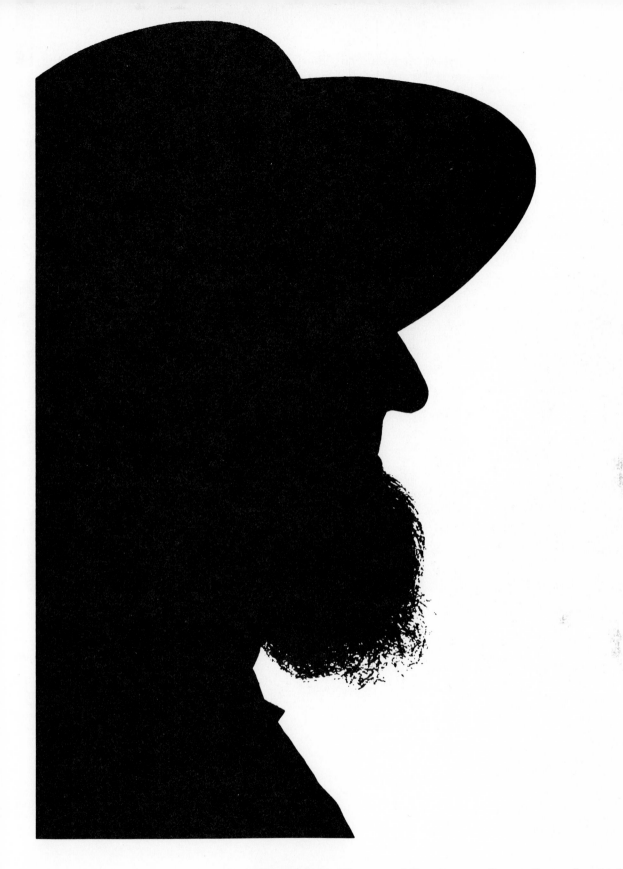

Pennsylvania—The annual Kutztown Festival in the Pennsylvania Dutch country is also fun. The festival is a showcase for local cuisine and crafts—everything from shoefly pie to broom making. There was an incredible amount of activity while I was there. I got photographs of grandmas knitting shawls, women baking apple pies in antique kitchens, a coffin maker, candle makers and kids husking corn. But my favorite shot is a profile of an Amish farmer in silhouette.

Restored Towns—You might enjoy taking a leisurely, history-filled journey. America is rich with restorations ideal for the history buff. All offer a chance to take photographs.

There are restorations like Deerfield, Massachusetts; Old Newport, Rhode Island; Winthrop, Washington, and Solvang, California all still lived in today. There are touch-me-not places like Delaware's Winterthur. Others are alive by day with people in period costumes engaged in crafts and tasks of past centuries. Among these are Colonial Williamsburg in Virginia; Sturbridge Village and Plymouth Plantation in Massachusetts; Old Tucson, Arizona; and Greenfield Village in Dearborn, Michigan.

During your travels, don't overlook such places, even if you are not interested in history. Wander through these towns and buildings and let the atmosphere grab you. If you do, you'll return to the 20th Century with some nice photos.

Whether you take a weekend trip or an extended vacation, there are many ways to get in touch with America. You don't have to head for the tourist meccas known to everyone. I'm not trying to deprive you of visits to famous places. See them too. So if photography is a key motive for your travels, also include something unusual, educational and off the beaten path.

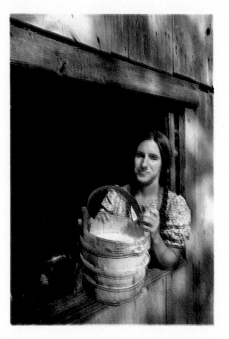

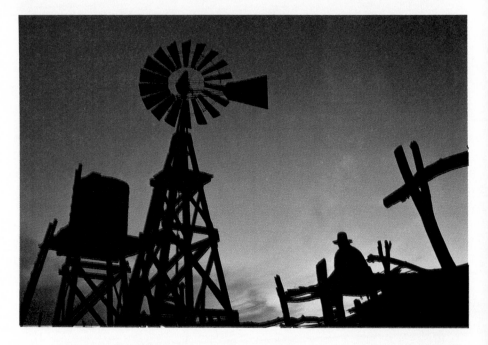

Above Right
Old Tucson, Arizona—Explore a variety of techniques when shooting a location. The human figure adds scale and interest to a sunset photo.

Above Left
Sturbridge Village, Massachusetts—I like the diversity of subjects that restored towns offer: still lifes, architecture, nature and people in period costumes.

28

Pasayton Wilderness, Washington—Shooting in the wilderness is always challenging. This composition took almost an hour to get, and I was lying on the snow the whole time!

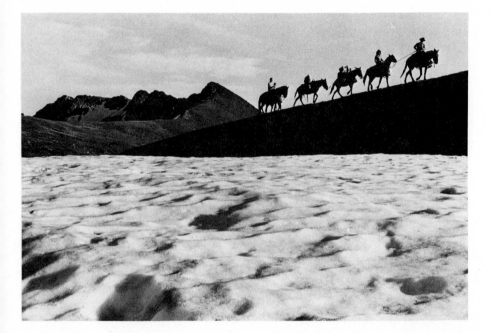

ADVENTURE TRIPS

America is also packed full of action for the adventurous travel photographer. There are few countries in the world that offer such diversity of organized, energy-expending activities. There are cattle drives, covered wagon trips, helicopter skiing and jeep safaris into Death Valley. You can go ballooning, river rafting, hang gliding or dogsledding. They are all fun things to do to stir the body and psyche. They make for dynamite photographs too.

I once had an assignment to do a story on a pack trip in Washington State's Pasayton Wilderness in the Cascade Mountains.

I was a day late joining the group and was riding up the trail with a group bringing in supplies. We stopped at a scenic location. Seeing the picture possibilities, I asked the people with me if they would ride along the ridge. They didn't know I was going to get into the just-one-more-time syndrome, and they rode back and forth about six times before I would let them stop. I was right to persist because only one shot turned out satisfactorily.

I may become a bit demanding sometimes to get good photographs, but never at the expense of grace and gratitude. It all depends on your attitude. Amateurs shouldn't be reluctant to put in special photo requests either.

I must mention here that you have to keep your wits about you when taking expensive photo equipment on unusual outings. Always ask yourself, "Is the gear out of harm's way?" On the pack trip, for instance, I had an extra camera body and a couple lenses in the saddle bag. During lunch one day, my horse decided to take a roll. I caught him on the descent and quickly brought him back on all fours. Without quick action the packed equipment would have been damaged.

Sometimes I find that coping with hanging cameras on outdoor expeditions is a nuisance. Some people find camera hitches helpful here. The hitch is an elastic brace that prevents the hanging camera from sliding around your chest. When you want to take a picture, the brace yields, and you can raise the camera to eye level.

Many-pocketed, zippered fishing vests are also great for adventurous photographers. They hold film, extra lenses and anything else you may need.

through Kiowa, Comanche and Sioux Indian buffalo hunting ground. If you love earth colors and blue sky as much as I do, you'll enjoy the flat, spectacular expanse.

Even though the trip is accompanied by some distracting elements, such as plastic cups and a chemical outhouse on wheels, it's still a grand experience full of photographic opportunity.

The wagons pull into a circle at night, and a roaring fire is built. The wagonmasters are real old timers who manifest pioneer qualities you don't see very often. The women, guests included, may be in calico dresses, which appears phony at first, but becomes more authentic as you get into the trip. When the wagon train is dwarfed by a red mesa, it seems to be from a Remington painting as does the herd of wild horses over yonder.

Ballooning—You may not wish to be earthbound for your photographic-adventure vacation. If so, try hot-air ballooning. The balloon has enjoyed a comeback in recent years all over the United States. The balloon convention held each year in Indiana is quite a sight when hundreds are up in the air.

The 140-acre Balloon Ranch, Star Rt. Box 41, Del Norte, CO 81132 and Professor Hall's Hot Air Balloon School of Higher Learning, 1656 Massachusetts Ave., Lexington, MA 02173 are two places to learn the gentle art of ballooning. While learning, you'll be able to photograph from ground level and while in the air.

INFORMATION SOURCES

If outdoor adventures such as these appeal to you, you may want to research all the possibilities at home. In *Adventure Travel—North America,* available from Adventure Guides, Inc., 36 East 57th St., New York City, NY 10022. The author, Pat Dickerman, lists everything from dogsledding to cattle drives. She now has a service whereby she will personally develop an American adventure itinerary for you. There's an outdoor expedition catalogue in her head, and she can instantly tell you about any kind of trip from white water rafting in a national park to diving in the coral reefs of Florida. Write or call Pat to learn more about her service.

Another book for travel information and inspiration is the *International Adventure Travel Guide,* available from The American Adventurer's Association at Suite 301, 444 N.E. Ravenna Boulevard, Seattle, WA 98115, U.S.A. Founded in 1976, this association provides members with up-to-date information on outdoor travel opportunities. Members receive a magazine, *Adventure Travel,* and an exciting monthly newsletter listing all sorts of expeditions all over the world.

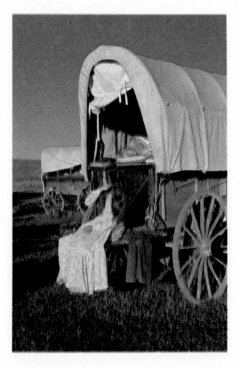

Wagon Trains—A very unusual American outing is a covered-wagon trip. There are a number of them in the Western states, and some are more authentic than others. The trip I took was on *Wagons Ho!,* Quinter, KS 67752. Ruth and Frank Hefner are the operators of the restored wagon train which travels the old Butterfield Trail

Quinter, Kansas—At first glance this photo is realistic, but the modern leather jacket and purse give it away. Adventure trips such as *Wagons Ho!* offer many opportunities for unusual photographs.

X-RAY SURVEILLANCE

These days a security check of air travelers involves X-ray surveillance of carry-on luggage. Pros know that one exposure of X-ray may not damage film, and two exposures might not either, but many vacations involve several airport-security inspections. The deleterious effect of X-ray is cumulative, so minimize it whenever possible. If your trip involves four or five flights and film is submitted to as many X-ray exposures, you may see some unexpected lighting effects on your vacation photos.

Your first thought might be to avoid the whole issue by packing film in a suitcase going in the hold of the plane. *Do not do this!* Holds become dangerously hot sometimes, and this can ruin film. Many airlines also spot check luggage with extra-heavy X-ray radiation. I've heard some sad tales about film being damaged in Germany and Hong Kong where hijackings and drug traffic have resulted in increased X-ray surveillance.

For pros the rule is: *Always carry film on the plane with you.* Recent technical field tests have proven conclusively that airport X-ray surveillance can damage ordinary film. This result is supported by a vast majority of professional and amateur photographers. The March 16, 1978 FAA ruling in the U.S.A. requires signs to be posted informing passengers they may request a hand inspection of their photographic equipment and film without exposure to an X-ray system.

You should *always* request hand inspection for your film. If airport officials are reluctant or if you are going to be making several flights and going through several X-ray checkpoints, you should demand it. Sometimes this will delay you from boarding the flight but better to lose a little time than lose all of your film.

For the times you may be unsuccessful in getting hand checks, possibly in countries in which the military runs the airport, you should have your film in Filmshield® pouches. These are available at most camera stores. The only trouble with these lead-lined pouches is that they don't totally stop radiation. If the X-ray machine is seriously maladjusted and emitting high levels of radiation, your film may still be ruined. The pouches do add weight, but I partially beat this problem by deboxing film and keeping it in the plastic containers before and after exposure. This protects the film from humidity changes and insures the film cassettes won't pop open under packing pressure.

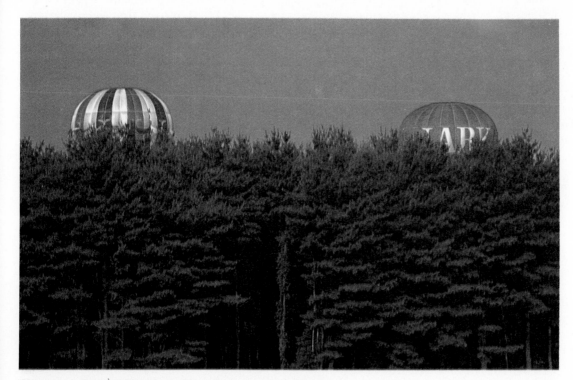

Washington's Crossing, New Jersey—The balloons America and Lark.

FACING THE ELEMENTS AT ARCHES NATIONAL PARK

Welcome to Utah, home of 43 state parks, five national parks, seven national monuments and two national recreation areas. Second only to California in its number of government-recognized natural wonders, Utah calls itself the *National Park State.* You and your camera can go wild there. I did, not only because of the state's natural beauty, but also because I ran into frustrating foul weather the day I was at Arches National Park.

Instant Homework—One January I was on assignment in Utah to cover the ski scene in the Wasatch Mountains. I decided to stay on longer to fulfill a longstanding desire to see one of the Utah national parks. Unusually heavy snows that year made many of the parks inaccessible. I was doing some research in Salt Lake City with the help of the folks at the Travel Council who called the Park Service to determine conditions. So I narrowed the choices of parks down to one: Arches, one of the nation's newest national parks established in 1971.

I was told there are more natural sandstone configurations in Arches than anywhere in America. The guide books and brochures at the Travel Council convinced me it was worth the trip.

After calling the weather service in Moab about ten times to make sure there would be blue skies in the south, my husband and I rented a car and set off on the five-hour drive from Salt Lake City.

It had been snowing and foggy all over the state for weeks, so I could not trust just one weather report. I only had one day to shoot at the park because I had to get back to New York City and immediately fly to Europe on another assignment.

The Fun Begins—We arrived in Moab by nightfall. There had been a lovely sunset and clear evening sky. The plan was to get to Arches and set up for a sunrise shot of Balanced Rock in silhouette with the snow-capped mountains in the background.

Next day at the park, I trudged through the snow, set up my camera and tripod on a bluff, and composed the picture. The sky was clear and the sun was about to light up the mountains and make Balanced Rock a strongly silhouetted foreground sculpture. It was wonderful to be there because it was off-season, unearthly and freezing cold.

Five minutes before sunrise I pulled out the light meter to get an exposure reading. I aimed it into the sky for an incident reading and saw a thick blanket of fog moving in.

I couldn't believe it. Quickly, I looked in the viewfinder to see if any shots could be made. But I watched through the viewfinder as the fog enveloped my picture in less than a minute. There had been no time for a meter reading or any exposure. I had never seen Mother Nature move so fast. Where there had been clear skies was now dense fog. Although disappointed, I kept my spirits up by remembering I had all day to shoot. The fog was surely a temporary whim of the weather because my ten phone calls to the weather bureau assured me it was going to be a gorgeous day.

As we drove deeper into the park to another location, we drove deeper and deeper into fog. I eventually forced myself to hike a short distance in deep snow to the North and South Window and Turret arches. Having reached them, I could barely see their shapes in the gray. Defeated, I sat down on a rock to think.

Suddenly I heard Landt's voice out of the fog. He had climbed up into one of the arches. "There's a small opening in the clouds and some sun coming. It's going to hit the Turret in a few minutes." There it was—a merciful hole with soft rays filtering through.

I rushed to set up a camera and tripod. Because I couldn't get any closer in a hurry in knee-high snow, I used the 80-200mm zoom. The clouds were moving fast. Again there was no time for a meter reading. In a situation like this a through-the-lens metering system comes in handy. But I don't have one, and for the first time I wished I did. When the sunlight suddenly hit Turret Arch, I bracketed like a fool and shot a whole roll of film. What I got was my only shot of an arch for the whole day. The resulting image is nice, but not what I'd come all the way to Arches for.

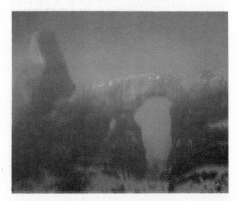

Arches National Park, Utah—Intense morning fog spoiled my expectations of clear blue skies, but I still like the soft misty feeling created by occasional penetrations of sunlight.

Arches National Park, Utah—
I made a still-life photograph
of borrowed snowshoes to
illustrate this winter activity
in the park.

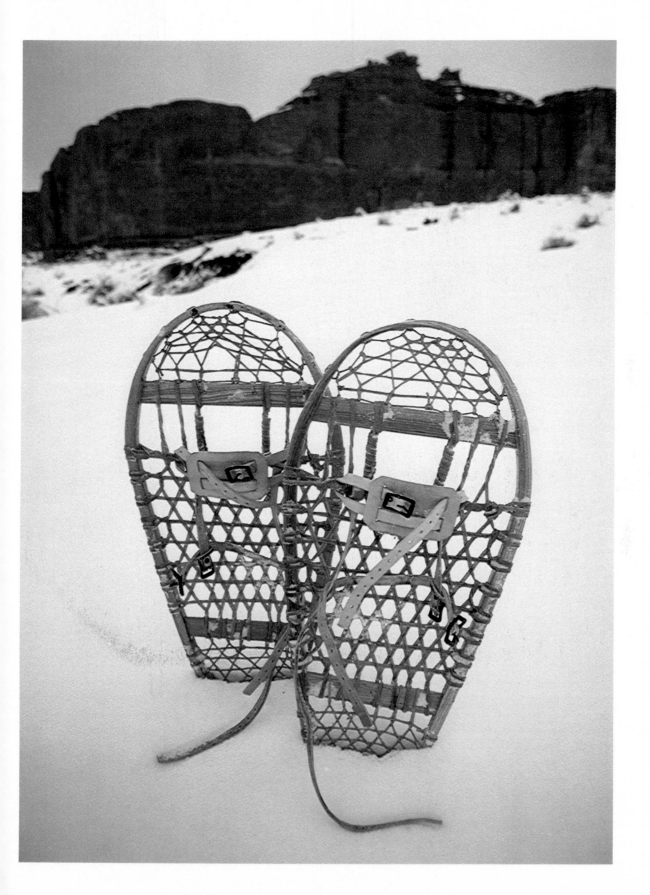

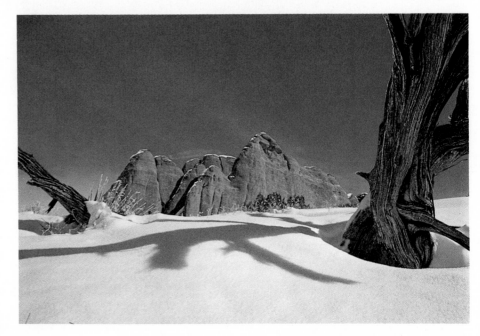

Arches National Park, Utah—Strong foreground interest often makes a scenic photograph work. Mentally remove the tree stumps and shadows to see what I mean.

It seemed as if I was going to have to give up all my previsualizations of what I wanted on film that day. Of course they were based on all the pretty pictures I'd seen in the Utah travel brochures, posters and in spectacular photo books about Utah. So I'd have to find my own photos under these circumstances.

After having declared my photographic independence, something very much my own came along. Down the road was a parked car, and heading toward it came a figure on snow shoes. We pulled over to meet this fellow who had camped overnight in a snow hole. He was a serene, skinny young man about 20 years old.

I became interested in his snowshoes when he took them off and stuck them upright in the snow. They had a marvelous shape and texture, and I had an instant idea for an illustration of winter activity in Arches.

After permission was granted, I turned the snowshoes into a still-life study by surrounding them with solid white, unbroken snow for maximum definition in the flat light. A 24mm lens allowed me to move in close and emphasize their shape in the foreground. I knew the snowshoes had to completely carry the picture because the background was not exciting.

I was satisfied after I made this photo because I felt I'd got something unusual, a little different and certainly not premeditated in the midst of miserable conditions. The picture also told a story. With patience, perseverance and some imagination, a photographer can usually get something even in the worst of circumstances.

We continued driving. Much to our astonishment as we drove higher, we pushed right out of the fog. Suddenly we could see the sun and blue sky. I exposed four rolls of film in 45 minutes, frantically shooting anything and everything in sight!

Don't you do that! Frantic photography, whether you fear you'll never see the sun again or not, is no guarantee of successful pictures. Most of the ones I took, while in a state of photographic gluttony, were boring. Only one is pleasing to me now.

Shortly after, the fog swallowed us again as we descended a few hundred feet down off the sunny plateau. Trees turned ghostly. Shrubs were snowy mounds. Long, rust-colored spikes of grass poked through the white like unshaven whiskers. Evergreens were frosted, each needle encased in ice, like fine jewelry from nature. Coyote, fox and rabbit tracks zigged here and zagged there.

It was late by then and the light was very low, so we decided to go back to Moab. Along the way the double yellow line in the road demanded my attention. It provided some needed color in the flat light. Even though recording yellow

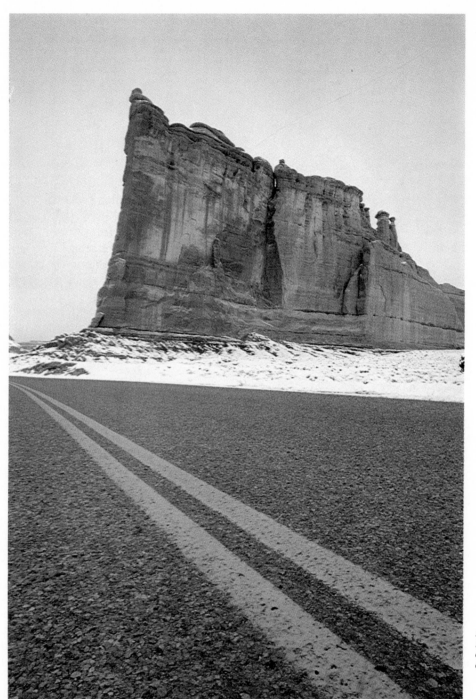

Arches National Park, Utah—
Although yellow lines are a
cliché, I used them as a
compositional element.

lines is one of the oldest photo-graphic clichés, I thought I'd give in to it under the circumstances. Lying on my stomach, I made a nice 24mm composition and steadied the camera with my elbows on the pavement.

I'd missed much that day due to weather. I'd gone to shoot arch formations and only got one, but I had the satisfaction of having stayed with it for ten hours. By trying to keep my mind receptive, my imagination fluid, my body ready for action and my nerves quiet, I still managed to leave with some acceptable photographs.

Despite the rigors, Arches National Park did cast a spell over me. I want to see and photograph it in every season under every condition. Don't miss it if you pass through Utah. Or make a point to pass through the state to see some of the natural phenomena that are among America's greatest places for photographers. But always expect the unexpected in the wilderness.

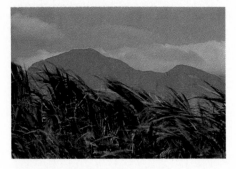

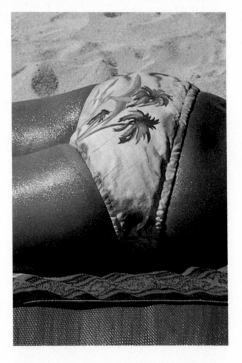

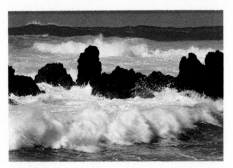

FOCUS ON MAUI

The Hawaiian Islands lure more tourists each year. One island, Maui, hosts over 1.5 million visitors annually and is considered one of the most interesting islands in Hawaii. Although most of the Hawaiian Islands offer ample photographic opportunities, I was only on Maui for a few days and photographed just it extensively. My motive there was to get variety in my pictures. I wasn't on assignment—it was simply a playtime exercise for me. So I became a typical American tourist, traveling around, doing my best to get good images without straining myself.

First Impressions—Maui is very green. Sugar cane, pineapples, forests and pastures create lush green scenery. However, solid-green terrain doesn't give a photographer much to work with compositionally. My eye requires an interaction of values and colors. When a location is predominantly dark-green foliage, the green almost becomes a noncolor. Nevertheless, I did want to get a scenic shot in Maui that included the ubiquitous green sugar cane.

This verdure gives way to sand on Maui's marvelous beaches where I got a shot of a Hawaiian print bikini worn by a deeply tanned, oily woman. The woman was asleep, so I quietly made my exposures and moved on. The reason I took this picture wasn't because it was an amusing graphic. I liked the bathing suit because it suggests the location. The colors and print *are* Hawaii.

Beyond the bikini was the Pacific. Typical of Maui, and the other Hawaiian Islands, is the sight of surf

crashing over lava rocks left by volcanic eruptions which formed the islands millions of years ago. I set up a tripod with the 80-200mm zoom to wait for the waves to crash dramatically. In this picture you can see three stages of wave development. It took awhile for it to happen, but patience pays.

The next shot also required some patience. This time it was a question of keeping my eyes peeled for someone who looked Hawaiian. I needed a portrait. One afternoon in a parking lot, a contemporary Maui princess trailing extra-long black hair approached a bright red Jeep. But she seemed in a big hurry, and I had just locked my gear in the trunk of my car.

The girl couldn't get the Jeep started, so circumstances were on my side. I rushed to my car to get a camera with the 28-45mm zoom. Immediately I began to visualize the portrait as I walked over to my subject. I knew the girl's hair was her most distinctive feature, and its length had to show in full. I realized that it would look sensational flung out the car window against the red door. My subject seemed not to mind the delay my picture taking caused, and when I was through, her Jeep started right away.

Haleakala—I learned of helicopter "flightseeing" at the Inter-Continental Hotel front desk. I was also able to arrange for the chopper's passenger door to be removed so I could get some aerial shots of the island and the spectacular Haleakala crater at dusk. I securely strapped myself into the seat, adjusted the earphones and organized cameras at my feet.

Haleakala is the world's largest dormant volcano and is a U.S. National Park. The crater's interior is dotted with strange cinder cones sculpted by nature.

On the way to the crater, I had a fabulous copter view of Maui along the north shore. Pineapples planted in symmetry—circles, rows and triangles—utilized every inch of ground. They became abstract aerial photographs. A school of blowing whales cruising off the coast reminded me of the island's former whaling days. Surf crashed and splashed, creating white, aquamarine and navy-blue water around the black lava rocks. The tropical lushness of Maui was glorious from this vantage point.

Then the pilot suggested I put on a sweater for our climb to 10,000 feet to view the crater. We rose quickly, penetrated a blanket of clouds, which usually enshroud the volcano, and the air chilled. The enormous crater loomed ahead—a moonscape on earth!

The waning sun created mysterious shadows, half filling the mouths of the volcanic cones. The scene was unreal and perfect for a science-fiction drama.

After recovering from the impact of my first view of the crater, I began to shoot. I've never been

Opposite Page, Left
Maui, Hawaii—I used a 1/30 second shutter speed to capture the windswept motion of sugar cane.

Opposite Page, Middle
Wailea, Maui—The composition and bikini print convey the island's atmosphere.

Opposite Page, Right
Naualele Point, Maui—After I decide what I want in a photo, I usually must wait for it to happen. Be selective!

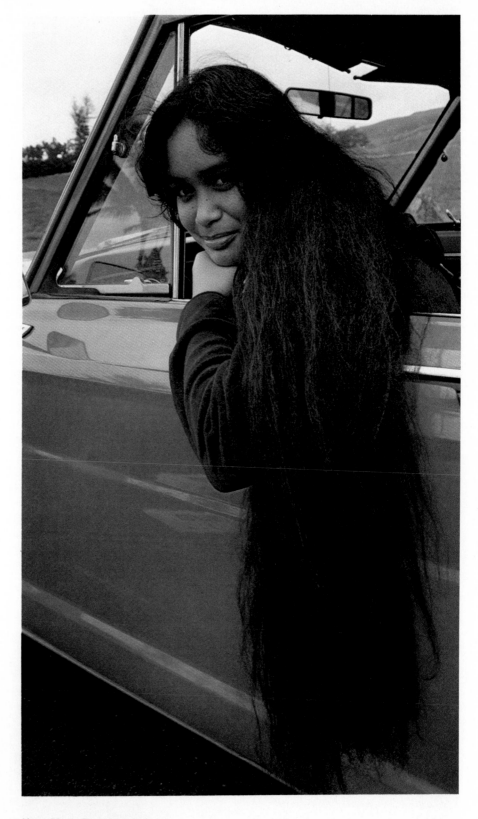

Hana, Maui—Even though the car wouldn't start, this beautiful Hawaiian was happy to pose.

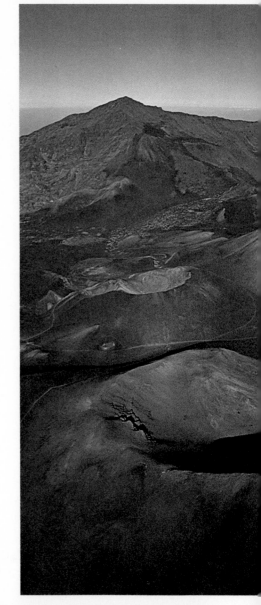

Haleakala Crater, Maui—Morning or evening light is best for aerial photography of this volcanic crater. Shadows at dawn or dusk give definition, contrast and add mystery to any landscape.

more pleased to have zoom lenses than I was that evening. With the 28-45mm and the 80-200mm zooms, I was able to frame and crop with a simple movement of my finger tips. Overall shots were made with a wide-angle lens and detail shots of the crater floor and cones with the telephoto lens. In the photo, notice the tiny trail leading to the cone's rim. The next morning, I was on that trail.

Hiking through the Haleakala crater is rough on the body, but also a mind-expanding wilderness experience. *Haleakala* means House of the Sun, but I didn't know it then, and I paid dearly for not doing all of my usual homework.

I entered Haleakala down the Sliding Sands Trail at 8:00 a.m. Seven hours later I dragged myself out via the Halemauu Trail up an enormous, near-vertical set of switchbacks. In between I logged 12 miles and exposed five rolls of film.

Seven hours of hiking at an altitude over 10,000 feet was tough! Hiking in the 90°F sun in a shadeless bowl without a hat was not smart. I sustained serious burns on my nose and cheeks that day. My new hiking boots were too small and killed a few toenails. The next time I attempt anything as challenging, I'll be in better shape.

Photos were a problem too! The sun was high in the sky, illuminating an open, barren and primarily brown bowl. It created no interesting, long shadows to give depth and texture to photographic compositions. The evening aerial photography turned out much better because of late-day lighting.

I advise photographers contemplating a Haleakala expedition to backpack in for an overnight stay in one of the U.S. Park Service

Haleakala Crater, Maui—The volcano is a thrilling sight from the air. I hiked through Haleakala—actually around the edge of this cone.

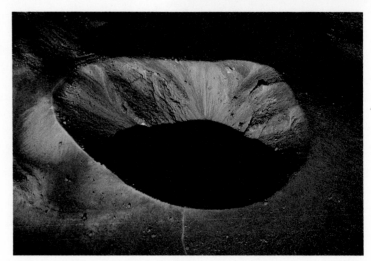

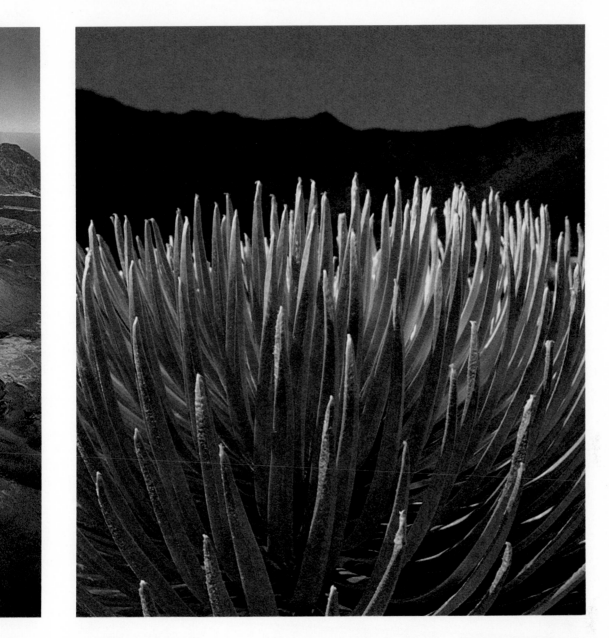

Haleakala Crater, Maui—By moving in close on a silver-sword plant, I made this unearthly image.

cabins. You can write ahead and reserve sleeping-bag space. This will enable you to photograph the effects of morning and evening sunlight on the crater floor. Take your time so you won't be confronted with the same problems I had.

There is plenty to photograph besides craterscapes. Flora watchers will enjoy the strange plantlife. It's also fun to record other hikers in the crater by including their shadows across the ashen floor. Bird watchers may see a Hawaiian goose, the nene, one of the rarest birds in the world. Once a water fowl, the nene is gradually losing its webbed feet and evolving land legs. The crater is one of the most unusual places I've ever been.

If you plan to penetrate the crater on foot, let me conclude my Haleakala account by urging you to get all the information you can beforehand from the park rangers at the rim. But if you are not this energetic, then get out of bed early one morning to see and photograph sunrise at Haleakala. It's one of the show stoppers on Maui and a "must see" for visitors. Any hotel can give you the details.

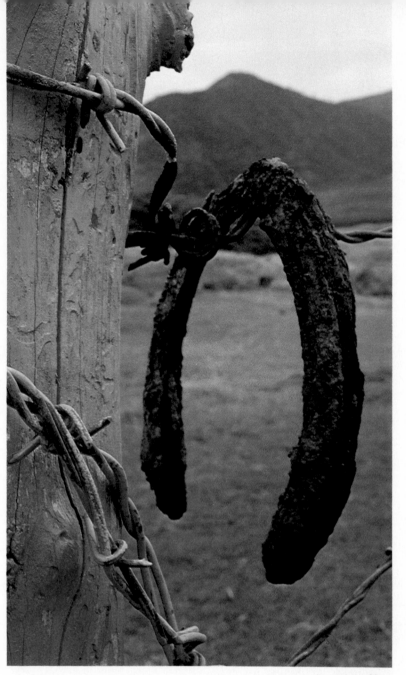

Hana, Maui

Lahaina, Maui—Obvious, but easily overlooked subjects often make good photos if you control all the elements.

Whaler's Village, Maui—A whale skeleton hanging over a shallow reflecting pool became an unexpected subject. Abstract photos are always fun to make.

Lahaina—Don't fail to visit Lahaina, another Maui "must see." This 19th century whaling port at one time was the home of 600 whalers, but today it is one of the island's busiest tourist attractions. See it for its historical and architectural value.

I assumed Lahaina would be a good place to get pictures of people in Hawaiian shirts, and I was right. Brightly colored Hawaiian shirts were being worn by scores of shoppers all over town. At the wharf I spotted two men waiting for their wives who were shopping. I asked them to sit where I could include water and the bow of an old whaling ship in a photograph. They were happy to do so, and although the result is staged, I got what I was after—a blast of colorful shirts in a setting that speaks for itself.

At the Hotel—While staying at the Hana Maui Hotel on the east coast, I enjoyed watching some colorful carp swimming in a natural rock pool. Floating in an adjacent bird bath were colorful hibiscus blossoms. By putting the two together, I knew I could make an image with an Oriental flavor. It was an overcast day, so the colors of the flowers and fish would be vibrant in the shadowless pool. Nor was direct sunlight producing confusing reflections in the water.

But this shot turned out to be a problem to make. When I put the hibiscus in the water for the first time, the carp immediately mistook it for lunch and attacked. After the blossoms proved to be distasteful, the fish ignored them completely and were seldom in the field of view! I remained poised with the 80-200mm zoom hoping the fish would occasionally swim in the vicinity of the hibiscus. For an hour my husband kept the flower where I wanted it with a long stick. The flower needed replacement constantly because it kept getting water-logged and would sink.

What you see here is the most successful shot of 72 exposures. I

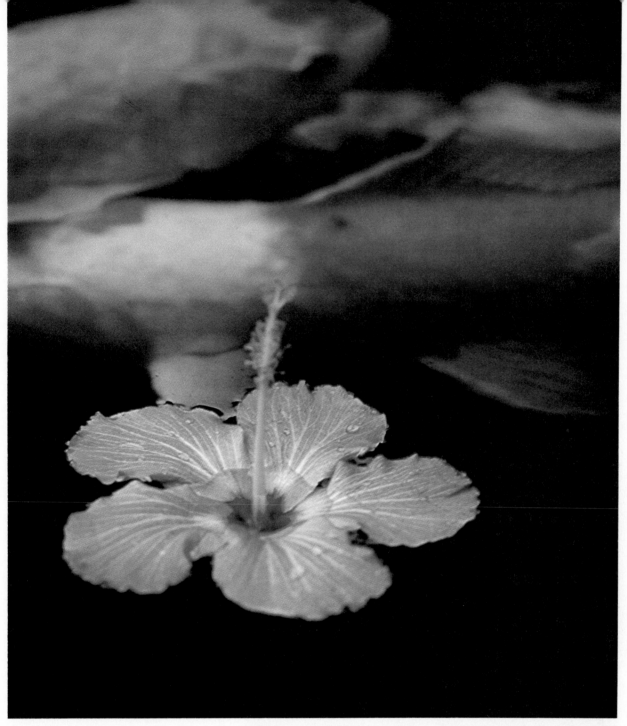

Hana, Maui—In this photo I wanted to convey the Oriental influence in the islands.

think it conveys an Oriental atmosphere. And it also shows what can be done with a little imagination and a lot of patience.

The hotel, incidentally, is a charming old-world resort owned by the Hana Ranch, a big cattle property. Above the village of Hana rises hilly pasture land where horses and cows graze. It's a real reminder that parts of Hawaii continue to be cowboy country.

With this in mind, I couldn't resist shooting a rusty, antique horseshoe with my 55mm macro. It was hanging over some barbed wire wound around a lavender fencepost. Only in Hawaii would you see such a fencepost.

Wailea—In southern Maui is an extremely attractive resort complex called Wailea. In addition to the beaches, hotel, restaurants and sporting activities is the Wailea Arts Center. The center offers courses in photography that can last from a couple days to several weeks.

Under the guidance of Richard Nelson, the director, you can have an intensive photo vacation with Wailea as your home base. You can make forays to other islands and return to the center to process and print b&w images. Color film is sent to Honolulu for processing, but that only takes a few days.

For more information, write the Wailea Arts Center, P.O. Box 160 Kihei, Maui, HI 96753.

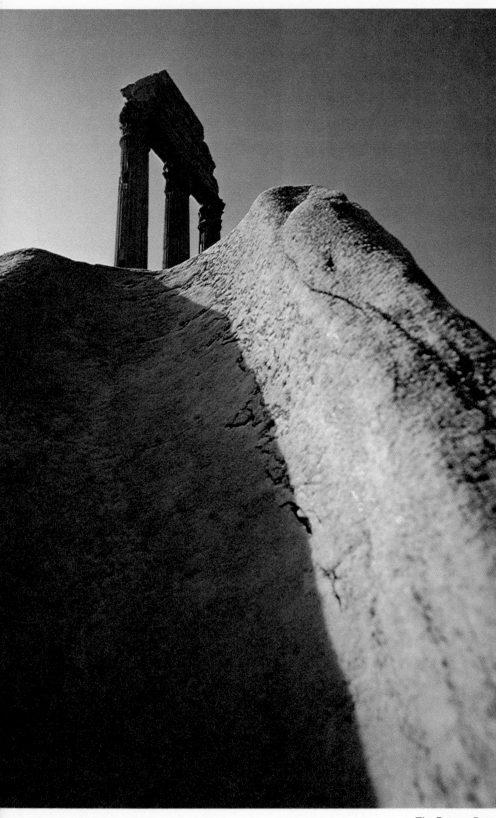

The Forum, Rome

OFFBEAT ANGLES ON EUROPEAN LANDMARKS

Every country in the world has historic landmarks, and they are often swarming with tourists. When photographing a historical site, I prefer to find angles that eliminate people who will date a photograph by their dress or will distract from the atmosphere of the place.

However, people are not always the problem. Sometimes I want to isolate a neat, clean section of a landmark from its very confusing surroundings. On bad days I want to minimize the gray sky.

To illustrate how I've handled these situations, I have pictures from the Roman Forum, Versailles, the Acropolis and the Houses of Parliament in London. Even though these are European landmarks, my approach is applicable to any historical site on the globe.

The Roman Forum—When looking for camera angles that flatter a location, I come up with some offbeat points of view. I think searching for angles is fun, and I had a good time probing the Forum one day in Rome. This ancient civic center is hard to photograph. What remains is fragmented with a column here and an archway there. Little is still glued together. It is hard to record the feeling of the place in the debris of this spectacular ruin.

I managed to convey some of the Forum's grandeur by using an 18mm lens and aiming up the fluting of a collapsed column toward a couple of standing columns in the distance. The ultrawide angle enabled me to move super-close and eliminate unwanted elements and tourist litter around me. It's what you might call a "white wash" angle, not the entire truth, but dramatic nonetheless.

Versailles, France—At the Palace of Versailles, I used a 24mm lens on the building and the oxidized head of a statue. The aged, mottled colors of the sculpture appealed to me as a foreground for the shot. I decided to superimpose the statue over the building to add interest to a dramatic landmark.

Versailles, France

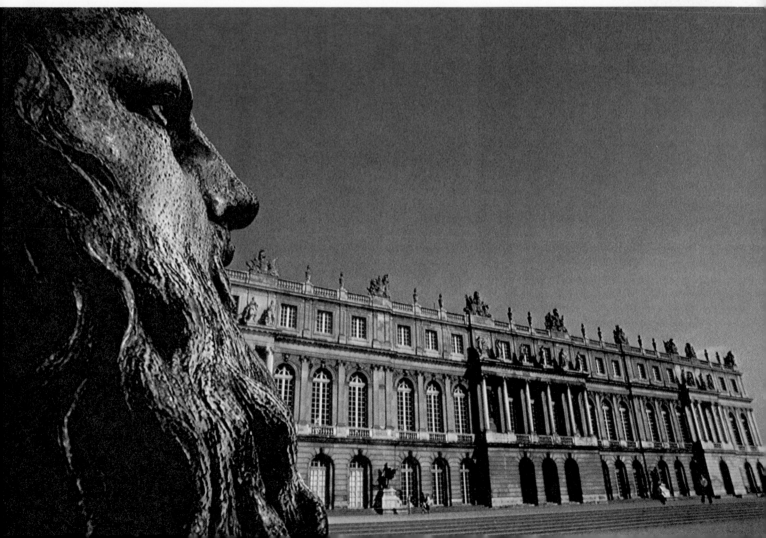

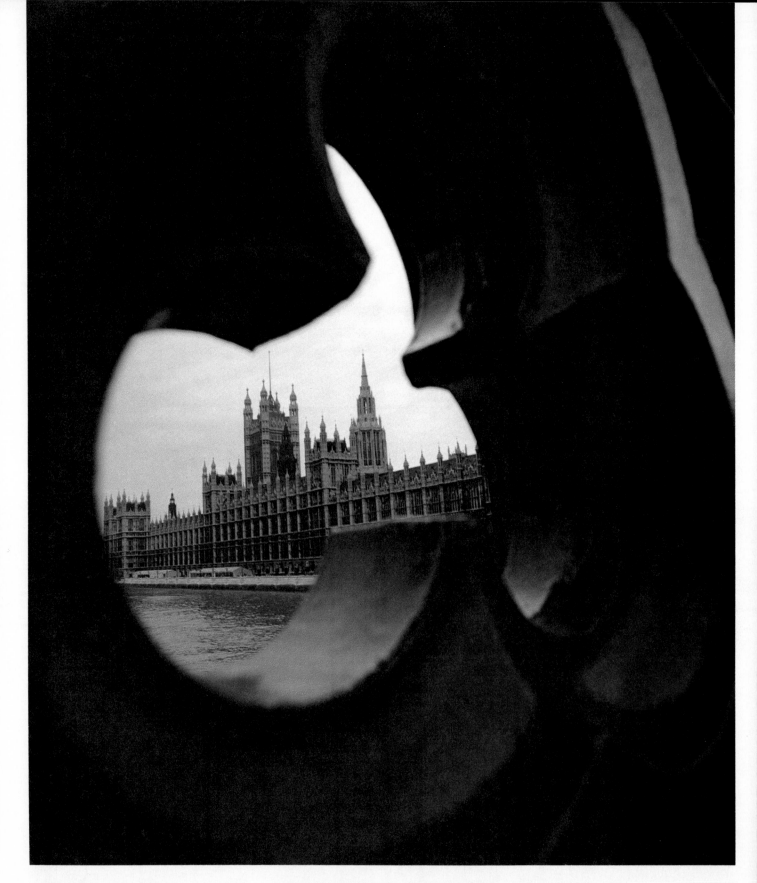

Houses of Parliament, London

London, England—At the Houses of Parliament, foul weather was the problem. With the 28mm focal length of my 28-45mm zoom, I shot the buildings through the filigreed railing of nearby Westminster Bridge. This approach minimized a dreary sky, and the black masonry is consonant with the stone buildings and the gray sky it frames. Without much color, the photo's strength is composition.

Athens, Greece—At the Acropolis I really did encounter a people problem; never had I seen so many. I didn't expect to have this ancient Greek site entirely to myself, nor do I dislike people. I just didn't need to bring home the world's tourists on film.

I used the superimposition technique again, but this time I had to eliminate crowds. I moved in tight with a 24mm lens on a section of low-lying Corinthian column. A classical feeling is conveyed by concentrating on the column's carved detail warmed by the morning sun. Beyond is a portion of the Parthenon, the architectural centerpiece of the Acropolis. So by moving in and aiming up above human head level, I cropped out crowds and photographed this landmark in an offbeat fashion.

Points to Remember—The key to coming up with unusual angles on familiar things, such as historic landmarks, is to walk around them investigating them from every direction. Look for interesting superimpositions and relationships of forms. Keep in mind that you don't have to include the entire thing. Show only what best conveys the atmosphere of the place.

Whether the subject matter is a landmark, portrait or cloud for-

mation, you must want to find new views and offbeat angles before you can see them.

When I embark on picture taking, I prepare myself mentally. I tell myself to strive to see the environment as uniquely as I possibly can. And I try to make at least one photograph that is a breakthrough. Some days I don't achieve my goal, but there would be no hope at all if I didn't rev my mental motor and insist on inspiration.

When I do get a breakthrough shot, it's a thrilling reward for the desire and effort I made to see uniquely. It also keeps me going. If you can do it once, you can do it again by applying patience and perseverance. You don't have to be a professional to develop this attitude. All you need is a love of photographs—your own and others.

The most important pointer of all is: Don't always shoot standing up. This is everyone's most common angle on the world, and it often results in merely common photographs. None of the shots I've shown of the landmarks were taken standing straight up. They all involved some extra effort. So you too must be willing and able to bend, climb or lie down to get the best possible image.

Athens, Greece

Accra, Ghana—In markets I often combine different wares to make an effective photograph. I bought the peppers and print for this shot.

Bottom Photo
Saba, Netherland Antilles—The pure splash of color and shapes is what I wanted to record. Only by using an extreme close up could I eliminate extraneous parts of the fish.

Chichicastenango, Guatemala—The flowers and fabrics of Guatemala explode with color.

MACRO AT THE MARKET

Open-air markets are in most foreign countries. You'll enjoy photographing and buying local produce—everything from animals and yard goods to spices and wood carvings. Most markets are sites of great congestion, and the jostling and bumping in narrow alleys may irritate you. But if you're gregarious, a market place is a wonderful happening with humanity.

For years I've enjoyed using my 55mm macro lens for shots in market places. So far, I've used it in Guatemala, Yugoslavia, Hong Kong, Ghana, Mexico and many Caribbean islands.

I look for design in these miniature views, and I don't hesitate to do a little arranging myself to get exactly the composition I want. Of course you should ask permission from vendors to push their produce around. I always do, and I have yet to be refused. The vendors in market places whose wares I've photographed have always been fascinated by the lady photographer on her knees toying with their peppers, eggs, flowers or fish.

In the famous Guatemalan market of Chichicastenango, I made the marigold macro shot. An old woman sat on the ground surrounded by blossoms on colorful cloth. When I spotted the marigolds, I knelt down, looked into the old woman's face, showed her my camera and pointed to the flowers. I got absolutely no reaction. So I

slowly proceeded to take the picture anyway. But I soon realized I wanted to isolate two of the blossoms on the cloth. I smiled at the woman again and arranged them. After finishing, I thanked the woman warmly. She gave me back a weak smile and I moved on. I had my marigolds on film.

On the Caribbean islands of Saba, I made the fish tail photo. Rainbow fish were sparkling in the early-evening sunlight on a pier. I asked a fisherman if I might take

two of the fish to a spot where I could photograph them and not be in anyone's way.

I arranged the striped tail of one fish on the red belly of the other and made both horizontal and vertical compositions.

In Belgrade, Yugoslavia I made my favorite macro market shot Two farm-fresh brown eggs nestled on white beans looked very sophisticated with a brown and white background supplied by a polka-dotted kerchief. The little lady in

charge was happy her still life commanded my photographic attention. She didn't mind me moving the corner of the kerchief to suit my sense of composition either.

You too can get a lot of satisfaction out of macro still-life photography. But getting close-ups can be exhausting, time consuming and frustrating. I don't think I've ever taken a macro shot standing up straight. It's always been necessary to be on my knees, stooped over or even flat on my belly. Maintaining awkward positions while you arrange and shoot can strain your body. There have been times when I've had to straighten up slowly after a close-up shot because my legs were temporarily locked into a bent position. You may have to remain contorted for some time if you are dealing with critical lighting conditions. The sun may be popping in and out of clouds.

Or if you're making a close-up of a flower on a windy day and you're trying to achieve a precise composition, you may have to remain posed for a long time, waiting for that split second of stillness when the wind stops blowing.

And you can't always use a faster shutter speed to stop the movement of the wavering flower. In macro photography, depth of field becomes very narrow. To compensate, I always try to stop down my lens to f-16, f-22 or f-32 if possible. This frequently requires hand holding a 1/30 second, or longer, exposure. Sometimes, using a faster film will solve all these problems.

Neither will a tripod eliminate all the hassles of slow exposures and bent-body photography. Most of the items I have photographed in markets have been displayed on the ground. Few standard tripods adjust that low. Even a mini-tripod won't do because I'm usually working only inches away from the subject, and most of the tripods are at least a foot high.

Macro photography is an acquired taste and talent. It takes a ready eye and a precise sense of composition to make effective detail shots. When they work, they are effective travel miniatures. They capture and concentrate the essence of another culture in a way no landscape can. One strong detail shot will sometimes enable you to re-experience the atmosphere better than an overall view of the whole place. For instance, I can smell the marigolds when I look at that shot and the *entire* Chichicastenango market comes back to me—all of its sights and sounds.

Belgrade, Yugoslavia—The subtle blend of shapes and colors induced me to combine these elements.

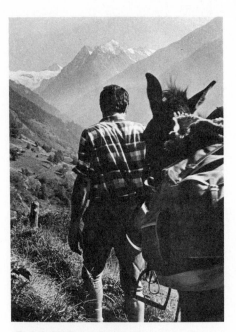

CAMERA ON A SWISS MULE SAFARI

A Swiss mule safari is an old but rediscovered way of getting from here to there in the Alps. In the Valais region not far from the Italian border, mules were used for centuries to transport goods from town to town along trails worn into once remote landscape. In recent years the Barraud family of *Welcome Swiss Tours* decided to get the hooves back on the tracks for the pleasure of vacationers interested in the area's natural history. The safaris are essentially hiking trips, but with one mule for every two people, you can ride part of the time to gain relief from walking.

Background—The mule population had nearly died out in the Valais when Yves Barraud sought some for his venture. Only one man bred the animals for the Army mountain troops which use them for training maneuvers. Barraud convinced the commanding general to reduce the Army's mule train by 20 and let him and his three sons operate this unique outdoor enterprise.

Today in Sion, Switzerland from May to October, visitors gather at the railroad station to meet each other and whichever of the Barraud boys is hosting the trek for that week. If you go, you'll also meet Charles. He's the mule master, a farmer's son and a real Valais man—tall, lean, handsome and quiet. He instructs all guests in the art of controlling and outsmarting the stupidest, strongest and most stubborn beast on legs.

Safari Equipment—Charles, the mule master, provided me with saddle bags for the two cameras I planned to operate—one for color and one for b&w film. I installed the 55mm macro lens on one and the wide-angle zoom on the other. In a backpack went film, the 80-200mm zoom, the 24mm lens, a hand-held meter, a cable release, a mini-tripod, rain slicker and all the personal things one needs for a week in the Swiss Alps.

I knew the saddle bags would be convenient when it was time for photography. I could put a camera in each, and they could quickly be removed from the bags more easily than from a backpack. When I needed a change of lens or film, Landt could dip into the backpack for me.

I planned to hike most of the time with a camera over each shoulder. I'd do better walking and ready to shoot than stuck astride a mule. Because I needed maximum freedom to photograph, Landt took charge of the mule for most of the journey.

The Trek—When the group I joined was assembled, we went by bus to Grimentz, a picturesque village about an hour up in the Alps. After a cozy night in a rustic inn, Landt and I met our mule and set out on safari.

For me, what lay ahead in the next week was greater self-knowledge of my photographic predilections and capabilities. The mule safari and other similar treks are sweet and sour as to how they yield images to the camera. Of course it depends on what kind of

pictures you want, but sometimes preconceptions and expectations aren't fulfilled. You can profit from my pleasant surprises and my disappointments on the adventure. Perhaps you'll photograph something similar one day.

Frustration—I expected to get some picturesque, overall shots of the mule train winding its way through the Alps. Such a shot usually begins editorial spreads in publications or slide shows. I didn't expect such a cliché photo would be difficult to get, but rarely did the animals actually form a train as I had expected. People and beasts sauntered along at their own disparate paces. When the mules were bumper to bumper, the scenery wasn't good. I conscientiously hiked up front almost all week to be ready to capture any photogenic coincidence of mule train and mountains. On any expedition the photographer must be in position to anticipate what is going to happen, and this usually means leading the event.

Another problem on the mule safari was a general lack of color and contrast. There was practically no snow on the mountains to give a Swiss look with white accent to my pictures. This wouldn't have been the case in the spring when the Alps are still covered with snow, but they were bare beige in the late season. The mules were dark brown, and most of the people wore drab hiking attire. The evergreen trees darkened things even more.

So you see the predicament. To my mind these factors amounted to a conspiracy against effective use of color on the mule train. Most of my color shots were dull.

Not being able to effectively integrate the mule train and the

mountains bothered me. After a couple days, I began to question my abilities as an outdoor-adventure photographer. I knew I had to take hold of myself because I was on assignment and had to deliver. With or without the mules, I had to get some good shots of these snowless, off-season Alps.

One day we stopped for lunch in a remote, ancient village. After a splendid meal of rabbit stew, Landt and I poked around the tiny streets and came upon some poppies bobbing gently in the breeze. As I squatted down to enjoy them, I noticed a view of the mountains beyond. This was the Swiss look I sought! I simplified the composition by removing a dead flower and extraneous stems. But now I know I could have pruned a bit more. Shooting the flowers became a tedious, hand-held ordeal at 1/30 second at f-22, to give maximum depth of field.

The small tripod I'd been carrying around would have come in handy here, but I'd left it at the restaurant this one time I needed it. I took many more exposures than I ordinarily would to ensure getting a sharp photograph. I had to shoot the poppies when they paused in the breeze.

People—Another expectation had been shattered in the Sion railroad station. I expected to take many candid shots of fellow travelers, but as we gathered at the station I couldn't find anyone who was especially photogenic. I don't mean that everyone was homely or that I require beautiful people for every exposure. But no one's features grabbed me as being photographically consonant with the mule-safari atmosphere.

During the trip no one did anything thrilling except fall off mules a couple of times. I wasn't anxious to record that. However, I did happen to photograph Cal, an American from the U.S. embassy in Brussels, nuzzled between two mules.

Opposite Page, Top
The Alps, Switzerland—I had to make illustrative photos like this to please an editor. And I really had to hustle to make this assignment a success.

Opposite Page, Bottom
The Alps, Switzerland—I captured a spontaneous moment of Cal nuzzling the mules.

The Alps, Switzerland—This is the closest I came to making a "typical" Alps photo of snowcapped mountains.

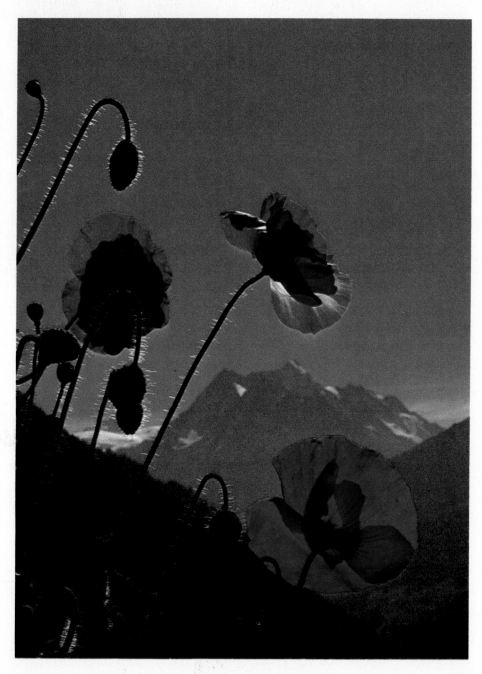

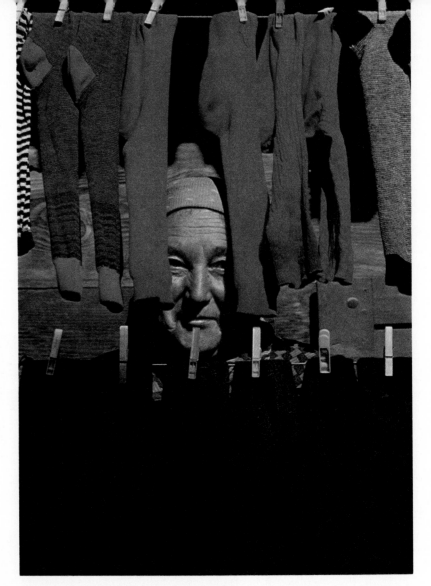

Haute Nenday, Switzerland—Luckily, we were often off the trail so I could penetrate towns and villages along the way to photograph people.

Eventually I found plenty of indigenous subject matter along the way, such as farmer ladies digging up potatoes and farmer gentlemen gathering hay. My favorite shot is the sock woman.

Before saddling up the mules one day, Landt and I were roving around a village looking for subjects. We saw a woman who seemed to be the official sock washer for the whole hamlet. Dozens of pairs were strung up on a line on her balcony. Landt spoke to her in French while I readied the 80-200mm zoom. He then asked her to part a pair and peek through, and she did this with hilarity.

Something like the mule safari can be a pleasant and unusual way to get into the country, enjoy its sights and meet people. Photog-

The Alps, Switzerland—As you look for light in a scene, also look for shadows. Often the shadow itself makes an interesting image!

raphy becomes part of the venture and shouldn't be limited to the activity itself. Instead, the trip should be used as a means for you to focus on flora, fauna, locals and views all around you. You may even come up with some unorthodox shots of the adventure itself.

Some Unusual Photos—I decided to try to get some unorthodox images because I seemed to be doing so badly with the usual ones. Here's an example.

For a few days I'd been noticing mule shadows gliding across stone walls and over trails. Knowing it would be fun to capture a shadow on film, I watched for one to pass over a plain surface that would give it a clear rendering. I anticipated this happening on a grassy bank. I preset exposure and focus, and shot three or four mules as they came toward me. This photo gives you an idea of the kind of unusual images you can find when you open your mind to them.

Top, Right
Sion, Switzerland—I never know where I'll find interesting designs to photograph. Sometimes even on the rump of a mule.

Bottom, Right
Grimentz, Switzerland— Only in the Alps will you see a planter like this.

The Alps, Switzerland—Use your imagination and a variety of camera angles to tell the whole story visually.

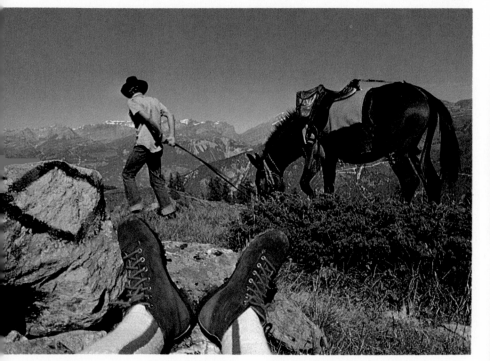

I had to open my thinking again to make the photograph of the hiking-boot planter sprouting geraniums. I don't usually go for schmaltz, but it was too quaint to snub. Even though it's in the same category as bronzed baby shoes, the picture's charm is growing on me. I *was* hiking in the Alps, and this flowering boot couldn't be a more real Alpine illustration.

I also enjoyed photographing the yellow and black trail signs along the way. I wanted to incorporate one in a shot. During a mid-morning pause, I rested my feet on a rock which featured one of the diamond signs. Beyond was Nick Barraud and mule; the latter eating as usual. I used the 24mm lens and aimed through my boots to make a fun illustration that tells the complete story of the safari. I used color on this one because color is a key element of the scene.

However, I didn't think color was important to my favorite images made on this trip. B&W worked fine in this case. These mules have a curious black line that runs over the ridge of their back, and it shows especially well on a sandy-colored animal with a leather element under the tail preventing the saddle from slipping forward on the mule's back during steep descents. I liked the pattern created by the tear-drop shape on the textured, lined behind.

In order to take this picture without being kicked, I clicked a frame or two around the mule's ears. I wanted him familiar with the sound he would soon hear around his hindquarters. Next, I patted him on the rump, so he knew I was back there. Then I began shooting cautiously. Some of the mules were kickers, but this one kept his feet on the ground while I got this shot.

Now that you've seen a few of the things I shot on the Swiss mule safari, it should be obvious why I had to take along both color and b&w film and use them almost equally.

51

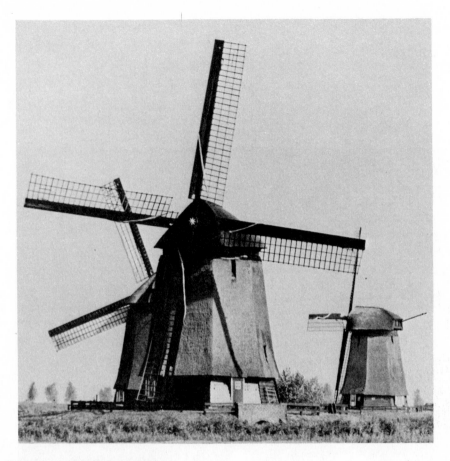

WINDMILLS—DUTCH NATIONAL LANDMARKS

Even though vacations are generally shot in color, I'll bet some of you enjoy b&w photography as much, or more, than color. Perhaps you have a darkroom, or plan to set one up in your basement, kitchen or bathroom. Even if you're a loyal color film photographer, I still urge you to try your eye at some b&w photography once in a while.

Here's why: The ability to conceive effective photographs in black and white is precursory to seeing effectively in color. The sensory impressions of colors often deceive you into thinking you've made a dynamite image, but the shot could merely be another color-for-color's-sake photo having neither substance nor good composition.

To avoid this you must train your conceptual muscles to recognize strong photographs—those which make some kind of statement without the WOW! of color. It is some-times difficult to shoot in b&w because it demands a different thought process. You must look for form, composition, light, and shadows and try to ignore color.

The exercise of shooting b&w is rather like sketching for a painting. The artist first sketches an idea in pencil. If it conveys his idea compositionally, he thinks about applying color. I think the photographer must also first prove himself visually literate, capable of conveying ideas in black and white before he attempts to express himself with color film.

I must sum these ideas by saying color photographs tend to be sensational; whereas, b&w is primarily cerebral if it's photographically successful.

A Photo Story in B&W—With these thoughts in mind, join me in Holland where I had great fun photographing windmills for a book my husband and I did called *CATCH THE WIND: A History of Windmills and Windpower.*

Dutch windmills are national landmarks. About 900 of them are left out of 9,000 that peppered the countryside in the 18th Century. As landmarks, many of the remaining windmills are restored and preserved by the Dutch Windmill Society.

Many of these landmarks are operating today as mills which grind grain for local bakeries and as houses for families. As homes, the windmills help ease the tight housing problem in Holland. Those who receive a permit to live in a mill must also be trained to operate the thing because the sails must turn at least once a month to keep the mill's machinery limber. As payment for such devotion, the Dutch government gives families financial aid for the restoration of their heritage.

Windmills are conspicuous on the horizon all over Holland. They are a delight to photograph and provide frequent focal points on an otherwise flat landscape. Rembrandt and Vermeer painted them in color, but our publisher wanted them in b&w. Windmills are either brick, weathered thatch or white-washed, and all the interiors are various shades of brown wood. Their only colorful aspect, when it's not raining, is the backdrop of blue sky. B&W film was ideal for such monochromatic subjects.

The Task—What I want to do is share with you how I developed a picture story on the windmills. I'll tell you what the challenges were, and how I resolved them. For instance, I now know that I failed to get a key photograph, and I'll discuss this goof too. I shot hundreds of pictures, but I've chosen a dozen which neatly cover the subject and capture the atmosphere I felt while tilting at windmills with my camera.

The first surprise I had after a couple days of shooting was learning that windmills weren't the easy photo subjects I assumed they were. The windmill is a static object with very little variation from one to another. They simply stand on the land in a perky fashion and don't strike any poses whatsoever! It was up to me to see, conceive or invent as many diverse images as I could without creating too many clichés.

I had to get a typical, overall shot to introduce the subject. I made something plain and simple with the 80-200mm zoom by shooting three windmills at the Schermerpolder near Amsterdam.

I later conceived a medium shot, an 18mm wide-angle lens view, looking up the thatched side of a mill with its wing in silhouette coming down behind me. This is my favorite windmill picture, and it released me from the belief that I couldn't photograph them in unusual, dramatic fashion.

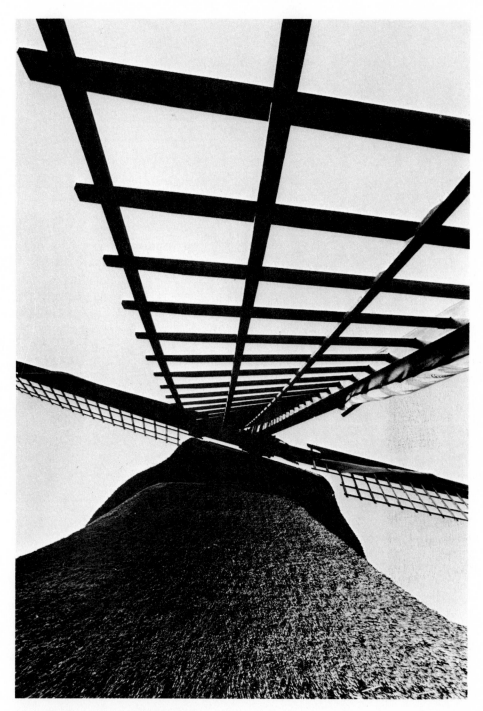

Opposite Page
Schermerhorn, Holland—Every picture story needs an introductory image that simply shows the subject. This overall view is necessary for the viewer to place other images in context.

Kinderdijk, Holland—I had to find dramatic viewpoints to avoid repetitious photos. Use various angles, lenses and your imagination when dealing with one photographic topic.

Top Left
Zaandijk, Holland—This interior view captures a typical windmill's atmosphere. I dragged a sack of flour into the scene to help the composition.

Bottom Left
Oudorp, Holland—I usually keep a small flash in my camera bag so I won't miss interior shots important to a picture story.

Holland—Details provide instant information. This photo of thatch shows what many windmills are covered with.

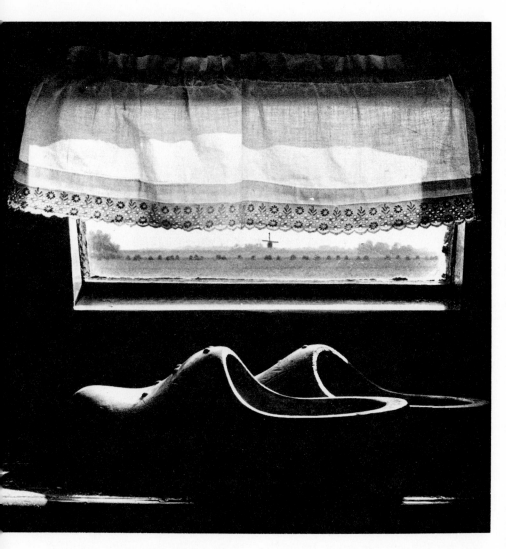

Schermerhorn, Holland—Frequently, museums and historical restorations provide subject matter for a picture story.

a picture story requires various focal-length views in order to communicate visually.

I then moved inside a windmill belonging to professional miller, Jacob Kaal. His mill stands in Zaandijk and is called *De Zoeker,* or The Seeker. This mill is open to the public so you too can pay Jacob a visit.

In *De Zoeker* I spotted a charming sketch of a windmill made by Jacob's daughter. An old Roman numeralled clock lent an even more domesticated feeling to the window lit scene. But something was missing; another element was required. After musing for a moment, I noticed several burlap bags of milled grain leaning against a wall. There was the needed element, so I dragged a bag into the picture, and you can see the result.

Inside another mill I photographed miller Arie Berkhout's sister as she sent a bag of grain down a trap door to a baker's truck below. Arie is a charming bachelor who lives and mills with his three spinster sisters in Oudorp near Alkmaar.

In the low-light of the mill interior, I used one flash unit. I'd intended to set up three flash units for even, shadowless lighting, but things happened too quickly. I had to settle for one, and fortunately it did the trick well. The strong shadows, usually produced by a single flash unit, fell inconspicuously into the background in this shot. Anyone can get good results with flash, and I'll discuss this a bit more in Chapter 7.

Continuing my quest for a variety of windmill photos, I made an atmospheric image of wooden shoes on a sill. Through the window is a distant mill which had to be retouched with spotting dye on the print. The mill was too small to print up clearly and needed a bit of help. During printing I also cropped the print square because I like the change from the usual 35mm rectangular format. If I were to hang a show of windmill photos, I would make sure there were different formats as well as a variety of print sizes.

Next, I used the 55mm macro lens to get a close-up shot of the mill's thatch. I made this photograph to show the texture of the stuff. Details of this sort are crucial to a comprehensive photo story. Not only do they allow you to get intimate with your subject matter, but they also provide needed variety of photographic treatment of the subject. If you were to hang a series of pictures for an exhibition or arrange a montage for the walls of your home, you'd quickly see the importance of interplay between overall, medium and close-up images. Just as a musical score includes everything from high to low notes,

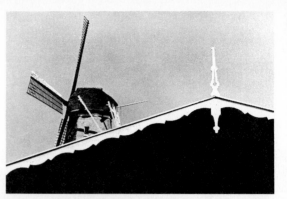

Workum, Holland

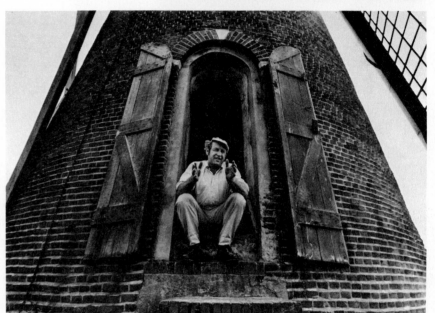

Bredevoort, Holland—This environmental portrait of Johan Jansen not only shows what he looks like, but also tells what he does and how he lives.

Another interpretation of a mill is a simple, sparse shot that emphasizes the "Dutchness" of the subject. Carved, wooden detail is common in Holland, and this black building was delicately trimmed in white wood. I like the contrast of the black and white, the pretty detail and the mill visible beyond. It all worked compositionally.

The simplicity of this picture appeals to me. When making a picture story, I think it's very important to keep shots as neat and clean as possible. Include only essential elements and compose them well. Always try to simplify confusing situations by taking the best angle for the scene. A series of esthetically undisciplined images will give you visual vertigo.

The Unexpected—On this windmill assignment, many unexpected good things happened which defied all preplanning and forethought. For example, while driving through the

town of Bredevoort, my husband and I noticed a classic brick mill behind a modern milling facility. We pulled in to poke around and make inquiries. Someone who spoke English told us an employee of the company, Johan Jansen, ran the old mill for fun on weekends. Immediately we expressed an interest in meeting Mr. Jansen, and the man went to find him.

Thus ensued a two hour happening. Although Johan spoke no English and we no Dutch, we communicated our interest and enthusiasm to the degree that Johan insisted on running the mill for us. He operated all the mechanisms and assumed working stances for me to get flash-lit shots of him. I made many photos of Johan working, but I still like the doorway portrait best. As I made my exposures, the wings were turning in the breeze, and I realized it would be important to include one in the scene. The shot

would not work as well without it. **People Add Action**—A good way to deal with a static subject photographically is to incorporate people as much as possible. They are seldom static. Luckily, one of the most interesting aspects of the windmill story is the remaining handful of full-time, professional millers. They are able to support themselves by grinding grain for local bakeries. Dutch bakers like the coarse flour for the natural, whole-grain breads.

One such producer of coarse flour is Tiddo Mudda, who operates a mill near Adorp. He welcomes visitors as well, but it's a nice idea to drop some change in a tin can Tiddo keeps by the door. The coins are only a small way to show your appreciation for his hospitality. But Tiddo isn't just a tourist attraction. He is a hard working miller. I got a shot of him hefting a bag of flour. I only wish he wasn't looking right into the camera. If his eyes were

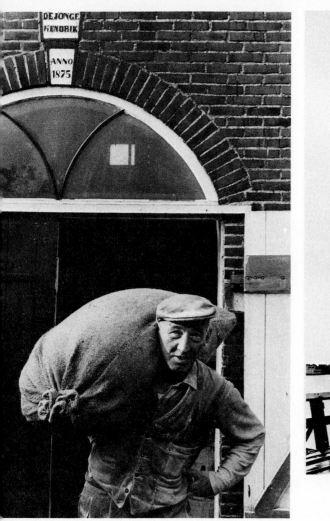

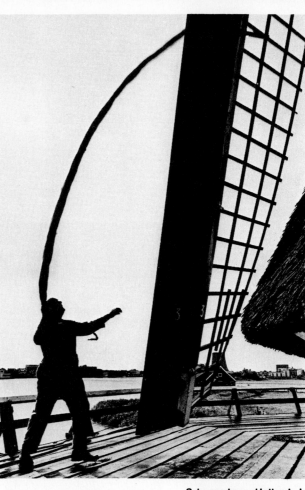

Schermerhorn, Holland—In a series of pictures, an action shot is essential to add energy to the overall theme. Here Jacob Kaal flips a windmill sail into place for the night.

Adorp, Holland—Millers all over Holland were very cooperative. They freely let me photograph them.

diverted to the side or even slightly down, it would have been a better photo.

I photographed another miller in semi-silhouette, flinging a furled sail back onto its hook where it rests between operations. I asked the miller to go through the flinging motion a half-dozen times before I made an effective exposure. A shutter speed of 1/250 second stopped the action of the sail.

I want to emphasize that it's a good idea to get a silhouette photo in any photo story. It provides a different texture and feeling that can be a welcome esthetic variation for your viewers. For my windmill coverage this silhouette is important. As I mentioned before, windmills are static subjects and I needed all the special effects I could get for variety.

Millers aren't the only people on the windmill scene. There are also families with children living in mills.

Thatchers can be seen rethatching old mills, and millwrights are scattered about the country. These latter folk design and construct windmills inside and out. Because there isn't much demand, if any, for new mills, the millwrights are kept busy by the government restoring existing national landmarks. It's their job to get the remaining windmills back into shape.

Here you see a portrait of a father-and-son millwright team whose shop is in Bredevoort. They posed for me by two millstones, the parts that actually grind the grain. There is much texture in this shot: wood, stone, brick and flesh. That's one of the reasons I like it.

Animals also relieved the static subjects. Driving through the countryside, I spotted a five-foot-high drainage mill in a cow pasture. The cows were eating their way east, and I realized that they'd tell the story if I could get a shot of them with the mill. With the 80-200mm zoom ready, I waited for them to

walk into view. Finally they placed themselves perfectly in my composition. Mentally remove the cows and see what we get—another routine picture of a windmill, that's what! Life, human or animal, is essential in some photographs.

The point is that man and animal really helped me spin the windmill tale more effectively. Without them, I would have one standard windmill shot after another—shots which would never have produced an eye-catching book. Don't assume all these elements were available to me on a silver platter. I had to hunt for them, and you will too if you take on this same subject or any other photo story some day.

Points to Remember—A disciplined approach to image making should never result in monotonous interpretation of a subject. A series of photographs on a single theme should include images with different moods, subject matter and photographic techniques. Don't shoot the same picture over and over again and expect to get an effective photo story. You won't. Instead you'll come away with exactly what you shot—the same picture over and over again.

In the beginning of this chapter, I admitted to goofing somewhere along the line in my windmill coverage. I failed to get a good close-up portrait of a miller. If you look at my picture story, you'll see what I mean. A tight head shot of an interesting face would greatly enhance it.

I was aware of the need for a good portrait from the outset, and I kept looking for a face worthy of close-up treatment. But I found no one I thought would do, so I

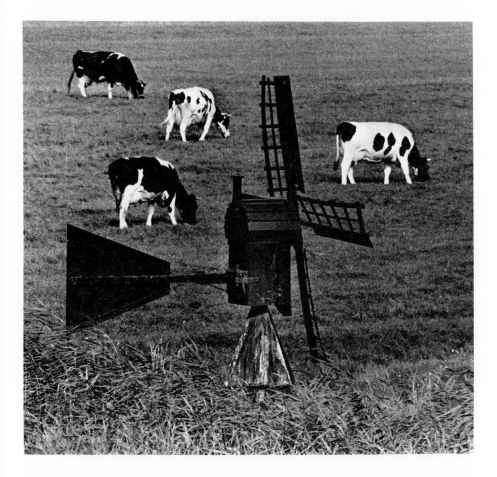

kept postponing the matter. All of a sudden, I was on a flight back home without a super portrait on film.

The moral of this goof is that postponement can be fatal in photography. Work with what is in front of you *now* even if it isn't optimum. If better subject matter comes along in the future, that's grand. In the meantime, shoot and do the best you can because you may be gone tomorrow.

You know by now I'm full of advice. I often have a hard time heeding some of it myself. Photography is so circumstantial that sometimes the best you can do is hold the photographic ideal uppermost in thought. When it comes to photo stories, you should have a pretty good idea of what the completed coverage should look like before you even begin to shoot. Previsualize the images necessary to tell the story; even make a list and check off shots as you make them. With this kind of reference it's easier to determine how you are doing with respect to overall, medium and close-up requirements.

The tips I've given you in this chapter also apply to making a color photo story. The principles of good photo-story production remain the same whatever film you're using.

Hoorn, Holland—This picture of a drainage mill would be less interesting without the cows.

CLOSED-ENVIRONMENT TRAVEL PHOTOGRAPHY

The cruise industry provides vacations world wide. It delivers many thousands of tourists in foreign ports each season because the cruise is a prime leisure-time activity. You may enjoy one of them some day, so now I'll show you how to deal with a closed environment photographically.

Special interest cruises, such as a musical cruise, offer you a wonderful chance to get your favorite musicians on film, whether they be classical, country western or jazz artists. There are even current-event cruises with key-note speakers, eclipse cruises and gourmet cruises too. Whatever your interest or need, there is probably a corresponding

cruise. I've even heard of one for weight watchers! Last but not least, there are photography cruises. Many lines offer them. Check with a travel agent for specifics.

Cruising—I don't like cruising because it's my idea of nothing to do. The only relief for me are days in ports. Days at sea offer too much food and too little activity. This is strictly personal opinion of course. I'm in the minority. Cruising is an addiction or a lifestyle for many people because many tourists love the pace of the open seas. The industry is beginning to attract younger customers these days, so the atmosphere is not necessarily embalmed.

If I cruise for professional purposes, I manage to preserve my san-ity and do my job by passenger watching. I photograph people doing funny things or funny people being themselves. Passenger pictures should be the key subject matter while you're aboard. I was on a cruise assignment once and needed to get shots of as many shipboard activities as possible. Early-morning jogging on deck was one of them. Here's a fellow running off the previous evening's midnight buffet. I perched an 18mm lens on the railing and waited for him to circle the deck several times. The trick was getting his stride properly placed in my composition. For me, it is never enough to simply take a photograph of someone running

with no regard to placement and esthetics. I prefer to determine these first and pray for the action to happen effectively within the frame. I'd never be a good sports photographer or gambler with these attitudes. These characteristics are necessary for the portrait photographer, and I think I'm a good portrait photographer.

This honeymoon couple was more than willing to let me take their picture the evening we sailed from Los Angeles on the S. S. Fairsea. At sailing time everyone tosses confetti and streamers. The newly-weds were so joyously festooned with the stuff that I couldn't resist a portrait. At times of high mirth and ceremony, resistance to being photographed is at low ebb. Don't hesitate to go right up to someone at such times and request a shot.

I always photograph the ship as do most passengers. Usually they take a photograph from the tender boat as it goes into port. Rather than make a standard photo of a lone liner, I juxtaposed a small, beached boat in front of my ship anchored in the distance. I used the 80-200mm zoom on a tripod to do the job.

Because some time is spent in port, you should know the best way to handle them photographically. This book is intended to be a guide to all terra-firma travel

photography, so there are two bits of advice I can give you about operating from cruise ships. They insure you maximum time and best conditions for shooting.

One: Be among the first passengers to get ashore when the ship is in port. Be at the head of the line to disembark so you have maximum time on land. If you must shop, then be the first in and out of the stores so you can get on with your photography.

Two: Never take the land-excursion trips unless they are going some place like Mayan ruins that would be either impossible to reach on your own or cost a fortune to do so. The best way is to walk all day or share a car and driver with some like-minded photographers you've met aboard ship. It's not conducive to photography to have a bus always waiting and dozens of fellow cruise passengers taking similar pictures. Be as independent as possible while ashore.

Above
S.S. Fairsea—Bon Voyage!

**St. Barts, French West Indies—
Make typical photos less ordinary
by finding new angles!**

Opposite Page, Left
**S.S. Fairsea—When in a closed
environment, look for
people activity.**

Opposite Page, Right
**S.S. Rotterdam—While on a jazz
cruise, I photographed the late
Cannonball Adderly.**

Sometimes I guest lecture to photography students at the New School in New York City. I discuss how I got into the travel industry and show some of my work. My slide show includes a portrait section that never fails to raise questions: "How do you get those peoples' pictures?" or "How do you get total cooperation from your subjects?" The students are mystified and demand play-by-play recounts of my approach to some of the portraits.

What I tell them and what I discuss in this chapter is the *practical side* of my approach to photographing people and different cultures. I share, as well as my memory allows me, what I thought, felt, said and did while making some of my favorite travel photos. Each example represents a different set of circumstances and conflicts.

PEOPLE IN 4 TRAVEL PHOTOGRAPHY

MOVE IN CLOSE

The well-known photojournalist Robert Capa once said, "If your pictures aren't good enough, you're not close enough." A frequent mistake photographers make, even many pros, is to be standoffish with human subjects.

How many times have friends shown you vacation photographs of their companion standing diminutively in the scenery or dwarfed by a monument? They look silly. I say, "Move in on them." We really want to see how they looked that day. Unless you have a good reason, you don't need to show people from head to toe. A tighter head-and-shoulder shot, which keeps the scenery or monument in the background, can still be made.

Opposite Page
Brussels, Belgium—I often fragment a subject to emphasize the most important and interesting elements.

Guadeloupe, French West Indies—I tested my subject's reaction to my camera by first photographing him from ten feet away. Not a bad result, but it wasn't quite what I wanted.

Guadeloupe, French West Indies—
I then moved in closer for a head
and shoulder portrait, but I still
wasn't satisfied.

The Proof is in the Picture—One languid day in the French West Indies, I took a stroll with my camera and 55mm macro lens. I soon came upon a little boy sitting in the doorway of his home. We stared at each other, and I thought he had a rather beguiling face. But surrounding him were tacky plastic strips hanging in the doorway to keep out flies. I first thought these colored strips were singularly unphotogenic; then I had an idea!

I gingerly walked into the yard to get permission from the boy's mother to take his picture. Marching into someone's property is always risky, so do it with caution. I've confronted everything from a Chihuahua to a German Shepherd. I'm an incorrigible photographic trespasser, but I always seek permission if at all possible. Neither the boy's mother or any dogs seemed to be home.

I gave the child a body-language greeting because I don't speak French well. A gentle wave of the hand and a wide smile work in all cultures. He didn't appear to be at all apprehensive, so I smiled even more and slowly raised the camera to my eye to make a couple of preliminary, ice-breaker exposures. I knew from the start I wanted to get a close-up of the boy's face, but I didn't yet know how close I could eventually get.

My first shots were of the boy seated in the doorway. He was still posing unflinchingly after these, so I moved in closer for a head-and-shoulder portrait. The plastic strips didn't work well in the scene, and I thought if I could inch my way even nearer to his face, I could effectively integrate the strips. Why not get the boy to hold some of the plastic in front of his face? Then I could make a macro portrait allowing the plastic strips to give some form and .color to the photograph. That way they would help, not hinder. I liked the idea, but was not sure I could get it across the language barrier.

64

Guadeloupe, French West Indies—I finally found the right position after moving in close!

Knowing the child felt perfectly comfortable with me, I took a few of the strips and rearranged them in his hands and around his face. Immediately he got the message to hold onto them while I zeroed in with the macro lens about four inches from his nose. He loved it, so did I, and so did Mom. At the end of the shooting I looked up and saw her leaning out of a window. She'd been watching all the while!

I think the two preliminary shots pale next to the closeup. Capa's advice was definitely correct in this case. Effectively integrating the colored strips with the boy's face has much to do with the success of the portrait. So it wasn't only moving close that made a strong image. Photography is a constant creative unfolding in which we frame reality in ever more effective ways. A writer tears a sheet of paper from

his typewriter and tosses it away as new and better thoughts occur. So too, the photographer may make many exposures from various angles or with different lenses before homing in on the strongest composition.

As you become more photographically resolute, you'll quickly see what should be included in an image and what should not. As a rule, the first question to ask yourself is, "Am I close enough?"

CONTROLLING TRAVEL PORTRAITS

Moving in close is just one helpful hint I offer to all interested photographers. What is more important than following a set of rules is to be a flexible, fast-thinking and friendly person. You must be able to make the most of circumstances. You may have to cajole or convince a subject to pose or you may only have one chance to shoot. Being able to respond to unexpected situations without missing a good photographic opportunity is the mark of a good photographer. Some of my improvisational portraits are discussed here.

The Fleeting Subject—The first portrait was made in Nebaj, Guatemala, where the country's most beautiful native dress is worn by women. They are especially known for their headgear. Long lengths of multi-colored cloth are twisted and piled high with hanging tassels. Not many tourists go to Nebaj because it's a mountain town near the Mexican border, and it takes about five hours to get there from the nearest town with a hotel, Huehuetanango. In spite of the arduous drive and frustrations, I came back with a portrait I call *The Prima Donna.*

I was having a difficult time getting pictures of some of the young

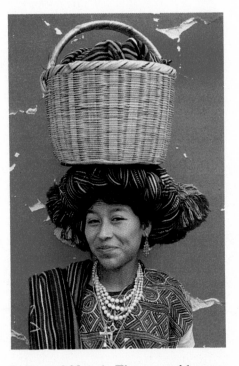

ladies of Nebaj. They would agree to be photographed, change their minds and run away in gales of laughter. This left me feeling foolish and annoyed. "Let's Bait the Photographer" was obviously a local game.

Later, as I walked to my car to drive back to Huehuetanango, I saw a beautiful young girl. She was more elegantly dressed than any I'd seen earlier. This was my last

chance. She'd dressed to the limit for market that day, and she obviously knew it. So I surmised her ego would make her more receptive to photographic advances than the other girls.

Again the usual dilemma arose. If she agreed to pose, where could I take her protrait? She was approaching me from a block away, and I figured if I kept walking and glancing down side streets, I might see a decent background. After a couple of blocks with my potential subject still coming along behind, I found a chipped, light-blue wall.

I slackened my pace to let the little lady catch up. I then sauntered along beside her drawing her attention to the camera and babbling in English as to how beautiful she looked. She got the message, and giggles erupted from her.

Next, I pointed to the blue wall. She paused in front of it long enough for me to make just one exposure, and then she too ran off giggling.

When I got home and edited the film, I discovered the girl had thrown me a silly look. I was disappointed at first, but after awhile it grew on me. I decided the giddy expression fit her perfectly.

Nebaj, Guatemala—The Prima Donna in all her glory.

The Coaxed Subject—Let's jet from Guatemala to the Kumasi market in West Africa. To get this portrait, I had to convince my subject to pose.

One evening in the market, I noticed a charming man watching me from inside a stall while I was photographing a mother and child nearby. The man maintained a bemused expression. I gave him a wave to make contact because I planned to ask him if I could take his picture next.

It was very dark in the stall, so I had to ask him to come out into the light. When I went into the stall to make my request, I maintained eye contact with the man, smiling in a friendly fashion. English is spoken in Ghana, so I asked him if he would move into the light on the street. Suddenly he changed; he became very shy because he thought I would make a spectacle of him in front of his friends and all the children. I sensed his reluctance could be changed, so I persisted with my requests. After several minutes of my gentle pleading, the man complied.

The man was embarrassed, but he maintained his smile. I asked him to pose by hanging onto the stall's beams. The angle of his arms gave form to the photo and revealed more of his beautiful shirt. By shooting only the upper part of his body, I eliminated all of the children who wanted to be part of the photo. Friends looked on with good-natured amusement, but the man never dropped his smile.

Afterward I thanked him, and he retreated to the darkness of the stall. I hope he enjoyed the interlude because everyone else seemed to have a good time watching.

Kumasi, Ghana—With smiles and gentle coaxing, I can often persuade photogenic people to pose.

The Maneuvered Subject—This portrait illustrates that sometimes you have to touch a total stranger to get the exact pose you are after. This is no big deal because most cultures are very tactile. My carousel-man portrait also illustrates that sometimes you must keep an image in mind until its elements come together. Keeping faith may take awhile as it did on a crisp December day when I found myself in Venice for the first time.

I'd risen at dawn to see as much of it as possible. Along the Grand Canal a street fair was set up, and I took an immediate liking to a magnificent carousel with gaily painted horses. I wanted a photograph of it that included a person, but nobody was stirring so early. I hoped the operator of the carousel would work well, so having previsualized the shot, I went on my way.

In the evening I returned to the carousel to see the operator. His Felliniesque face and his clothes were perfectly coordinated with the picture I'd envisioned that morning. I dredged up some dusty Italian I'd learned while living in Florence some years earlier, threw on a smile and approached the man. There was no resistance to my request to take his picture. However, my limited Italian didn't cover all my needs for communication, so I maneuvered the fellow into position, pressing his shoulder against the horse's head and placing his hand on the bridle. Because he was Italian, the man didn't mind my gently pushing him around. He was very amused by it all, and when we parted after the shooting, he asked for a print of the shot. I sent one to show my gratitude.

Because I like to completely control the composition of portrait shots, I must handle people often—especially when there is a total language blackout. I've never offended anyone because it usually increases rapport if it is done in a free and friendly spirit. It shows your subject that you are truly interested in making the best possible portrait.

Venice, Italy—Sometimes you must position your subject to make the best composition. Don't be afraid to take control.

The Well-Known Subject—Just as you shouldn't be reluctant to touch subjects when necessary, neither should you be reluctant to ask well-known people for a photo. I was on assignment in Nantucket when I made a double portrait of the Kite Man and Kite Lady, Al and Betty Hartig. They're world renowned for their beautiful kites and have been photographed by many photographers, including Yosuf Karsh and Alfred Eisenstadt.

After I'd photographed them in their shop, I asked permission to put their portrait in this book. I asked because I thought they might not want all the picture seekers such exposure might bring, but they were delighted by the idea. They don't mind at all when people drop in for a photo of them. Don't ever hesitate to ask a well-known person to pose. You aren't the first photographer to do so, and you may not be imposing.

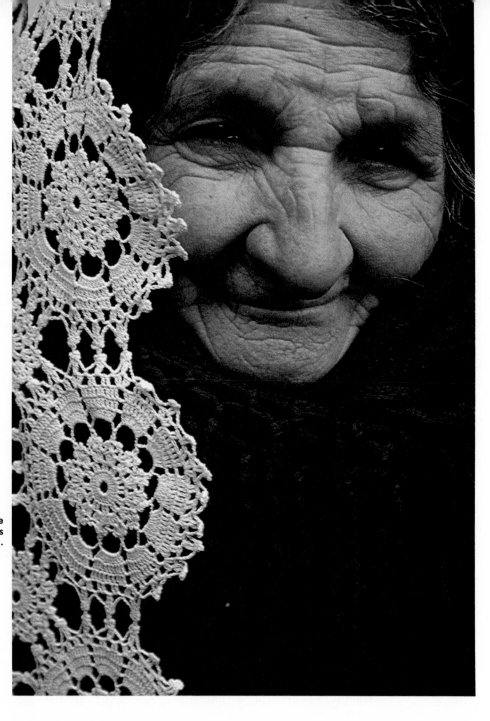

Zagreb, Yugoslavia—Skilled people are always proud to pose with examples of their handiwork.

Cooperative Subjects—Sometimes you may get away with being an imposition. In Belgrade, Yugoslavia I was sufficiently imposing that my subject was willing to close down her entire business for me to photograph her where I wanted.

At an open-air market a grand country dame in mournful black was peddling her lace handiwork. I preferred her old face and black dress against a neighbor lady's whiter, larger patterned lace hanging conveniently from a clothesline. The little lady could easily stand next to it with the lace circles against her face. I went up to her, and in spite of the language barrier, got my wish across. With a combination of body language and gentle maneuvering, I made the portrait as I wanted it. The neighbor merchant didn't mind a bit either.

The incredible thing was that the little lady actually packed away her own lace items to move a couple of stalls away for her sitting. She had to because she had no business partner. In gratitude I also sent her a print of this portrait.

On the island of Madeira, I got cooperation from a man whose portrait I wanted. And I could only communicate with body language from a distance. He was selling bright orange carrots in the crowded, hectic market of Funchal. His produce was piled high on a truck, and the man was doing a brisk trade that morning. I'd been taking some telephoto shots of him selling his wares. He saw me, but paid no attention.

Then I wanted a portrait of him against a carrot-orange background. He would have to stand on the truck's tailgate to make this possible. And then I could easily zoom in tight from my distance.

Our eyes met again. This time, knowing what I wanted, I waved at him. He waved back. I gestured to him to hop up on the truck and look straight at the camera. He complied for a few exposures, and I got the photo I had visualized.

The Patient Subject—Every August on Guadeloupe, French West Indian cooks join in the *Fête des Cuisinières* —Festival of the Cooks. The event honors St. Laurent, the patron saint of food. At the festival one year I saw a proud woman in her Sunday-best beads and satins. I asked, and she willingly agreed to my request for a picture.

Being a good talker and having an assistant are two assets for a photographer. My husband was with me, and he is a conversationalist *par excellence.* He can chat at any level. I've developed the same talent because it's an invaluable aid to travel photography. The key to conversation, whether with the Queen of England or a Caribbean cook, is the ability to ask questions. The key to asking questions that will stimulate conversation is a genuine interest in the answers.

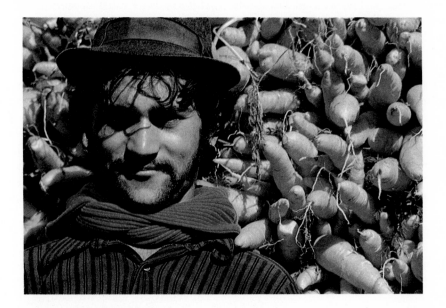

Madeira, Portugal—Farmers are always proud of their produce!

It was a gray day, and the sun was out from behind clouds only occasionally. The woman was seated on a chair I'd placed for her against a plain wall. She was dark skinned, and there were no highlights on her face which the portrait needed. There would be some in just a few minutes because a hole in the clouds was moving toward the sun. So Landt and I took turns in pleasant conversation with the patient woman.

"Foul day for the Fête," I ventured with my fractured French.

"Was lovely last year," she lilted in reply.

"I'm sorry this shot is taking so long. It'll be so much better with a little sun," I explained, stalling for time.

"Never mind," she said politely. She was pleased to be picked out of the crowd for my picture taking.

Landt took over. "That's a splendid dress," he said.

Our friend glowed with pride.

"You ladies make your own costumes for the Fête, don't you?" he went on.

"Oui, monsieur. Each year I change a little something." She beamed with pride.

"Where do you get the fine satin?" Landt continued. We were both gazing up at the sky, praying for sun to penetrate.

"Oh, we get plenty imported from France."

Then I interjected, "I think we're going to get a few seconds of light very soon. Let's get ready for it."

I placed Landt on my right side so he could continue the conversation to keep the lady interested. When looking at him, her face would be turned toward the sun. I had thought this out while waiting and keeping up my end of the conversation.

"Here it comes," I exclaimed. "It won't last long."

Landt knows, having worked with me for years, that good expression and exposure must be simultaneous. He gave my subject a little verbal tickle.

"I'll bet you're going to win the prize for the prettiest costume today," he said. The lady beamed while I made several quick exposures before the sun ducked under again.

Does this sound like manipulation to you? It wasn't. Landt's compliment was sincere and friendly. Our friend *was* more splendidly dressed than most of the other women that day. I wouldn't have wanted a portrait of her otherwise.

You might think carrying on a conversation like we did is kid's stuff. It may sound like it, but try it sometime with someone from a different culture while you're coping with the hassles of getting a photograph. Your head is so busy handling exposure, expression, sun and everything else that it's tough to generate even the dumbest questions.

It really is a useful talent to carry on conversation with subjects. Cultivate and develop it to increase your photographic potential.

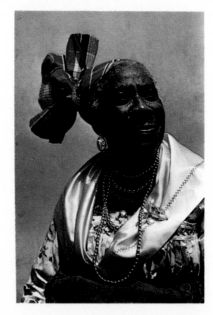

The Coincidental Subject—Sometimes I find a scene or background that needs a person in view to make an effective composition. This occurred once at the Farm Museum in Hoorn, Holland. As I walked into the museum, I noticed an interesting patch of fragmented light reflecting on the whitewashed wall. I noted it and went on about the museum looking at paintings and old farm artifacts from the Friesland district.

The paintings impressed me. They were primitive portraits of Dutch farmers with ambiguous expressions—somewhere between timidity and pride. I noted the poses, the placement of hands and mostly the expressions on the subjects' faces. I thought it would be fun to make some similar photographic portraits.

While passing the patch of fragmented light again, I saw a woman approaching the museum dressed as a 17th century Friesland farmer's wife. She was a hostess in costume to add to the antique atmosphere of the museum. This was it! The woman had a fine Dutch face, and the costume was perfect for the background light on the wall.

The woman was shy but willing to have her portrait made. Her

Guadeloupe, French West Indies—Once you have cooperation from a subject, select the proper light, pose and background. Sometimes this takes a little time, but it gives better results than shooting quickly.

coyness and curiosity about me combined to approximate the expressions in the paintings I'd been studying earlier.

You never know just how a photo will fall into place. Always keep good backgrounds in mind as you wander around a location. You may be taking a subject to a spot you discovered earlier.

Points to Remember—I want to give a little more advice for photographing strangers. Don't simply charge up to people with your camera ready. It's always wise to read a potential subject first. By *read* I mean you should develop an intuitive feeling about the person. Does he look pleasant and open or hostile? There's no sense approaching someone who seems antagonistic.

As you've seen with my portrait anecdotes, there's absolutely no formula to photographing people. You must use an inner sense in each case. Tactics are determined by your ability to read a potential subject and by your own feelings that day. I find myself being sensitive and mellow with one person, bold and brassy with another, and charmingly cheeky with the next. So I play it the way I feel it.

Hoorn, Holland—I purposely made this portrait reminiscent of a 17th Century Dutch painting.

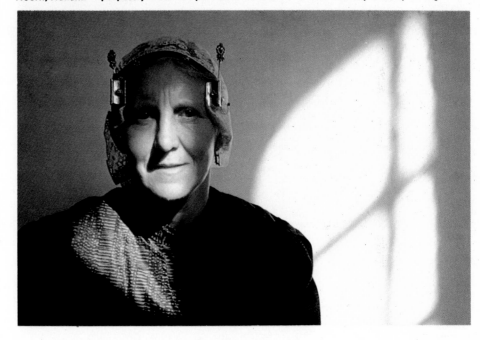

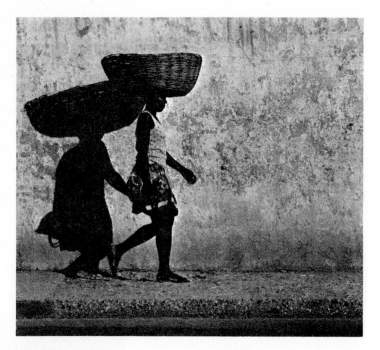

TO TIP OR NOT TO TIP?

Recently I reintroduced myself to a woman with whom I'd traveled in Haiti on a press trip. She'd been with her husband, a prominent travel writer.

"Oh, yes, I remember you," she said, "You're the photographer who never gave that poor person in Haiti any money after you took her picture." Yes, that was me.

This woman with the flawless memory was dragging up ancient history. The incident must have impressed her because it was about three years ago. We had shared a car and stopped to do some shooting. I saw a Haitian lady walking down a road, balancing a huge basket on her head.

I approached her in a cheery fashion as one human being glad to meet another. My dark-skinned sister didn't mind my taking her photograph after I had asked her permission. I made about six exposures, and I shook her hand afterwards with smiles and warm thanks. She was giggling and pleased by my attention. However, she requested no financial recompense and seemed satisfied with the personal interaction of the shooting.

Queued behind me to take pictures of the same woman was the prominent travel writer. He made one perfunctory exposure and never made eye contact with the Haitian. Then he nervously whipped a dollar out of his wallet and gave it to the woman. There was no human touch—only payoff.

One American dollar would probably take two days of hard work to earn in Haiti. This local lady had earned one in less than one second. I'm sure no photographer will ever get a picture of her again for anything less than a dollar. Furthermore, she probably waved that greenback all over her village, and now all its denizens might have a $1.00 minimum price for photo privileges. Possibly an entire village of Haitians was turned into photo-extortionists by a single insensitive and self-justifying American assuaging his self-image by throwing around money.

This anecdote discloses my general feeling about tipping for photographs in foreign lands. However, I'm the first to acknowledge that it's not a clear-cut issue. Sometimes it is right or necessary to tip. There have been times when I reacted to circumstances and handed over some change. But only some change because a dollar is gross overtipping in underdeveloped countries.

In Guatemala—I began globe trotting after photos in 1966. In recent years I've been averaging at least six months a year on the road. In all this time I can count on one hand the number of occasions I've tipped. The criteria for these few offerings are very simple. There have been rare instances when I've been so anxious for a photograph that I've been willing to tip to get it. One example occurred in colorful Guatemala.

In Chichicastenango I was attracted by rose petals scattered all over the steps and entrance of a church for a religious ceremony. The magenta petals were striking against the grubby stones covered with dirt and candlewax. I wondered how to make an effective composition of it all. At this point a small boy, with equally grubby bare feet, came out of the church with his father. I noticed his blue trousers and the blue wooden door. Instantly I threw all the elements together in my mind: the feet, the petals, the steps and the door. But they were not together. I had to arrange the shot.

First I snagged the father. I don't speak Spanish, so I simply stood in his way as he went down the steps. I did this in a friendly fashion so as not to intimidate or annoy the man. I then exhibited my camera and pointed to his son.

"Pagueme," responded the man in a polite but businesslike fashion. There was no hostility or undue greediness in his manner. He simply wanted some payment for his willingness to share his son's feet with me. I really wanted this shot, and I was glad it would be possible. This time tipping felt right.

Having agreed in body language to tip the father, I took the boy back up the steps and stood him against the door. He was not at all shy of me. So I grabbed a handful of rose petals and sprinkled them around his feet. Finally, I made my exposures while his father was looking on with fascination and pleasure.

I gave the man 25 cents. As frequently happens in any tipping situation, he demanded more. But I indicated with movement of hand and expression of face that 25 cents was quite enough. He smiled sheepishly. He was trying to play me for for all he could get. After farewells he pocketed the coins and left with the child trailing behind him.

Guatemala is the country where I have done the bulk of my tipping. Photographers, pros and amateurs alike, should have some change in their pockets if they wish to record the Indians there. I don't find the frequent requests for money offensive in Guatemala because Indians have an attractive approach to the matter.

It isn't like the Caribbean, where many people have become overtly greedy and overly assertive in their demand for a tip. Years of indulgence by tourists have created the situation. In Guatemala there is a direct, charming and businesslike attitude displayed by the Indians when they hold their hands out.

Another time in Chichicastenango illustrates the lengths I'll go in upholding my end of a deal. I chased a woman through a crowded market place, tapping her on the shoulder three times to get her to stop and allow me to take a picture. I agreed to tip for the privilege of photographing her baby and the mother's braided hair wound with blue brocade ribbon. I knew I didn't have any change on me at the time, but I was longing for the shot.

After I'd finished, there was only one' way to pay the woman. She would have to follow me back through the market to a church

where my husband was watching a religious ceremony. I beckoned to the bewildered woman to follow, and I asked her to wait while I went in to get change from Landt. The woman was satisfied with 25 cents and went on her way. Again, tipping felt right.

You should notice I shoot first and pay later when I strike a deal with a subject. If you deliver a tip first, the person may strike a pose only long enough for you to make one exposure. But if you make your pictures first, you can get several exposures, maybe even shoot a

Chichicastenango, Guatemala

whole roll if the person is willing. The longevity of their cooperation depends on several factors: their patience, how pleasant you are to them and the expectation of a tip.

You might find this tactic rather manipulative. It is, but remember you are communicating across language barriers, and you must find practical ways to control situations and get what you bargained for in each photographic encounter. My shoot-now-and-pay-later tactic would be improper if the subject were in any way abused. I try to be sensitive to the person's tolerance of me and my camera, and back off when it becomes clear that the subject has had enough.

Sometimes you will be surprised. There are those who will take all the photographic attention they can get. If they are enjoying themselves, why not shoot away? For such people the tip is an inconsequential dividend.

In Ghana—You don't always have to dish out dollars to photograph your fellow man. Don't begin with the assumption that you'll have to tip. I always assume I don't have to.

I was told by the public relations firm that represents the Ghanaian National Tourist Office that I should bring goodies to barter for photographs. I'd heard that some of the African people were among the toughest to photograph, so I prepared to play the game by buying some inexpensive items at a local department store.

But in Ghana I had total rapport with the people. I can't remember anyone asking me for money, and I never had to use my loot to barter with. In some of the markets, people actually asked me to take their picture. They wanted the fun of being in front of a camera with all their friends watching.

Some of the colleagues I was traveling with in Ghana were astonished by my success. Photographically they were getting nowhere with the people. These same colleagues continually threw candy

and other stuff out the bus windows at packs of scampering children. While this may seem a mere game, it does say something about the average tourist. They think they're communicating with the locals by flinging sweets at them from the safety of an air-conditioned bus. Personally I found the gesture reprehensible.

The approach I took was to advertise that I was OK by being super nice to the kids. Walking through the market in Kumasi, I became a Pied Piper to dozens of the little ones. While I was photographing someone with one camera, children were scrambling to look through another hanging from my shoulder. I even held a camera firmly by the strap so they could take turns peeking through the viewfinder.

I was not afraid for my camera because I had total control of the situation. The adults watched the antics with pleasure. Not only were they fun for everyone, but these antics established me as a friend to the children *and* the adults. I made many wonderful people pictures in the Kumasi market that day.

In the Caribbean—Whether you are a rich traveler or not, there are times when it's clearly correct to offer a tip in exchange for a photo of someone. If you interrupt a person while they're engaged in their work, you should offer a tip. On St. Lucia in the Caribbean, I photographically prevailed on a little boy for over a half hour. He was peddling dried pieces of sulphur at the bubbling sulphur pits on Mont Soufrière. I'd prevented him from selling his product to other tourists, so it felt right to give him some change. He never asked for a tip, but I gave him one anyway.

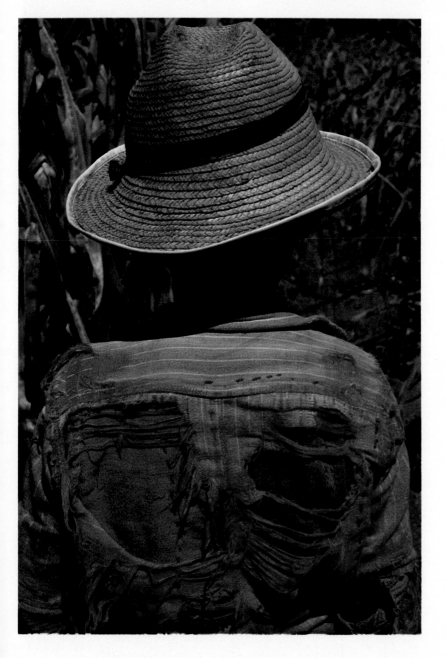

Atitlan, Guatemala—Money isn't the only payment people accept. This boy bartered with us for a lift into town because he was carrying a heavy load.

Atitlan, Guatemala—I sent the man a print of this shot. This is a good way to express appreciation instead of offering money.

Opposite Page
Avignon, France—Sometimes my subjects offer *me* a tip after I photograph them. How can I ever refuse?

Don't immediately assume that some people wouldn't welcome a break from their work. A fisherman mending a net may have from now until kingdom come to finish the task. He may be happy to drop his mending to pose for you, or you may simply want a shot of him doing his work. In this case you are not interrupting him at all.

Alternatives to Tipping—Money isn't the only commodity people will accept. Some would rather have a print of the picture you take. This is a request you can't deny. It's impolite to say you want to take a shot of someone, and then say you won't send them a copy. Always have a pencil and small notebook at hand for these occasions. I must admit I've not been 100% faithful in this matter, but I think I've done remarkably well in getting prints to people who've cooperated with me

photographically. It is sometimes expensive after you add the costs of film, prints and postage, but I try to keep my promises.

I've even been on the *receiving* end after photographing people. I've been offered gifts from subjects delighted by the attention. Once on the Caribbean island of Nevis, a woman and her husband, both octogenarians, gave me six eggs and a squash after I'd spent 45 minutes poking around their place shooting pictures. I took the food graciously and gave it to the cook at the hotel in which I was staying.

Another time in the Caribbean, a woman who had enjoyed being photographed offered to bake me a coconut cake in her ancient, out-door oven. I went back that afternoon to eat it. There was no financial transaction—just friendship and a pleasant encounter for both of us.

Once in France I was taking shots of a man on a ladder picking cherries. He came down and gave me a basket of the sweetest, plumpest cherries I've ever eaten. He never asked me for a tip either.

Points to Remember—I prefer to leave someone a commodity more important than money. I hope my photography does something positive for the person's self-esteem. There are many people who relish the opportunity to manifest themselves through being photographed. It gives them a chance to express their highest concept of themselves— even for a fleeting moment and even if they never see the result.

When a photographer singles out a subject, it means he or she is an individual standing out from the crowd. This is a flattering notion for most of us. And under these conditions, it's tough to resist the tion and appreciation we can get, and if it comes from a friendly photographer wishing to record us on film, so be it. If you actually establish a line of communication with a subject, you may be expressing more interest than the person has received in awhile. This could be worth more to that person than money.

You can repay people with kindness, interest and gratitude. So always make sure you abundantly thank a person who has posed for you. *Never shoot and run.* Doing so is taking advantage of people.

The burden is on you, the photographer, to make sure the encounter has been mutually rewarding. To instill an atmosphere of comfort, you must treat the subject as an equal, not as an oddity to capture on film. This raises the encounter out of the realm of a business deal. do so! And it means you must have something valuable to give.

While you are exposing film with another person, you are simultaneously exposing yourself through the manner with which you work with the subject. This self-exposure should be a positive giving of yourself to the person in front of your camera. To fulfill this ideal, the photographer should impart qualities of heart and mind which benefit, perhaps even bless, his subjects in some way. By doing so, you will take exploitation out of your people photography.

Frederick Sommer, a noted photographer, once said, "All rare things should be lent away. I have borrowed very freely." I too have borrowed photographically from many rare individuals. In exchange for the photographs, I have given recognition, entertainment, enthu-

friendly photographer. With this awareness of human nature the photographer is not just taking advantage of people's egotistical frailties. I think we need all the atten- It will also do much more for international and interpersonal relations than throwing money around. The only catch is that it will require so much more of you as a person to siasm, encouragement, advice, genuine interest, friendship and gratitude to people around the world. Money has a very small part in such exchanges.

Antwerp, Belgium—Before I made this portrait, I had to silence the silly arguments of inertia that ran through my mind. Inertia afflicts all photographers, but I've learned to overcome it.

The heart of travel photography is happy encounters with people at home and abroad. Getting a good portrait of someone is more rewarding for me than an equally successful shot of an inanimate object. And the main reason I find photographing people more gratifying is because it's more challenging. But you must continually subdue the various subtle problems that I call *inertia*. As subjects, people are definitely not the course of least resistance to the photographer.

The Challenge—The challenge begins when you spot a potential photograph involving people. Immediately, you must get rid of inertia. This negative force comes in the form of any argument which may prevent you from pursuing the image you want.

Inertia whispers: "The people don't want to be bothered with me and my camera. I feel timid today. I'm too tired. I have enough good shots already. They'll demand a tip. I don't want to stop the car. I don't speak their language. I don't want to be rejected again."

The list could go on and on. Inertia will argue in every conceivably silly way to turn you away from the photos you desire. Each argument subtly tries to justify your forgetting the shot. It makes you feel better about missing it—but only for the moment. Inertia is clearly seen as the culprit when you get home from your vacation and discover you don't have any good people pictures. The louder inertia argues against it, the better the potential picture—it's almost a rule.

Inertia tries to operate on all kinds of subject matter, but I've noticed it argues double time to divert us from human subjects. The reason is that it requires so much more of us to create rapport with people. Actually, you are bothered by your own inhibitions and assumed self-limitations. People

photography can accelerate personal growth because without increasing patience, grace, humor, consideration, charm, gratitude, love and self-confidence, the process of taking people pictures becomes a personal drag. The trick is to overcome inertia at every opportunity and gain freedom in photographing people.

My personal growth has been forced because I'm a professional photographer who *must* bring back the shots of both animate and inanimate subjects. You can be your own client or editor. A little game playing won't hurt. Put a little pressure on yourself to succeed; you'll survive. You must decide for yourself how important good photographs are to you. Are you willing to try breaking through some personal barriers to get the pictures you want? If the answer is *yes,* and you make the effort to get some lovely people pictures, I guarantee you will have had the best vacation of your life.

Hearsay Inertia—Sometimes inertia tries to do its dirty work in very subtle ways. If friends report inharmonious photographic experiences with certain groups of people in the world, they may insist every photographer will. Your friends just may not be diplomatic in applying a camera to a foreign culture. So never assume that someone else's problem will be yours. The stories of soured photographic attempts are usually based on a very subjective experience.

When I told friends I was on my way to the ancient cities of Samarkand and Bukhara in the Uzbekistan Republic of the U.S.S.R., they said I'd have a difficult time photographing people. These friends insisted the Uzbeks were camera wary and brainwashed by the Soviet radio to be uncooperative with photographers. They also said Intourist, our tour organization, would be keeping an eye on my photography to be

sure I didn't get any uncomplimentary images.

Little of what they said actually happened, and I had a great time with the Uzbeks. Intourist gave us a guided tour the first day in Samarkand and then left us totally alone for the next three days. I was with my husband, and together we had one fascinating experience after another with the people.

Samarkand, U.S.S.R.—
I had very little trouble photographing people in Smarkand once my initial fears were allayed. And markets are always a good place to lose photographic inhibitions.

Samarkand, U.S.S.R.—Children
rarely have photographic inhibitions
to compound yours! Work with them
to gain self-confidence.

As we wandered around the two old cities, we were fascinated by turbanned men and women and scampering children. The centuries-old, hand-painted tile buildings, the buzzing markets, and the blue mosaic domes seemed to propel us back to earlier times.

At first I was rather apprehensive about making photographs. I hadn't done much traveling and shooting in exotic countries at that time, and the Uzbeks were different from any people I'd worked with before. They didn't appear hostile as my friends had forewarned, but I still wasn't sure how to pace myself with these Eurasian people.

Overcoming Inertia—To ease into the strange environment with my camera and gain a little self con-

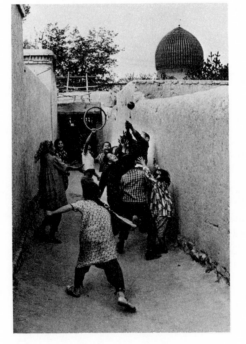

Samarkand, U.S.S.R.—Children rarely have photographic inhibitions to compound yours! Work with them to gain self-confidence.

fidence, I began by working with children. This is always a good idea. Kids are usually unafraid of photographers, and the first good shot of them boosts my morale. After having been accepted once, even by a child, I have greater confidence with other people. Wherever I am, I try to photograph people as early as possible to override all of inertia's arguments. I've come to call my first people picture for the day the *ice-breaker* shot. I find that not only do I need to break the ice with each new environment, but it also must be done on a daily basis. People photography is a bit like ballet. You must practice every day if you want to stay limber.

As I strolled around, I came upon children playing with a hoop and ball in an alley. I saw my ice-breaker shot for Southern Russia.

Immediately the kids stopped their game to stare and giggle at me. How was I ever to get a natural, spontaneous shot of them? I didn't speak their language and couldn't direct them in any way. Then it suddenly occurred to me: I could play with them. Child's play has never required a common language. I motioned to the boy holding the ball to toss it to me. He did, and I tossed it back. They sprang into action. My scheme would work.

I asked my husband to take my place while I prepared to shoot. To get the picture I wanted, I took a

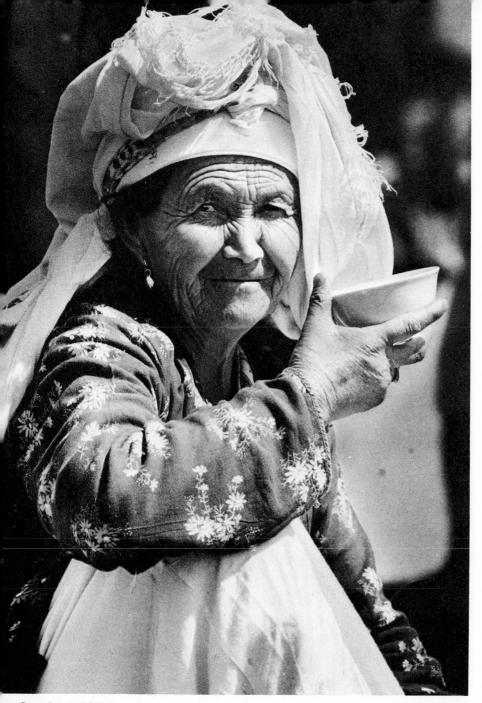

Samarkand, U.S.S.R.

sitting position and was ready for the decisive moment. While my husband continued to play with the kids, I told him where to toss the ball. We went through this four or five times. After getting the shot and having such fun with these new friends, I was elated and expected memorable experiences for the remainder of my stay in Uzbekistan.

The feeling proved to be right. I poked through open-air markets and marinated in the atmosphere. Every spice known to man was there to be touched and smelled. There

were broom makers, hat makers and an old man with a cane selling pigeons. I offered greetings to dozens of Uzbeks, and there was plenty of reciprocity. My friends' warning about the indifference of these people to foreigners was based on their own subjective experience.

Not only did I have fun with the Uzbeks, but they had some fun with me too. At the market in Bukhara I discovered an outdoor restaurant. Merchants and townspeople sat on raised, rug-covered platforms while chatting and sipping tea. One mar-

velously funny woman I spotted didn't mind her photograph being made, but in the process I became lunch-time entertainment for everyone. The woman ultimately cracked up in laughter and self-consciousness. I played the episode for laughs too because it was the best way to overcome my own self-consciousness at having 50 Uzbeks watch my performance. The sight of photographers shooting will always attract attention. It's something you simply have to get used to, so don't give in to inertia's argument of stage fright.

Apathetic Inertia—Neither should you give in to inertia's lure of photographic apathy as I did in an incident that occurred while I snooped around Samarkand's back streets. I came upon a group of people at the entrance to a court-yard. There was music and applause in the air. As I peered over shoulders into the courtyard, I found myself suddenly being ushered into it by a couple of women. Inside was a teenage boy dancing on stilts and doing tricks to the music. Every now and then someone would tip him. At first I felt out of place at the happening, but I soon settled in. I later learned this part of the world is full of traveling circuses, wandering minstrels and entertainers. It was warming to be so naturally included in this event, but I went away with no photos and no excuse. A fantastic photo opportunity was served on a silver platter, and I stood there with my cameras unused. Ordinarily I would have extensively shot the event, but this time inertia disguised as photographic apathy took over.

Inertia Removed—A pleasant act of hospitality came to me in Bukhara. While walking down an alley, I was greeted by a bearded, robed man leaning against the entrance gate to the courtyard of his house. Recognizing his interest in my cameras, I stopped to show them to him because I always want to be open to any human interaction. It does no good to be charming *only* to those people of whom you want a picture and be laconic with others.

After a brief chat, he speaking his language and I mine, he opened the gate to his courtyard and gestured for me to come in. This time inertia in any form didn't have a chance. I had an opportunity to see how these people live. I was then offered a glass of something strong enough to fuel a rocket. After a sip or two to be polite, I wondered if I would be out of focus for days.

Bukhara, U.S.S.R.—I consider this photograph a warm gift of friendship. A father shared with me, a total stranger, this sight of his sleeping son.

After our cocktail, the man whispered words that seemed to mean, "Follow me." His eyes twinkled. We tiptoed across the courtyard, and he urged me to look into a room where a child was asleep. Hanging in back of the bed was a magnificent Bukhara rug, and a tiny painting of a baby was attached to it. The sight of the child asleep in such a dramatic setting was a must photo for me. Later I wondered if the shot was a reward for my courtesy in not abruptly passing by the father on the street just because I didn't want *his* picture.

The Inertia of Fear—There was no fear on my part when I accepted the Uzbek's invitation to see his house that day in Bukhara. None-theless, fear is one of inertia's most successful tools in discouraging photographers from people pictures. A photographer must be free from fear to interact naturally with people of different cultures. You should assume that your subjects are probably a little apprehensive about you and your camera to begin with. Try not to compound the problem by being fearful yourself.

Perhaps a tip request for a photo-graph leaves you uptight. Language barriers may make you uncomfort-able, or public rebuttals by a desired photo subject may upset your equi-librium. Self-consciousness about being a conspicuous foreigner may prevent you from penetrating the

nooks and crannies of a place. Or the thought of being mugged might keep you in the safe part of town. These are difficult problems that all of us face, so use your best judg-ment in each situation.

All these reactions are kinds of fear and will cramp your freedom and photographic style unless you nip them in the bud. There is no question that the photographer working with people of a foreign tongue must become an actor in spite of stage fright. Lack of a com-mon language forces you to act out your request to take someone's picture. Body language must become your vernacular. The way you move, look and your facial expressions are all you have to project your wish to photograph someone.

You might be balking at the thought of making a spectacle of yourself with body jive in public. You might even think your body isn't very articulate, but this is simply inertia talking again, trying to prevent you from getting the people shots you want. Shyness gets you nowhere. Force yourself to stroll right up to a photogenic foreigner. You'll find that when you make the initial move and give yourself to the desire to take a picture of someone, there's no turn-ing back. Your effort will carry you through, and you'll find yourself fluent in the gestures that convey, "I want to take your picture."

Puerto Vallarta, Mexico—At first this man was apprehensive of me and I of him, but we achieved an appropriate compromise with this pose.

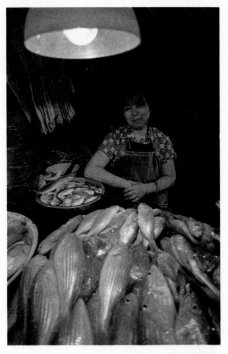

Hong Kong

Religious Inertia—A comfortable excuse for avoiding people is that they may be opposed to the camera because of a religious belief. It isn't that we shouldn't respect the beliefs of others—indeed we should. But religion should not become a handy excuse to *not try* to find willing subjects.

Some photographers use two approaches in dealing with religious-based resistance. They either go the grab-shot route, a predatory approach, and sneak photos with telephoto lenses, or they slide up to people and photograph them right in the face. Both methods can be rude.

There is still another approach, and it works best. You can discipline yourself to be looser than you've ever been before and lower the level of friction created in pursuit of photos. Through utter ease of being and by projecting yourself as harmless, you can actually ingratiate yourself with enough individuals to get some of the shots you want. Despite prevailing religious beliefs, never assume *no one* will allow his picture to be taken.

Meeting Antagonism—While in search of people receptive to you and your camera, you must be very patient and persistent. Rebuttals should not discourage you.

So be understanding and try not to cause animosity. Animosity can arise by pitting your will against the wish of another person, and these feelings can ruin your day and your photography. They could even turn you off to the country you've spent hundreds of dollars, maybe thousands of dollars, to see, enjoy and photograph.

I had an opportunity to keep animosity in check while up against photo resistance in Hong Kong. As I penetrated the back-street markets, word passed from one merchant to another that a photographer was in the area. I could hear, see and feel it happening. I quelled my unease and annoyance each time someone refused my photographic advances. I maintained my smile, moved very slowly and did not show discouragement. Someone even threw some nuts at me while I was shooting, but I still refused to be intimidated, infuriated or humiliated. Instead, I joined in the laughter around me, and by so doing I felt closer to the people and not a reject.

After a couple of hours I still didn't feel I had made any decent photos. I wanted one photograph that showed the subject was as pleased to be photographed as I was to take the picture. I was determined not to let Hong Kong get me down.

In a fish market I reached my goal. Under a hanging lamp were rows of lovely red fish. The woman merchant looked pleasant, so I went up to admire the fish. And she seemed delighted by my interest. A few minutes later I used body language to ask if I could take a picture of them. She indicated it was all right, but knowing she would be in the shot, she started to move away. I urged her to stay. She did and was ultimately pleased by all the attention she and her produce were receiving. We parted warmly after I thanked her and expressed great enthusiasm for the beauty of the fish. Gratitude is very important. Never shoot and run.

Points to Remember—What I am concerned with is overcoming all of inertia's silly arguments against happy photo encounters. My photographs of people that mean most to me are ones in which I established rapport prior to making exposures. I've also learned that when you have gained the acceptance of an individual or group, you are in control. This lets you move freely in a ceremony or situation where you would otherwise be an imposition. Gaining acceptance enables you to make special requests of people; you can then carefully control the form of your photographs. You can position yourself in whatever relationship to the subject you desire—maybe in very close.

Once you overcome inertia and make contact with your subject, you have the power to give the person in front of you a pleasant experience. This also helps photographers who follow in your footsteps. Subjects who have enjoyed having their picture taken will be receptive to the next request.

There is, indeed, an exhilaration which comes from subduing inertia, approaching a stranger of a different language and culture, making a request to photograph and getting a positive response. You must monitor your reactions and those of your subject to insure both parties are enjoying themselves and are as free as possible from self-consciousness or apprehension.

CERTIFICATE OF REGISTRATION FOR PERSONAL EFFECTS TAKEN ABROAD	Form Approved O.M.B. 48-R0394
	Number

Name of Owner	Address of Owner

Description of Articles

I certify that the information shown hereon is true and correct to the best of my knowledge and belief.	Signature of Owner	
Port	Date	Signature of Customs Official

➤ *Certifying officers shall draw lines through all unused spaces with ink or indelible pencil.* ◄

**The Department of the Treasury
United States Customs Service**

Customs Form 4457 (5-22-73)

DEALING WITH U.S. CUSTOMS

Photographic Equipment—If you are an American traveling overseas with foreign-made photographic equipment, you should first register it with the U.S. Customs. To get a certificate of registration, illustrated here, take your equipment with you to the nearest customs office. Any international airport has one. Fill out the form by listing your equipment by brand, item, serial number and any other identifiable markings.

The form expedites the free entry of your equipment upon your return. If you didn't have the form, you could be suspected of avoiding duty charges on equipment bought abroad. So take no chances. I recommend making three or four *extra* forms so you can show foreign customs officials that your equipment is registered. It has no official power in a foreign country, but it may make passing through many customs offices simpler.

Film—Any developed or undeveloped film manufactured in the U.S. and exposed abroad reenters duty free. You can also mail it home to yourself or to your laboratory for processing. Foreign-made film and prints are dutiable, but you can include them in your customs exemption.

LANDSCAPES IN COLOR AND B&W 5

Hillegom, Holland—Striped tulip fields are graphic landscapes. The stark, white tulips dramatically offset the colorful blossoms.

Opposite Page
Antigua, Guatemala—
Whenever you see an unusual natural phenomenon, waste no time photographing it. This cloud floated past the volcano in a few minutes.

When it comes to seeing, all photographers, whether professional or amateur, have weak and strong areas, and landscapes are not my visual forte. I'm not suggesting that the world we live in isn't spectacular, but I think getting panoramic views of it on film is especially challenging. Frequently, a lovely scene, which is impressive to the

graphically glib with scenics. The seeming ease may result in inattention to the real challenge of landscape photography.

See Landscapes for Yourself—You can observe a mass case of glibness in landscape photography most dramatically on bus tours. People hang out windows or shoot through them with no possible thought to

a *Photo Opportunity* sign. The spot may really be spectacular, but perhaps only under certain lighting or weather conditions or possibly from farther down the road. Don't be an automatic photographer. Beauty is in the eye of the image maker. Use your opinion and tastes as to what is worth recording around the world. Neither signs nor peer-group pressure from fellow travelers should tell you what to photograph.

eye, is a flop on film. Let's explore some of the reasons why and find ways to avoid getting anticlimactic landscape photos.

Landscapes are a major subject of travel photographers, and I'd even wager that amateurs take more of them on their vacations than any other kind of shot. In many respects, shooting scenic views is the course of least resistance. Scenery doesn't demand a tip, rebuff you or run from the camera.

Landscape simply sits there passively while you make as many exposures as you like. This may be one of the reasons why pros and amateurs tend to become photo-

composition. I know it's tough being stuck in a bus and watching scenery slide by unrecorded. It has happened to me many times on familiarization trips for travel writers and photographers sponsored by national tourist offices around the world. But I'd rather miss a shot than not get it exactly the way I want it.

When the bus finally pulls into a scenic spot, the locale seldom seems scenic to me. This may be snobbery, but I've seen amateurs expose frame after frame on dull coastlines or undramatic mountain ranges simply because the park service, tourist office or chamber of commerce established a parking area and posted

Sometimes there is no doubt in anyone's mind, pro or amateur, about a potential scenic shot. Such was the case of a bus tour I was on in Guatemala. We were speeding down a highway near the 18th century colonial town of Antigua, and about 60 people let out a simultaneous scream to stop. To our left was a thin layer of cotton cloud across one of the nation's many volcanoes. The sight impressed everyone, and we piled out to photograph it before the swiftly moving strip of white passed by.

I began by making a few wide-angle shots that included the valley beneath the volcano, but I wasn't happy with them. The drama of the volcano was lost in the wide-angle view which minimized its height in relation to the surroundings. So I decided the surroundings were not important and tried longer lenses.

Just before the bus pulled off again, I noticed a pine tree. With the 80-200mm zoom, I made a few exposures, framing and cropping precisely with the lens. The dark branches added needed tonal contrast to the monochromatic scene. The shot fulfills my personal requirements for landscapes. It is both pretty and mysterious.

Palm Springs, California—
At sunrise or sunset, be
on the alert for silhouette land-
scape shots.

Nauvoo, Illinois—Although
sunset shots can be clichés,
they often make pleasant
landscape photos.

Not all landscapes must be made with a wide-angle lens. Be very selective as to what you include in your viewfinder. Your eye may distill a broad panorama into a telephoto shot, so don't be surprised if this happens.

Composition in Landscapes—I don't think composition can be governed by absolute laws such as: Never put the horizon line in the middle of the frame; or Don't place your key point of interest in the center of the frame. Like most laws learned in any art form, these two can be successfully broken. Composition depends on an inner sense of esthetic verity. You must move freely between following the laws and breaking them when necessary. Without an innate sense of composition, you are confined to rigid structure and a monotonous collection of images.

What many landscape photographs lack is a key point of interest properly placed in relation to less-important elements of the scene. The eye needs something specific, big or small, to hang onto in the foreground or background of the picture. This element serves as a point of departure so the eye can roam the scene and return again to the reference point. This may seem to be just another rule of composition, but it is the one I follow most faithfully.

This challenges me to find new angles on landscapes. During one spring in Germany, I was walking in fields of fruit trees and mustard plants. I noticed a hunter's blind high in a tree, so I climbed it to make a landscape photo best suited to my style. The foreground blossoms catch the eye first, and as your eye follows the blossoms, they lead to the mustard fields and sky in the distance.

Bad Wimpfen, Germany—
From the ground, the strip of yellow
mustard was pretty, but not strong
enough to make a good photograph.
I had to climb an apple tree
to get an effective
landscape photo.

Manzanilla, Mexico

Another time, in Mexico, I almost bypassed a scene because of its complex composition. I noticed some bougainvillea vines and at first only saw the magenta splash of the flowers. I am not much of a flower photographer, so I didn't immediately see the flowers in relation to their surrounding elements. The shadows framing them, the rocks, and symmetry of the water and mountains in the background all contrast with the flowers to make them the key point around which the eye scans.

Shadow areas are perhaps more crucial to landscapes than to most other subject matter. Where there is light, there is shadow! These opposites are the warp and woof of most photographic compositions, but with landscapes especially, shadows provide the form of the composition. As a travel photographer, keep your eyes peeled for the light and shadow of landscapes while looking for intersting compositions.

The warp and woof of light and
dark exist even on overcast days.
Look closely at this photograph of
a colorful little rowboat on the
banks of the Yonne River in
France. There is an inner frame of
shadow surrounding the boat. This
darker area sets off the boat as the
reference point and provides in-
teresting form to the composition.
Drizzly-day photographs are subtler
than fair-weather shots and require
a keener eye.

Candanchu, Spain—The foreground skis point into the mountain scene. A well-composed photograph often manipulates the viewer.

Sometimes there's no way to get an unusual angle on a panorama. This happened once when I considered a shot of the Spanish Pyrennes at the ski resort of Candanchu. The mountains were marvelous, but they alone weren't dramatic enough to merit a photo. I wanted to get across the idea of skiing into the scene, so I introduced ski tips as a strong foreground element.

Another time while driving into the Swiss Alps for some skiing, I stopped to take a picture of a rural abstraction in brown and white. Brown is beautiful to me, and the variations of it, contrasted by the patches of melting springtime snow, caught my fancy. The little mountain huts, probably for brown Swiss cows, provide a focal point in this abstract scene. Abstraction in landscape photography is hard to come by, but fun to look for.

St. Moritz, Switzerland—When is an image abstract? One test might be to see if it works compositionally when viewed upside down or from either side. Try it.

Sarrians, France—What I like about this composition is the assymetrical repitition of tree trunks.

Review the Literature—To see a variety of styles in landscape photography, I recommend you investigate many books that contain landscape photos. A good library or book store usually has an ample selection. See what works and what doesn't in the different styles of photographers.

Ansel Adams and David Muench are two photographers who mainly photograph the American West. Adams' books are in b&w and Muench's are in color. Compare their books to see how each man uses the virtues of his medium to maximize the drama of his work.

International photographers Ray Manley and Dennis Stock produce color photographs of famous and exotic places. Their books may help you plan your photographic strategy when you travel overseas.

While you are doing this fun homework, remember there is a world full of landscapes. They are everywhere and everchanging. Discover local natural beauty as subject, seasons, weather, light and moods constantly shift and recombine to let you make a landscape photo that expresses your photographic style.

Bermuda—This is a fun way to combine a self-portrait and a landscape photo. That's me on the left and Landt on the right.

PHOTOGRAPHING
SPECIAL
EVENTS 6

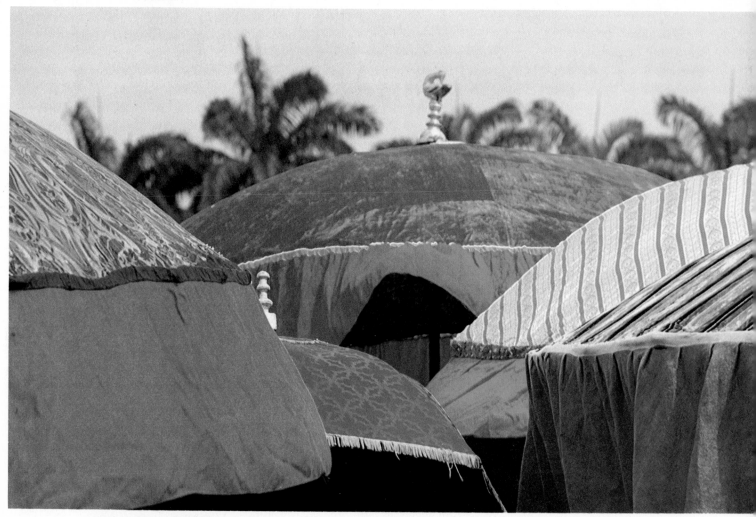

Kumasi, Ghana—Beautiful brocade and
velvet umbrellas are used by chiefs
who come to an Ashanti Durbar,
one of the most exciting
events in the world.

A SPECIAL EVENT IN GHANA

I began my photographic career on the staff of the *Boston Globe* newspaper. While working for the paper, I learned something of the art of covering public events. I had assignments for such happenings as Ted Kennedy's press conferences, student squabbles in Harvard Yard and crowded funerals of well-known people.

Whatever the occasion, I learned how to function photographically in public without stage fright, how to harmonize with other press photographers, how to move into the best possible position for shots, and how not to take offense when yelled at or caught out of bounds by authorities.

You, too, will need photographic finesse when shooting special events such as carnivals, parades or ethnic affairs. Stamina and wit are the primary qualities you'll need to cope with crowds, law-enforcement officials, weather and competition. To show you how I do it, I must

Kumasi, Ghana—This golden sculpture adorns a staff held by an Ashanti attendant.

recollect a fantastic event I once covered. It was an Ashanti *durbar* in Kumasi, Ghana.

This durbar was a state reception given by the gold-worshipping Ashanti. In Kumasi about 50 Ashanti chiefs and their clans came together and met with Prince

Charles of England who was in Ghana on an official state visit.

Before Prince Charles arrived, each chief entered the durbar grounds, shielded from the sun by a huge, brocaded velvet umbrella carried by his attendants. The retinue also carried gold artifacts indicating the wealth of the tribe. The Ashanti goldsmiths have long been considered some of Africa's finest artisans.

During the procession, chanting, drumming and dancing increased everyone's excitement. The combination of sights and sounds was one of the most incredible things I've ever experienced. Before my eyes were hundreds of magnificiently dressed Ashanti sitting around their respective chiefs. In the mounting heat they patiently waited for the arrival of their king, Otumfuo Opoku Ware II. He would be carried in on a palanquin and would sit at the opposite end of the field from Prince Charles.

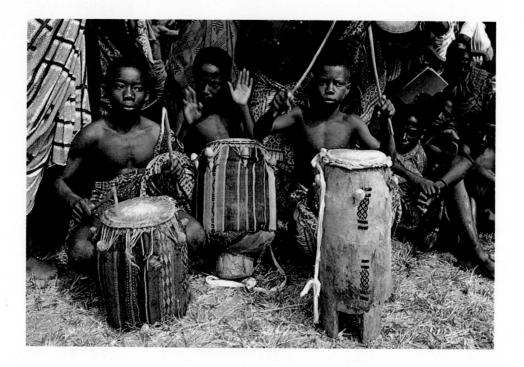

Strategy—To capture all of the excitement on film, I had to do homework before anything happened at the durbar. The first thing I had to find out was exactly what was going to happen when and where. This meant getting there early. For me, the most important moment would be the arrival of the king. For dozens of press photographers from all over the world, the high point would be Prince Charles' arrival. It was his picture their editors wanted on the covers of their magazines and newspapers. Because of this difference, I knew I wouldn't have to worry about competing with U.P.I. or the B.B.C. television crew.

I also asked officials to tell me precisely what the prince would do when he arrived on the field. Would he proceed to the right or the left? Would he greet all the chiefs or just the King? I thought I might as well find this out in case I became interested in the prince. It had been awhile since I'd been a press photographer, so I needed some extra help and priming.

The answers to these questions told me where to position myself to best advantage. Assuming the other press photographers hadn't done their homework, knowing the details in advance gave me a better chance to be in the best position for all the action. You'll be surprised at how easy it is to be a step ahead of many professionals at an event like this. Some photographers become jaded and lazy, and others simply aren't too sharp.

The Event Begins—At the durbar the king appeared at the entrance of the festival grounds, carried by four muscular subjects. I knew he would circle the field one time, acknowledge each chief and then take his seat on a podium to await Prince Charles.

Above
Kumasi, Ghana—When covering a special event like a durbar, record the sound "visually."

Only a few of the press photographers bothered with the king. Those who did shot from far away and seemed almost intimidated by the happening. I was so inspired by the heat, the exotic clothing, drums, chants and the King of the Ashanti smiling down on me that I felt welcomed. I even felt loose enough to join his entourage as its self-appointed, unofficial photographer.

I went around the festival grounds underneath the king's umbrella. I made photos as best I could beneath the attendants' armpits and between pulsating, sweating black bodies. I was overjoyed not to be rejected and made a point of smiling at the king from time to time. In effect I was acknowledging his permission to hang in there.

As King Otumfuo Opoku Ware II approached his podium, I ducked out from under the umbrella to position myself at the steps for a shot of him coming up to his stool. The Ashanti do not use thrones; highly decorated stools do instead. I had previously investigated the podium and made my acquaintance with the Ghanians in charge. When I arrived for the action, I was an established friend and not a photographic pest. The durbar was a madhouse, but my forethought and planning made the job easier.

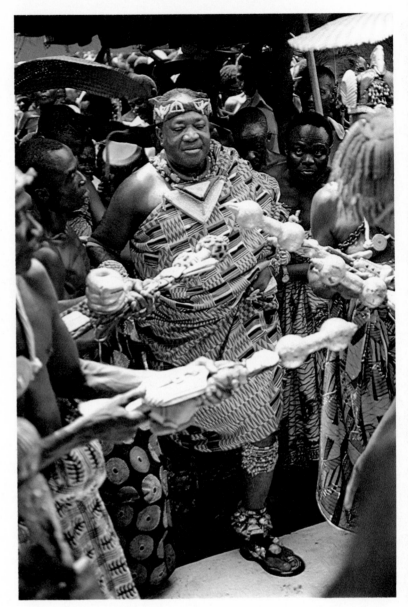

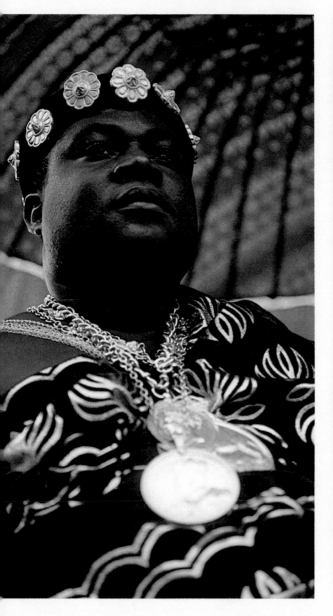

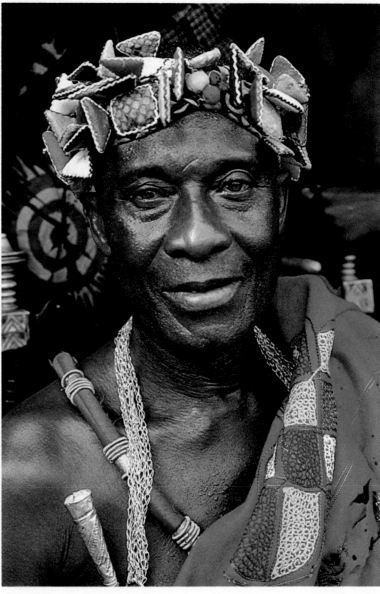

I then decided to wander around the durbar grounds and look for fun shots. First I visited some of the chiefs. Ghana is an English speaking country, and I had no trouble asking permission to take macro shots of fantastic rings on fingers or bands of gold around ankles. I also took several portraits of different chiefs as I made my rounds. There was no resistance of any kind to me and my camera at the durbar. The Ashanti welcomed my attention to their festival.

But I was amazed to see other photographers at work. They'd shoot from 15 feet away from these hospitable Ghanians. They hid behind their cameras as if they were shields. But the camera should never be a shield. In my opinion, it should be the opposite—a handshake.

Left
Kumasi, Ghana—
I was waiting and ready for the King to approach his platform. Anticipation and planning are always necessary when you shoot a special event.

Right
Kumasi, Ghana—
By using a low angle and aiming up, I found some extra background color from the chief's umbrella.

Middle
Kumasi, Ghana—
The Ashanti chiefs were completely at ease with me, and they didn't mind me moving in close.

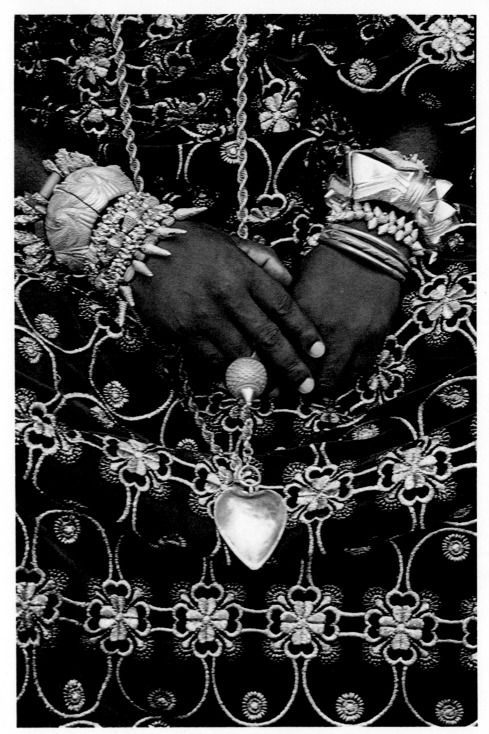

Kumasi, Ghana—The Ashanti
worship gold, and this
is reflected in their
clothing and jewelry.

After the king was seated, I decided to photograph Prince Charles. There was a photographic fray around the prince, and dozens of photographers, television crews, plus his own Secret Service created a barrier. I didn't have a press badge because I hadn't gone to the press photographer's briefing held earlier in the day. Everyone had been told to maintain a distance of twelve feet from Prince Charles at all times. When I finally got within five feet of him and made a wide-angle shot, the authorities came down on me. They informed me of their rules, so I continued my coverage from the allotted twelve feet.

A SPECIAL EVENT IN BROOKLYN

Special events at home are always fun to shoot, and because I live in New York City, one of my favorites is the West Indian Festival in Brooklyn. This carnival is growing in size and popularity among city blacks who hail from the islands. It is a rollicking good time with steel bands, floats, costumes, painted bodies and marvelous food.

The West Indian festival isn't a big time carnival like the one in Trinidad. It's a small family affair. The floats are not especially grand, costumes are more outrageous than spectacular, and nothing is really organized or professional when it comes to staging the parade. It's really a happening, but this is exactly why it's such fun to photograph.

Small ethnic celebrations allow you to deal with the people. I got a helping hand up onto a float to get some overall photographs. Later an old lady gave me her seat when she saw me having a tough time coordinating my three cameras and lunch. I felt completely welcome and able to make all the pictures I wanted.

Brooklyn, New York—Only color film could convey all of the excitement of the West Indian Festival.

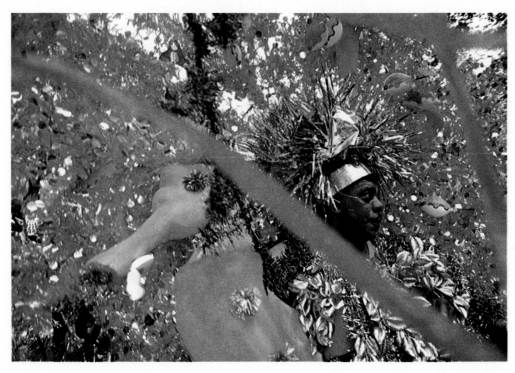

Opposite Page, Bottom
Kumasi, Ghana—By moving in close, I could photograph details of Ashanti craftmanship.

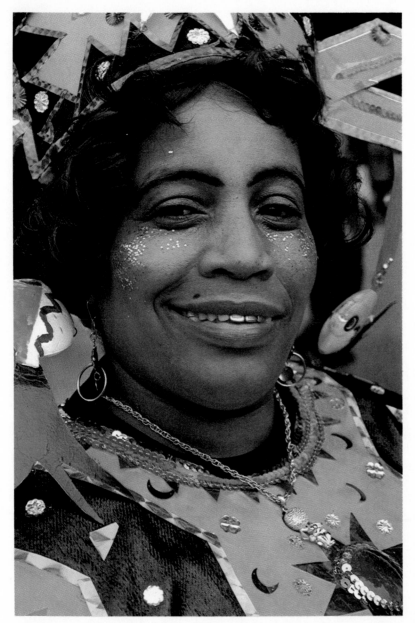

Brooklyn, New York

One of the first shots I made that day was a portrait of a woman with glitter cheeks and gold-capped teeth. I used the 55mm macro lens and moved in quite close to eliminate confusing background. Getting uncluttered pictures is the greatest challenge of photographing special events. So much is going on near messy backgrounds and unwanted buildings that sometimes the only thing to do is move in close to crop out undesirable elements.

Opposite Page
Brooklyn, New York—Experiment! Aim up or down as the spirit moves you.

Another way to move in close is to jump right into the event. Don't hesitate. It's the most fun place to be as you go along with the music and motion of the parade. You'll find yourself taking many pictures off balance or actually in motion as you walk backwards, so use shutter speeds of 1/250 or faster to stop the action.

Have fun aiming your camera up, down, all around. Be part of the action and see what you get. Interpret your excitement visually. When I was milling around the middle of the parade, I found myself photographing fellows featuring body art. Their skin graffitti was reminiscent of an African tribe, and the contrast of colors and skin was striking. I consciously included the nipple in this picture to prove that there is a human being beneath those colors.

Brooklyn, New York—Isolate detail by moving in close!

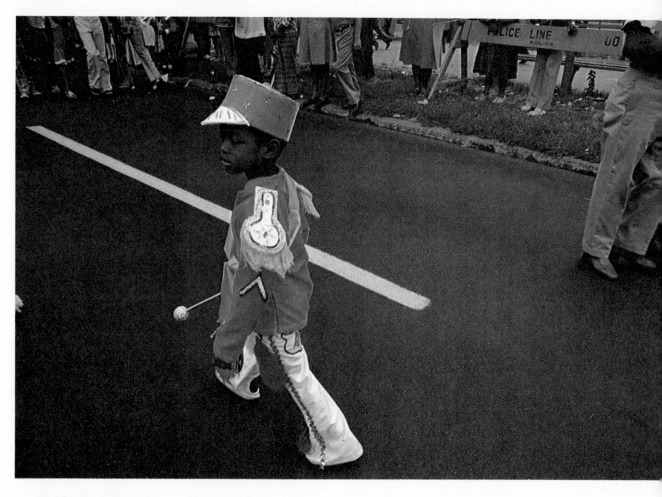

Brooklyn, New York—This marcher glows with color amidst the drab city background.

Equipment—Special events are usually crowded with people and photographers. Because I'm not shy, I move into the middle of the action to make photographs that reflect the excitement of the event. I must change the way I carry and use my equipment under these circumstances.

Wiggling through crowds is difficult enough without having the extra bulk of a camera bag. If I carried it, it would thump into other people and throw them and me off balance. I leave the bag with my husband, at my hotel room or any other safe place.

Without the bag I must carry my three camera bodies equipped with my three favorite lenses: the 28-45mm zoom, the 55mm macro and the 80-200mm zoom. With this range of focal lengths I can record most of the action, wherever it happens.

Some photographers prefer to carry film in canisters taped to their camera straps. This is much too awkward for me. For a special event I may expose 10 or 12 rolls of film. And if they were attached to my three camera straps, they would become tangled as I switched from one camera to another. So I usually wear a vest or pants with large pockets; unexposed film can go in one pocket and exposed film in another.

I attach my hand-held meter to a retractable key chain that clips onto my belt. The meter is very handy and doesn't get in the way of my cameras. For most situations, the lighter the load, the quicker the draw.

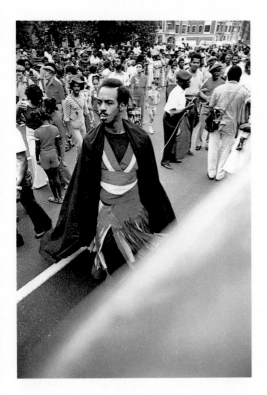

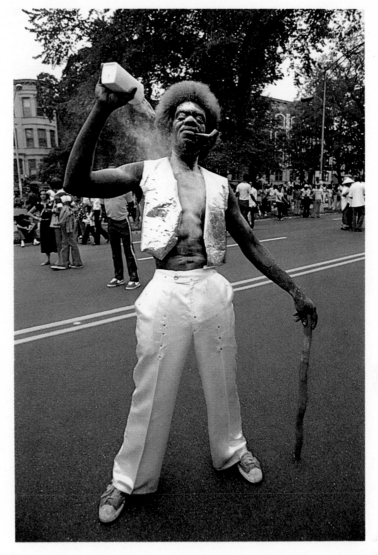

Points to Remember—There's a rule press photographers who cover special events follow. Get overall, medium and close-up shots. This lets you tell the complete story visually. And if you can get close in any situation, go ahead. This is one of my major tenets. Don't miss any opportunities when photographing.

The overall photo should show the event and where it's happening. Usually it's made with a wide-angle lens, but it doesn't have to be.

Medium shots are of the middle ground. These photographs record the substance of an event and tell the story of what's happening as a witness of the event would see it.

If you don't need or want to tell the full tale, no one says you must. You may prefer shooting only portraits. A special event is usually a good place to do that.

I realize you're never going to encounter precisely the same snags I do. Nevertheless, the following anecdotes illustrate typical problems and solutions. The tales will either fatigue or inspire you. I certainly hope it'll be the latter because you may need some of these tactics for upcoming dilemmas.

St. Vincent, British West Indies—In the Caribbean, clothes are often put in the sun to disinfect them. But I was unaware of this and merely photographed them because I liked the shapes and colors. A young man who observed me was indignant because he thought I was deliberately shooting them to illustrate squalor on the island. This misunderstanding led to a tense confrontation. By carefully explaining and convincing him of my intent, I avoided what could have been a volatile situation. Remember that in some cultures your actions may be misunderstood, and sensitivity on your part is required to cope with these instances.

PROBLEM SOLVING 7

Charleston, South Carolina

UNWANTED AUTOS

In Charleston, South Carolina I wanted to get some shots of the charming back streets and the town's old-world atmosphere, but the street-level camera angles included up-to-date, unwanted products of Detroit. Parking is bumper to bumper in Charleston. To appreciate the architecture and antiquity of the place, you must overlook the autos, and I had to do it photographically.

I took a very low, 24mm wide-angle view of a typical brass bell-pull on a brick wall. Beyond was a silhouetted tree and a Colonial Charleston house. Aiming up from the low angle enabled me to eliminate the street lined with cars and make an unencumbered picture.

With clever utilization of angles and lenses, you can edit unwanted elements in almost any photographic situation. Some purists argue such tactics amount to fictional photography. I don't agree. The angle I used is available to everyone. It exists as much as any other angle, but it is rarely used. The challenge is to make the commonplace seem uncommon.

CANTANKEROUS ADULTS

We are still in Charleston, and the little girl behind the daffodils is Barbara. I spotted her peddling the flowers along with adult members of the local black community. They sell flowers to drivers stopped at red lights on the main street and are an institution in Charleston. Naturally, I wanted to photograph them. The problem is: They're almost impossible to photograph. They show their worst faces whenever a camera is nearby.

But Barbara was conducting her business about a block away from the older folk, and she seemed sweet and not yet photo-phobic.

I knew I'd never get a shot of her anywhere within view of her elders, and the intersection where she was working was typical downtown ugly. It wasn't a photographic setting for a charming flower child. There was only one thing to do. I had to abduct her!

With this tactic in mind I approached the girl. She was happy to have her portrait made when I asked her permission. I explained that the intersection wasn't pretty and asked if she'd come around the corner to a prettier street. Barbara was trusting and followed. We walked about three blocks and chatted about the flower business the whole way. I finally found a plain, brown wall and used it as a good backdrop for this portrait of a flower child. Then I brought her back to her intersection.

You may think abduction such as this is a very debatable practice. But Barbara came with me under her own will, and I certainly wouldn't have pressed her to follow if she hadn't wanted to. She could have reported me to her elders, but I had no malicious intent. And Barbara and I had a delightful time during her portrait session.

Charleston, South Carolina

St. Lucia, British West Indies

LANGUAGE BARRIER

Once on the enchanted Caribbean island of St. Lucia, I favored a view of the Pitons' twin peaks that included a colorful fishing boat beached in the sand. The Pitons are the principal topographical attraction of this island, so I wanted to record at least one of them.

The boat wasn't a good enough foreground element for the scene, so I started looking around for more interesting elements to include. I saw a group of fishermen sharing the daily news, and among them was a handsome fellow wearing a straw hat. Immediately I knew he belonged in the boat in a relaxed pose.

I overcame my fear of rejection and sauntered over to the men. English is the language of St. Lucia; therefore, I had no problem saying hello, asking whose boat was on the shore and getting permission to photograph it. I knew I didn't need permission, but making a polite request was a good way to ingratiate myself with the men. I then asked them about the day's catch.

After this warm-up conversation, I turned to the handsome man and asked if he would be in a picture. He replied in French! The others explained that he was visiting from nearby Martinique, but fortunately he'd understood my point and was willing. My problem was explaining how I wanted him to pose.

Body language was the only remedy. I put my camera bag down and climed into the bow of the boat. As I dropped my leg over the side, the fishermen broke into laughter at my charade and the thought of their friend posed in such a manner. I laughed also to go along with the spirit of the day.

My subject didn't think it was so amusing! I had appealed to his ego, and he took the whole thing very seriously. He climbed into the boat and posed perfectly. And when this shot appeared on the cover of a major travel magazine, he received much fan mail. Apparently my taste in men is shared by others.

Langeland, Denmark

CREATIVE PARALYSIS

During a magazine assignment to photograph biking tours in Denmark, I was horrified to discover the only cyclists on the itinerary were my husband and I. How could I photograph the story? I couldn't do so effectively with just pictures of us. It wasn't what the editor wanted. He expected photos of fellow bikers wheeling through the idyllic Danish countryside which would tell the story in a conventional way. I didn't have the expected elements to work with, and I felt creative paralysis settling in.

During a sleepless night the revelation came. I could incorporate a section of my bike in a series of wide-angle photographs that would also show scenery and architecture along the way. These would be photo illustrations instead of standard reportorial shots, but they would tell the story in a more dramatic way. The next day I got the shot of Tranaeker Castle on the island of Langeland.

The moral of the story is never say die when the odds seem stacked against good photography. Use your imagination, overcome creative paralysis, and you may discover new and exciting ways to photographically illustrate.

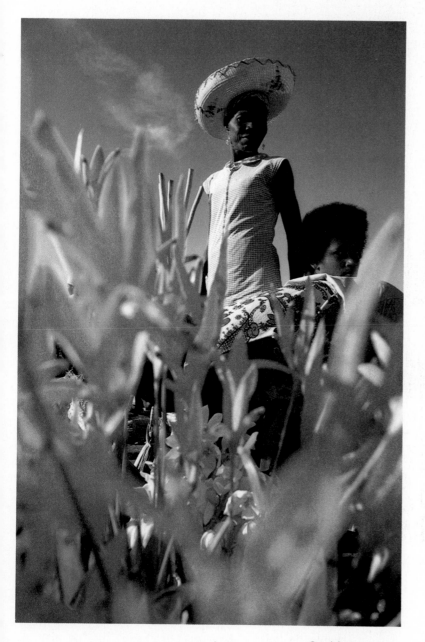

**Guadeloupe,
French West Indies**

CAMERA-SHY SUBJECT

On Guadeloupe I wanted some market place photos, but the people were too shy to be subjects for my camera. In a few cases they were hostile. I don't like doing it, but the only solution that day seemed to be photographic subterfuge. And I resorted to wide-angle sneak shots.

My method of deception was very simple. With a 24mm wide-angle lens I knelt down to make what appeared to be a close-up shot of some Bird of Paradise flowers. The coy vendor was unwilling to be photographed, but she didn't mind my shooting her flowers. But what she didn't know was that my wide angle included her.

This tactic is very useful in busy market situations, and I've utilized the approach in many countries. You can hide behind things with a preset focus and exposure, and simply wait for interesting people to walk into your viewfinder. In a bustling, noisy market no one is the wiser.

Don't hesitate to use a foxy tactic to get people pictures if you know you will do no harm or be rude. It could be argued it's better to record people unaware than create ire by a more conspicuous approach. Nevertheless, I always prefer to work with subjects directly after having received their permission.

**Isles des Saintes,
French West Indies**

LACK OF LIFE

On the little known Isle des Saintes in the French West Indies is a French rooster who reluctantly posed for me. I pressed the fowl into service because of a scene I wished to record that needed life in it. Many a photo is greatly enhanced by a heartbeat somewhere therein, and you'll be surprised how any form of life can provide the necessary element.

When I saw a boat loaded with fishing nets, oars and wicker baskets and the little island beyond, I thought it all very quaint. But I knew it wasn't enough to make any exposures of. I looked around for someone to include in the picture—man, woman or child. But there were none—only chickens.

At that point an elderly woman appeared at the entrance of a near-by shack, and I rightly assumed the birds belonged to her. I asked if I could run one down for my photograph. She granted permission while giggling at the thought of a chicken chase.

Soon I realized the difficulty of chasing down a bird. My choice was a big, sturdy rooster who was clearly a good sprinter. If I got my hands on him, he'd surely go into a flap, so I walked to the main square and asked some small boys if one of them would do the honors. A 10-year-old volunteer pursued the rooster all over the beach. Finally the bird was caught and calm in the boy's arms.

I got into the boat and crouched down. I readied exposure and framing for the shot because I assumed I'd get only one shot of the bird before it flew off. Then I gestured to the boy to put the rooster on the nets. He did and quickly dropped out of sight behind the bow like I told him to. I made one exposure. The bird looked around quizzically, and I made another exposure. I then bracketed exposures, and the bird was still happily posing when I reached the end of the roll. Finally he took off.

I've chased animals all over the world to include them in photos. I realize not all photographs require life, but as a general rule I ask myself if a photo without life could be enhanced by some breathing element. For me the answer is usually, "Yes!"

CITY CONGESTION

Hong Kong hustles and bustles like any other busy downtown. I have a tendency to not shoot when in any country's cement jungle because I don't see very many pictures to my liking in urban chaos. But one day in Hong Kong I couldn't help noticing some children seated outside a drugstore. Each one was reading a comic book from an adjacent sidewalk newstand.

I loved this unusual sight but I wondered how I could capture it without the kids seeing me and staring into the camera. The sidewalks were rush-hour busy, and everything seemed to conspire against recording the scene. Nevertheless, I decided not to let the hectic surroundings upset me.

I moved to the curb and took a deep breath. Next I determined the 55mm lens framed the kids perfectly. They hadn't spotted me yet. I knelt down and brought the camera to eye level, but all I saw were legs rushing past the viewfinder. My tactic was to make a few shots when there was a break in the pedestrian traffic. I knelt for some time, camera to eye, without any clear shooting. My knees began to ache, but I still held out.

Suddenly I had a clear view, and I made several exposures with the kids unaware. They then spotted me, but it didn't matter because I had my picture. I waved to them. Then I saw that I had stopped all pedestrian traffic in both directions. Everyone was being so polite to let me get the shot that I had caused a people jam.

This story shows that if a photographer stays at it, works quietly, cleverly and is patient, there's no telling how things will work out for good photographs.

Hong Kong

ARCHITECTURAL CHALLENGE

Things happen for me photographically in ways I could never stage on my own. One morning at St. Peter's Square in Rome, serendipity came to the rescue in my attempt to get an unusual shot of the basilica. I wanted to add to my ongoing series of landmark photographs that avoid clichés as much as possible.

In Rome that day, tourists were in the way. St. Peter's Square was crawling with tour groups of every nationality. There were also unsightly bleachers left from a canonization ceremony.

I retreated in frustration to the far end of the piazza where I discovered a classy red wheel. The dull hues of the architecture and the gray cobble stones didn't make for a very exciting picture, so I positioned myself to superimpose the red wheel over the bleachers and tourists. I then exposed a few frames.

Having succeeded in getting color into this landmark shot, I was about to leave the scene, but I decided to finish the last two frames of the roll. Then a Bible-toting priest strolled into the viewfinder to add much needed middle-ground interest to the image.

Serendipity adds magic to the photographic experience. Sometimes it introduces much-needed elements to an otherwise typical shot of popular photo subjects. Always be ready.

Opposite Page
Vatican City

Accra, Ghana

UNPHOTOGENIC FACE

Have you ever liked what someone was wearing, wanted a picture of it, but didn't much like the subject's face? This is a problem; however, I've found there are ways to work around it. But you must exercise sensitivity and diplomacy.

In Ghana I fancied a mattress salesman's woven cap. It was an especially pretty design, but the fellow wearing it wasn't the most handsome man Ghana had to offer. The solution was very easy. I simply asked him to turn around so I could photograph him from the back. This angle also showed more of the hat than a frontal view.

But *before* I asked the man to turn around and stare at his mattresses, I took several portrait shots. By doing so I acknowledged his individuality and his humanity. He posed proudly. *Then* I asked him to face the mattresses, which he did willingly. My tactics didn't hurt his feelings in any way, and I achieved the design photograph I was after from the start.

Opposite Page
Istanbul, Turkey—The bare-bulb flash lights
a scene evenly without casting harsh shadows.

Istanbul, Turkey

PHOTOGRAPHIC DEAFNESS

In confusing, tense photographic situations, it's easy for me to be deaf to the constant, creative guidance going on in my head. I become so absorbed in the exterior circumstances that I fail to listen to the inner voice that drops constant hints as to how to make a better photograph.

I was in the Istanbul market and was admiring a huge Turkish flag hanging on a wall. Then a fabulous old man in an army uniform passed by. I went right after him, tapped him on the shoulder, exhibited my cameras, and pointed to the flag.

The vendor's table of Turkish flags would have to be moved so the old officer could pose against the big one on the wall. The vendor was enthusiastic about the shot, and he moved the table away from the wall.

Soon a huge crowd gathered to watch me work. Concerned that the old man wouldn't put up with my fuss and walk away, I quickly, but gently, positioned him between the table and the flag. This left the table as a barrier between me and my subject. I couldn't move in close, so I used the 28-45mm zoom to frame the portrait. I began to shoot. The flash was flashing, the crowd was laughing and the old man was bewildered by the activity.

All the while, a little voice in my head was saying, "You're not close enough. You have a zoom; zoom in more. Drop in tighter on the Turkish logo. The soldier is more important. Zoom in."

Eventually I began to hear these esthetic pointers and obeyed. I later learned that the man was an 85-year-old war hero who fought with Atatürk, the country's liberator from Greece. It was a portrait well worth listening for.

118

COPING WITH MURKY INTERIOR LIGHT

Dim light doesn't have to inhibit your photography. Use artificial light for murky interiors. There are many small flash units available that are fine for this purpose. Some are not much bigger than a pack of cigarettes, and you will rarely require anything more powerful or complicated.

Not only can a small unit be the primary source of light, but it also can be used as fill-in light for portraits in back-lit situations or to balance window light in a room. Because these units are small, you must learn their effective operating range for the film you are using. Pros often travel with three or four large strobe heads with all the attachments, such as umbrellas, barn doors, stands and cables. I do too sometimes, but I must use the bare-minimum equipment for certain situations. Such was the case when I was on assignment in Istanbul.

The covered bazaar in Istanbul is one of the oldest commercial crossroads in the world. With 4,400 shops compressed into an area of about four city blocks, it is a must for the world traveler. It still retains some of the sound, smell and excitement of its ancient history.

The light in the bazaar creates a murky interior. I went prepared with several rolls of both daylight and tungsten-balanced film for available-light shots. I also brought along a flash unit with a bare-bulb attachment which fits into the head. I think this kind of flash is ideal for such situations because it gives soft omnidirectional lighting similar to scenes shot outdoors on a cloudy day.

During the first day I was in the bazaar, I saw an incredible man in a world of his own. I stopped him for a portrait in front of a shop window dripping with gold jewelry. But I could not shoot it with available light because the window created a strong backlit scene and made the man's face go very dark. I needed enough artificial light to balance the reflecting gold. The bare-bulb mode of my flash provided sufficient light to do the job.

I held the flash high over the subject with my left hand and operated the camera with my right. I bracketed several exposures of the man because I knew from experience the shot needed an aperture setting somewhere between *f*-8 and *f*-4.

With a bare-bulb flash, like the Ascor model shown here, you can make flash-lit pictures without harsh shadows. Photo courtesy of Berkey Marketing Corporation.

Top
Istanbul, Turkey—I couldn't light the area behind the coat and flag because of the fall-off of light. A flash supplies only enough light to illuminate a subject a certain distance away. And areas beyond go dark.

Bottom
Istanbul, Turkey—Shop owners offer customers a cup of tea as they consider their purchase. Mine became cold as I made this photo.

Another advantage of the bare-bulb mode of my flash unit is that I can get close to my subject and not worry about overexposure from the light source. The flash is spread in all directions and light falling directly on the subject is only part of the total flash power. I was only inches away from the tea cup placed on a kilim rug and had to hold the flash unit an arm's length away to prevent overexposing the shot.

Sometimes in the bazaar I used the regular flash head for anything farther away than about four feet. I know from experience that for anything between four to ten feet the proper aperture setting will be some-

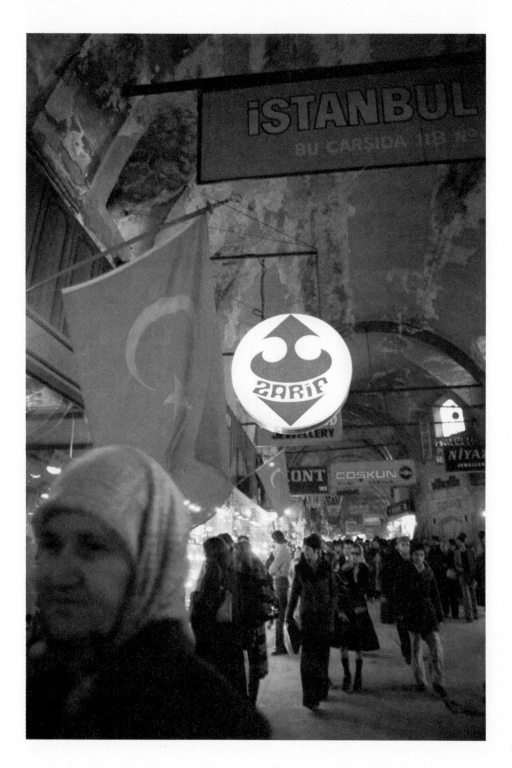

Istanbul, Turkey—The warm
light of the Istanbul bazaar makes
a realistic photo. I used daylight-
balanced color film for
this effect.

where between *f*-8 and *f*-22. Beyond ten feet it's somewhere from *f*-5.6 on down. You must know and work within the limitations of whatever flash unit you have. Experience teaches you what those parameters are. With any single unit you must remember that you can't light any big spaces with it.

At other times I didn't want to use artificial light because I wanted to retain the atmosphere of the bazaar. This happened when I wanted to photograph the street life in the area of the bazaar. I used daylight-balanced film, so the street light would be reproduced in warm colors. If I had used tungsten-balanced film, the sign would have become yellowish, the street lights whiter and the ambient light from windows would have been bluish. I think it would have been less realistic. For this available-light scene I used a long shutter speed and hand held the camera as I leaned against a post for stability.

FOUL-WEATHER PHOTOGRAPHY

Travel photographers cannot control nature's every whim; nor should they want to. Even if the heavens are snowing, hailing or pouring, there are still many photographic opportunities. On the occasional foul day, be practical and philosophical about the elements. There are a few guidelines to help you get the most out of your vacation photos.

Rain—Suppose you have a rain cloud for a canopy over your holiday. What to do? Forget the sun ever existed. See beauty in subtle, earthy hues of grays and browns. Primary colors, which are often too loud under sunny skies, are pleasantly softened. Low key, subtle images are to be made during rainy days.

An example of what I mean is brought out in a photograph I took one rainy day in Japan. Foul weather has been faithfully recorded by Japanese artists for centuries. The typical ones are of people carrying umbrellas over little bridges in sublime gardens. I found myself in such a garden and looked for a way to avoid the proverbial umbrella shot. I did it by using a sign as the visual focal point because the white letters and dark wood give a needed contrast to the gray. In foul weather photography there *must* be a visual focal point strong enough to catch the eye. The other factor that makes the shot work is the color of the flowers in back of the sign. It provides just enough color in a gray-day photo.

Conversely, there are many strong monochromatic images to be made on rainy days. Once in the Portuguese island of Madeira, I noticed lovely rust-colored ferns on the side of a macadam road. I picked a gracefully shaped one and placed it on the wet, shiny blacktop. I love the sophistication of the simple design and low-key hues. Frequently, flora takes on a fresh appearance

Tokyo, Japan—The white characters add contrast to this rainy-day photo.

lens and focusing screen. Submerge all parts in a container filled with fresh, tepid water, and swish them around in the clear water for 15 minutes.

Empty the container, refill it, and soak the gear for 15 more minutes. What you are doing is removing the corrosive salt from the camera by diluting it.

Next, get the equipment to the nearest or most cooperative automobile service station. There you'll find compressed air with which you blast the bath water from the camera parts. Your small can of compressed air hasn't enough pressure to do the job. It is best used to remove sand and heavy dust. *Be very careful* not to blow into the focal-plane shutter with any pressurized air because you could ruin it. Removing as much moisture as possible reduces the threat of rust. This is a critical step and must be done with extreme caution.

Find an oven you can monopolize for awhile and set it to 120°F (49°C). Place the camera parts in the oven and let them heat for about an hour. This evaporates moisture not blown out by the pressurized air. After the oven treatment, package the parts and get them to a camera-repair center. Inform them of the situation. They'll probably totally clean, lubricate and adjust all parts. It may be expensive, but definitely cheaper than replacing the camera.

If you can't perform all of these steps, do the fresh-water rinse. Put the camera in a plastic bag full of water and place the bag in an empty coffee can. Leave the camera submerged until you can get it to a repairman. Water is not the major enemy of the camera; the *combination* of air and water is.

when wet, so don't ignore it in foul weather.

Rain Equipment—You can have a lot of fun taking shots that are all wet. Dripping verdure, reflections of neon signs on slick city streets, and brightly colored umbrellas always make pretty rainy-day pictures. Unless it's a downpour, a few rain drops are harmless to camera bodies. Wipe them dry immediately when you go inside after a stroll on a wet day.

If you want to keep yourself and your camera as dry as possible while working in a downpour or drizzle, use a simple plastic bag and your own raingear. Cut a small hole in the bag for the lens to poke through. Fasten the bag to the lens barrel with a rubber band, and work the camera from inside the bag so it acts like an umbrella over your hand. Another approach is to have a friend hold an umbrella over you while you shoot.

If you are a dedicated wet-weather photographer, an underwater camera or one of the camera enclosures used for underwater photography could be a good investment.

Protect the Front of Your Lens—I used a UV filter for photos in this chapter. This piece of glass cuts down on ultraviolet rays, reducing bluishness in color photography, and keeps rain and snow off the front element of your lens. This filter should be a permanent fixture on your lenses to protect them from debris of all kinds, but they are especially important in rain or snow because you may be wiping the filter constantly with a soft cloth or lens-cleaning tissue. A single raindrop on the front surface at exposure time will create a vague splotch on the resulting photo.

And after years of such wiping, it's cheaper to replace a filter than replace the lens.

Maderia, Portugal—With many still lifes the simpler the better.

Shoot from Under Cover—In Germany I was depressed after two days of rain and was staring disconsolately out the window into the hotel garden, seeing nothing in particular. Then the winding path caught my attention and directed it to the urn surrounded by red tulips and the yellow forsythia bush. It became charming to my eyes, and I went to get a 400mm telephoto. I opened a hotel window, attached the camera to a tripod and made the photograph you see here.

You don't have to get wet to take good foul-weather pictures. Shoot from open windows, under awnings or any other outdoor covering. Or keep a small flash unit in your camera bag on bad days and concentrate on inside shots of museums, churches or historic houses.

One day in Wales I was caught in the rain and ducked into a church during Sunday services. In the vestibule, three parishioners had parked their umbrellas on a ledge. Leaving the door open to let in the available light, I made a photograph clearly saying, "Great Britain."

Heidelberg, Germany—A bit of red and yellow makes a drab-day photo a bit livelier.

Opposite Page
Brecon, Wales

Snow and Cold—Snow falls too, and like rain it doesn't have to inhibit your photography. But unlike rain, snow takes shape. I often enjoy the way snow creates form, shadow and texture.

In Park City, Utah I saw a red picket fence festooned with fresh snow. It was perched on a corner-post like a marshmallow and sat securely on the horizontal beam. The snow had personality as it posed on that picket fence, and it shaped up nicely for a shot.

Cold, dry snowflakes bounce right off cameras without harm. If it's a soggy snowfall, keep your camera body inside your parka as much as possible as you would if rain was falling. The best thing for carrying an extra lens or two on a cross-country ski, snowshoe or hiking trip is a fanny pack. It is a pack that straps around your waist. The pouch could also ride under your belly, kangaroo style, for easy access. If you venture out with many photo gadgets, a fisherman's vest under your parka will accommodate many things probably better left home.

Eliminate the need for lots of lenses by using two zooms.

Condensation—The greatest cold weather problem is condensation, which forms on lens elements and camera eyepieces when gear is taken into a warm area. To prevent it, put the camera equipment in a sealed plastic bag while you are still out in the cold. Bring it into the warm area and let it acclimate to the different temperature. You shouldn't use the camera until it is at room temperature and the threat of condensation is past.

Cold-Cold Weather—Cameras begin malfunctioning in cold weather at temperatures well below your own comfort thresholds. Don't worry about it unless you are planning an Arctic expedition. If you are, consult your camera repairman for advice on winterizing your gear.

Motor drives are not very cooperative when in normal cold unless they are operated by a separate battery pack tucked inside your parka. NiCad batteries will work only in certain temperature ranges, and if it is too cold, they deliver too little power.

Lillehammer, Norway—When I cross-country ski, I use a fanny pack to hold my equipment. The pack is out of the way when I am not using it, but it is also readily accessible when I do need it.

Opposite Page
Park City, Utah—You usually have to give more exposure than the indicated meter reading when you photograph snow.

Kumasi, Ghana—As a professional photographer, I try to get as much use out of my favorite photos as possible. This one is used in my portfolio shown to prospective clients, in a slide show about Ghana, and as a picture decorating my apartment.

USING YOUR TRAVEL PHOTOGRAPHS 8

Most people make travel photographs as a record of their experience. They have small prints made, show friends and file them away in albums. This is fine, but there are many more ways to use your photos.

My two favorite ways involve displaying them. By hanging graphic photos or telling a story with your images, you can expand the use and potential of your photographic efforts. The way you approach these presentations is strictly personal and essentially depends on the images you have. My preferences work for me and my style of shooting.

HANGING PHOTO GRAPHICS

Many serious, contemporary-art photographers question whether photographic images are capable of sustained, prolonged viewing. Work in the medium has traditionally been for temporary use. You look at a photo in a book or magazine and then turn the page. This is the treatment given to photos because we are inundated with so many photographic reproductions each day. Newspapers, magazines, books and advertising bombard us with images to be absorbed immediately.

Decorators are now beginning to use photography for both private and commercial clients. It's their opinion, as well as mine, that well-composed, graphic-design photos are entertaining to live with. Graphic photos are more than just a record of a sunset or a face. They express *qualities* about the subject such as color, tones, texture, shape, dimension, mystery and balance. The qualities of the subject that first capture your interest should be in the photo you make. This is very subjective, but also very rewarding. The test of time usually tells you if you have succeeded.

A well-executed graphic photo is like a time-release capsule. Gradually, its mystery and impact grow on you. You will see new and engaging features of the work as you view it again and again. True art tends to withstand repeated viewing.

Graphics from Bermuda—A favorite place of mine to photograph is Bermuda. Topographically, Bermuda is relatively unscenic. But my favorite places are its white, sandy beaches and its architecture. The architecture is great because of the simple and intimate atmosphere created by the design, colors and sun. Pastel pinks, pale blues, saffron yellows, clean whites and a rich blue sky never fail to give me graphic subjects just right to decorate a wall.

St. George, Bermuda—This is the chimney and roof that first attracted my attention. The bold colors and shapes enticed me to photographically dissect it for graphic images.

Once while on assignment in Bermuda, I took time out from my work to shoot interesting colored sections of buildings. I found a fabulous private house in St. George, a restored 18th century town. The chimney and roof were accented with stark white trim. Combined with a pale brown paint job and the blue sky, it immediately caught my attention.

With the 80-200mm zoom I made an overall shot of the chimney as an illustration of the subject in its entirety. I then broke down the sub-

ject by using different focal lengths of the zoom to frame precisely. Eventually I made six different compositions; three are reproduced here.

I had a 25" x 40" print made of the white diagonal roof line for a wall of our apartment. I think the bigger the print the better. The print has been hanging for several years, and its appeal has yet to wane.

St. George, Bermuda—I like this photo best because of color contrasts and the balance of shapes.

CREATING A SLIDE SHOW

A slide show is a very flexible and everchanging visual treat. A number of images displayed in sequence for different lengths of time, with different colors, subjects and viewpoints combine to make your travel photos an interesting record of your experience. The power of a slide show is how you create it. You make the photographs, arrange the order or presentation and perform the narration or description during the show.

Considerations for Shooting—You should know from the outset whether you intend to show all aspects of a destination in your slide show, or whether you are using a theme. If you choose general coverage, include a variety of things: portraits, architecture, details, landscapes, festivals and sports activities. An action sequence is always effective too.

Constantly weigh what you've already photographed against the total requirements for an esthetically diverse slide show. I enjoy making lists at dinner each evening to itemize what I've already shot and the kinds of photos I still need.

To achieve diversity, use all the focal lengths you have. Break some of the rules you've read about. For example, don't assume close-up shots are always made with macro or telephoto lenses. Move in on things to the point of closest focus with ultrawide-angle lenses. Play your lens range for all it's worth. Be as technically creative as possible. Use filters, double exposures and silhouette shots. You'll be glad you did when you finally put your slide show together.

Diversity of technical and visual approach is most important if you are working on a slide show with a specific theme. It's fun to concentrate on people, possibly children, architecture, gardens or whatever interests you. Obviously, with a single subject you really need imaginative approaches.

If you are shooting people for a thematic show, photograph them with every lens in your bag. Make more than portraits. Photograph them at work and being human too. If it's architecture you're after, look for details such as door knobs, window sills and abstract patterns of light on walls. Avoid showing one whole building after another to your audience. They'll soon be snoozing if you do.

Title Slides—A title slide usually indicates the theme or location of the slide show. I suggest you start thinking about what would work as a title slide at the outset of your shooting. A fun, informal, if not new approach, is to photograph the title spelled out in sand, with pebbles or other workable material. Local signs can also provide titles, but record them close and fill the whole frame.

Nantucket, Massachusetts—Mime Charles Senack posed for a title slide I made for a slide show about the island.

The best place for a title in this slide is in the white area.

Photograph the letters with slide film. The correct exposure is the one that gives a clear background and dark letters.

Sandwich the two slides and enclose them in a glass slide mount.

Use some imagination to come up with a title slide which demands audience attention. Try photographing someone wearing a destination-plugging T-shirt. Again, move in close, perhaps even eliminate head, arms and limbs by framing tightly on the T-shirt and chest. An ultra-wide-angle lens on this subject would add dramatic distortion and possibly include some of the surroundings. Try placing a T-shirt in an interesting location and recording it as the strong, dominant foreground of a wide-angle scenic shot. I can easily envision a beach scene with sandals, towel and the destination T-shirt dominating the title slide for a Caribbean island slide show.

Your thoughts as to what makes an effective and innovative title slide will jell as you marinate in the location. Don't think it has to be the first image you make. It could easily be the last, but you should be thinking about it all along so you're not blind to good possibilities when they happen.

Perhaps you'd prefer to wait until you get back home to make a more formal title slide. Camera stores offer a selection of prefabricated ones which may suit your taste.

Using letters superimposed on a slide from your travels is a fun project. Buy some black rub-on letters at an art-supply store and use them to spell your title on white paper. Photograph the letters with a high-contrast b&w film such as Kodak High Contrast Copy film. The processed negative contains clear lettering on a field of dense black.

The next step is to make an in-camera double exposure with the title negative and the selected slide from your trip. Make the first exposure with the slide as the subject—it will be the "host" for the words in your title. You'll need a macro lens or some other close-up equipment to make the copy of the host slide the same size as the original. Use the indicated exposure setting given by your camera meter for the first exposure.

The second exposure on the

For a superimposed title slide, choose a slide with a dark area.

Make a high-contrast negative of the title.

Then make an in-camera double exposure of the slide and the title negative.

same frame is made with the title negative. Try to place the letters in a dark area of the host slide. This will give good contrast between the clear letters and the dark parts of the pictures.

Make the second exposure with a half step *more* exposure than the first slide. This works if the host slide has normal density and contrast and if both are being reproduced the same size. If you make an exposure reading with the title slide in place, its dark background could fool your exposure meter. Bracket for best results.

To get black letters in a clear part of the host slide, photograph the rub-on letters with slide film. Then sandwich the title slide with the host slide, which has been removed from its mount, and place the letters in a light area, such as the sky of the host slide. Remount the two together in a glass slide mount available in camera stores. The glass mount holds them flat.

The Final Photo—All the while you're shooting the main body of your slide show, you should be looking for the grand finale picture. It doesn't have to be a sunset. It could be a stop sign or somebody waving goodbye. The total slide show—the beginning, middle, and end—should be in mind as you go about making pictures.

It's like a juggler keeping several balls in the air at once. You have to juggle right from the start. Don't wait until the last day of your trip to make a finale shot. If the elements come together properly, it could be one of the first pictures you take. Or it could even be a shot you make an hour after you get off the plane while on the way to your hotel!

Playa Blanca, Mexico—A sunset shot always works as a final photo. This one was for a slide show illustrating a typical day at a Club Med resort.

Editing—Once you are at home with all of your slides, you must edit and arrange them for the show. You will need a light box big enough to accommodate all the slides under consideration for your show. Suppose you plan to have 140 slides, which is the maximum for a Kodak Carousel tray. You'll need a light box with a working surface of at least 20" by 28". But 20" x 56" or the equivalent area is best so there's ample space to push the slides around. This way you can see the slides and easily weed out inferior, unimportant or redundant images.

Rough edit the slides to immediately cull those disqualified for technical or esthetic reasons, and eliminate slides which are grossly over- or underexposed. Try to use slides of similar color balance and saturation. But if you want to use a slide that is underexposed, try duplicating it with regular color slide film. This copy will have more contrast than the original and possibly salvage the image. Sometimes, sandwiching an overexposed slide with a colored gel will also save the slide.

Because I bracket all exposures, I have a minimum of three slides for each subject. I usually throw away the overexposed slide and use the other two. The properly exposed slide, or the one which looks best in the light box, is perfect for reproduction in magazines or advertisements because contrast and color saturation are slightly increased during reproduction. Because much of my work is reproduced, I save and file these slides. The slides which seem slightly dark, or a bit underexposed, are still usable. The diffuse, fluorescent illumination of the light box is not as strong as the light of a slide projector, so when the slide is projected, strong, saturated colors result. I show a slide portfolio to prospective clients, so I must save and use these.

The fun part is just beginning. Once you have chosen the contenders for the show, narrow them to the exact number needed. Then you face the challenging task of putting them in order.

Keep in mind that you need a beginning, middle and end like any effective story. Don't be dismayed by the many changes you'll make while editing and arranging. This is part of the creative process of making a story or presentation.

There are only two rules I follow strictly when sequencing slides. The first is that the colors of one slide must be harmonious with the colors in the preceding and following ones.

A light box simplifies the task of editing and sorting all of your slides because you can compare many at the same time.

134

This doesn't demand a constricted color sense. Rather, this approach needs a liberated sense of colors, as in reds preceeding pinks and browns following oranges. A color playing a minor role in one slide works well before or after a slide in which this color is dominant. When you think you have your slides arranged, scan them left to right for color harmony and make changes where necessary.

The second rule I insist on is a mixture of viewpoints in the scenes. Photos made with macro, normal, wide-angle and telephoto lenses are mixed in the show to add variety and impact. And the viewer is better able to absorb the flavor of your travels as different perspectives of the locale or theme are presented.

Narration and Script—After the show is assembled visually, you must consider the audio portion of the presentation. If you are planning a live show-and-tell performance of a strict script, the projection of slides must be synchronized with the narration script. So make a list of the slides in order of presentation.

For an informal presentation, write down notes about slides you want to talk about next to those slides on your list. Refer to these notes when necessary during the show to make your narration flow smoothly. You must decide how long a slide should remain on the screen. This can be determined by the content of the slide, what you want to say about it, and the level of interest it creates in your audience.

Generally, I leave strong images on the screen longer than mediocre ones. Slides I talk about are usually on the screen longest. Supporting slides are projected quickly. And action sequences are projected quickly to imply motion.

Be prepared to answer questions from your audience and be flexible with your intended script. If a slide gets little reaction from the audience and you planned a long statement, you may have to change your strategy. Audience response and practice will bring out the best in your slide show as you adjust

script, timing, order or even choice of slides to make the most of your travel photos.

Taped Narrations—After you succeed with informal presentations, you may want to attempt a more sophisticated audio-visual extravaganza. You can tape record a narration and play it while you advance slides manually. Or you can add music or sounds recorded on location to the tape, or even buy a synchronizer, which automatically changes slides according to your programming schedule.

A number or recordings, narrations and slide projectors can be combined to make a professional-looking show. An incredible amount of editing, writing and adjustment of projection times is necessary before the show is ready. I don't want to underemphasize the effort that goes into a slick slide show made with fancy electronic equipment. The total considerations of scripting, timing, working the equipment and projections are beyond the scope of this book.

Belgium—Starting at the far left below, this is the order I had these four slides in when I made a slide show about Belgium. Notice how the colors flow from one slide to the next.

Opposite Page, Top
Honfleur, France—Part of the daytripping assignment included picnicking in the country, so I assembled the props and used my husband's arm in the photo.

Opposite Page, Bottom
Epping, England—I assembled these props to illustrate country walks near London.

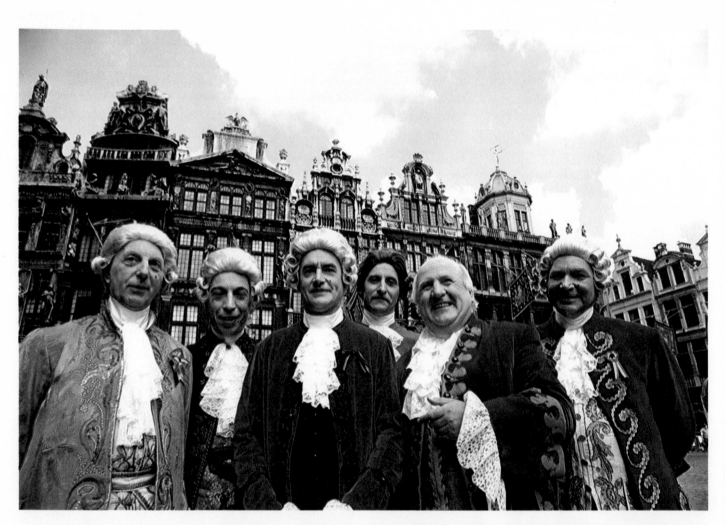

SO YOU WANT TO GO PRO? 9

Brussels, Belgium—While on assignment to photograph Belgium for the National Government Tourist Office, I made this photograph at the Grand Place. Assignments such as this make for an exciting life, but it wasn't easy getting started.

Many of my photographic prejudices, experiences and abilities are different from yours because I am a professional photographer with different requirements made of my photography than perhaps are made of yours. I've established my own style, way of working, thought processes and ambitions because they are necessary for me to retain my independence and still succeed as a freelancer.

No two pro photographers become successful in the same way. Freelancing isn't easy, and for most people it requires a combination of ambition, self-discipline, drive, tough breaks, luck and talent. More than raw talent is necessary to become a success. Those interested in becoming a professional photographer, in the travel industry or any other field, should be aware of some of the pitfalls, fantasies and realities of this challenging business.

This chapter tells how I got from where I was to where I am. Some of my experiences are unique, but many have been shared in one way or another by many young photographers with desire and dedication. Some made it, some didn't.

This past year was a good one for me and my husband, who is a writer. We collaborated on many assignments, and the combination of our talents helps our cause. Here's a part of our schedule: In April we spent two weeks in Holland doing a magazine assignment. In May I did some shooting for a corporate client. I photographed employees, new buildings and executives. In June I went to seven states for an advertising assignment. Farmers who used a specific brand of fertilizer on different cash crops were the subject of this campaign. In July my husband and I did magazine and newspaper stories on two European adventures—a mule safari in Switzerland and a barge trip in France. In August we had assignments to do stories about daytripping out of London and Paris.

I know this all sounds very glamorous and exciting. It is! I enjoyed all of these assignments immensely *because* they were exciting, challenging and rewarding projects. It is demanding and often tiring work, but I love it. It is worth the years of effort and times of disappointment I went through before reaching this level in my profession.

Taormina, Sicily—My self-imposed assignment was to make a b&w portfolio on Sicily. Part of my success was due to the openness and warmth I felt from the Sicilians I photographed.

THE BEGINNING OF MY AMBITION

After high school I decided not to go to college. I spent nine months in Europe staying with friends, relatives and acquaintances. While there I began to photograph people during my long hikes and excursions. I detected an ability to put people at ease in front of the camera. From the start I was a confirmed people photographer.

Once home I had to work for a living, so I spent some time working on a ranch in Wyoming. That summer I recorded ranch life, scenery and anything else which caught my eye, and I was seeing pictures everywhere.

Then I moved to Boston to work for a friend, but the notion of becoming a photographer was gaining momentum. To fan the fantasy, I had color prints made from my best European and Wyoming photos. Everytime I went to the lab to pick up or order prints, I saw more photographers, made their acquaintances, and received more exposure to their work and world. I was constantly asking them for information in all facets of photography.

Eventually I wrangled an interview with the chief photographer of the *Christian Science Monitor*. I showed him my color portfolio, and without comment on the qualities of the work, he told me to learn to shoot b&w to get started in photography.

My rising expectations of instant fame and fortune were quickly dashed. I felt hurt that he had nothing nice to say about my expensive color prints. But I was angry enough to take his advice and learn the art of b&w shooting.

I saved for months to get back to Europe. For three weeks I enjoyed a photographic vacation in Taormina, Sicily. Each day at dawn I rose to go into the country to record rural Sicilians shepherding, knitting, lounging, and working in the vineyards. I was using only one camera with one lens and shooting b&w film.

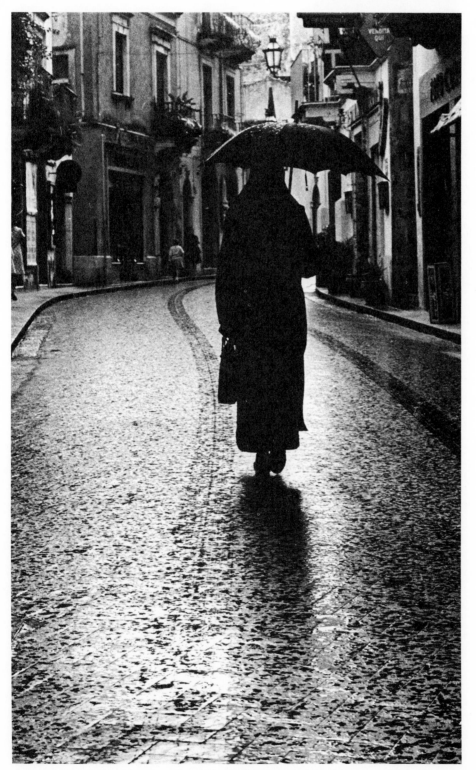

Taormina, Sicily—This is among the first travel photographs I ever made.

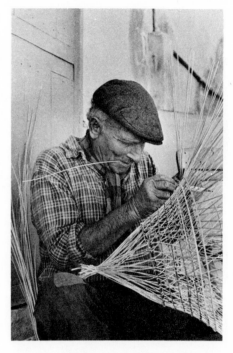

Acireale, Sicily—I forced myself to move in close so I wouldn't miss any of the details of Sicilian life.

I returned to Boston with 30 rolls of exposed film. Because I had no darkroom skills then, I had to incur another major expense by having the film processed and proofed. For months I could do nothing with them but stare at the proof sheets because I hadn't the funds for enlargements.

My luckiest break came at this time. I managed to get some of my color prints hung at a café, and they were noticed by an influential friend of mine from the *Boston Globe*. He sent a photographer to look at the photos. Soon after that I received an invitation to become a darkroom assistant at the newspaper for six months. I was in the right place at the right time—ready, willing and under-qualified—but I was a woman, and the staff needed a token female.

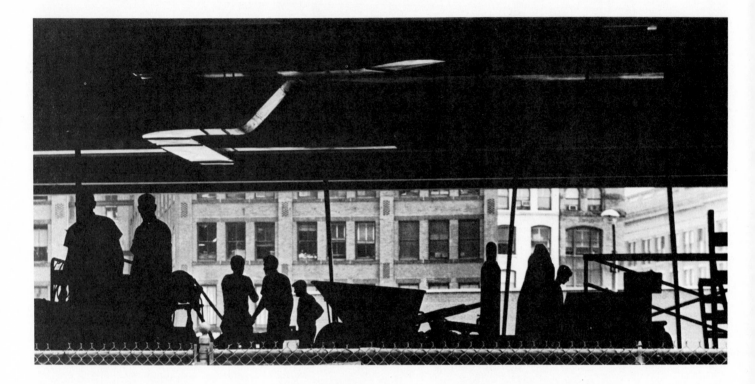

AT THE *BOSTON GLOBE*

At the precocious age of 21 I started at the *Globe*. The first thing I learned to do was mix huge vats of chemicals for the 20 male photographers on the staff. They taught me to process film quickly and efficiently and to print negatives. But before I could touch their negatives, I had to practice with my own. It was another lucky break for me because I finally got a chance to see my Sicilian photos enlarged. This trial-and-error education quickly showed me that I had the stamina to stick with my photography and my ambition.

After a few months in the dark I was allowed to go in radio cars with photographers and see what happened in the real world.

Later, I began receiving assignments from different editors on the paper. Initially I covered the construction boom in and around Boston. Because my father is an architect, I was somewhat familiar with the subject. I photographed all facets of the busy building activity. My shots regularly made the paper, and I was increasingly trusted with more challenging assignments and deadlines.

Eventually, I handled freckle contests, drug-rehabilitation centers, hospital wards, press conferences, fashion shows, travel stories, Boston society, funerals, the campuses and many more varied assignments. The gamut of assignments for a rookie photographer was a fantastic training ground. The two years I spent at the *Globe* were an intensive photographic education that would be difficult to duplicate anywhere else.

Boston, Massachusetts—One of my favorite assign-
ments was a story about the clowns of the
Ringling Bros. and Barnum & Bailey Circus.

Boston, Massachusetts—While photographing a
feminist rally, I recorded an interesting
reaction of Betty Friedan listening to
then-Governor Seargent.

Opposite Page
Boston, Massachusetts—One of my first assign-
ments for the *Globe* was to photograph
construction sites.

GOING FREELANCE

After these two years at the *Globe*, I felt sufficiently secure in my abilities as a photographer to resign from the paper, get married and begin freelancing with my husband as a writer-photographer team. Landt had 10 years of experience in the travel industry as a tour guide, public relations man and newspaper writer.

We had plans to become a unit composed of two specialists. Most photographers are not writers, and most writers are not photographers. We would offer our services to the travel industry and enjoy our new-found fortunes together as editors beat a path to our door.

This fantasy was quickly killed. The connections Landt had in the travel industry were not the right people to give us assignments. So we decided to produce some stories and photos on speculation, and with our own funds we financed a two month trip. Transportation was supplied by an airline that invited us to report about one of their new routes. We went on a junket from Sidney to Bangkok that was scheduled for only ten days, but we were allowed to stop anywhere along the route!

We stretched the ten days into a two-month project in which we did stories in Thailand, Southern Russia, Greece and Denmark.

The trip devoured most of our savings, but we had expectations of selling our essays and photos to a newspaper syndicate. If we had done our homework before the trip, we would have discovered the syndicates were not interested in any of our photo stories. We then sent samples of our work to travel editors of large-circulation newspapers. A few ran photos and text, but we received very little payment for our efforts. We peddled our stories to magazines, but their pay still wasn't enough to cover the cost of our trip. So we were beginning to realize how difficult it would be to break into the field.

For the next few months we sent sample work and story ideas to newspaper and magazine editors everywhere with some success, but very little of it was financial. We began to wonder how to survive in this business. In spite of some

Ghent, Belgium—I illustrated canal trips by including the bow of the boat with scenes along the way.

freelance writing jobs Landt landed, our savings were running on empty.

The starving-artists routine was our next assignment because we had no money. For three years I did a number of odd jobs such as proof reader, photographer's assistant, receptionist and typist. During all this time we were constantly evaluating our goal to become successful freelancers. We were tempted to change our mind and find permanent jobs.

But we stuck to what our greatest talents were—travel writing and photography. These three years of hand-to-mouth existence were not easy, but our ambition, perseverance and confidence helped us make it.

The fourth year was our first good year. We did a photo-illustrated book about windmills and windpower. Stock sales of my photographs improved, more magazine assignments came our way, and Landt and I became contributors to a national magazine. Our financial problems began to disappear, and our bruised egos started to heal.

To date, we've been freelancing for nine years. As we look back we see a pattern that is encouraging in today's economy: We are doing better each year! We are working for publications we thought we'd never crack; my stock photographs are selling well; Landt writes independently of me; and I often shoot independently of him. Plus, ad agencies and national government tourist offices are giving me more assignments.

I made the photos on these two pages during an assignment for the National Government Tourist Office of Belgium.

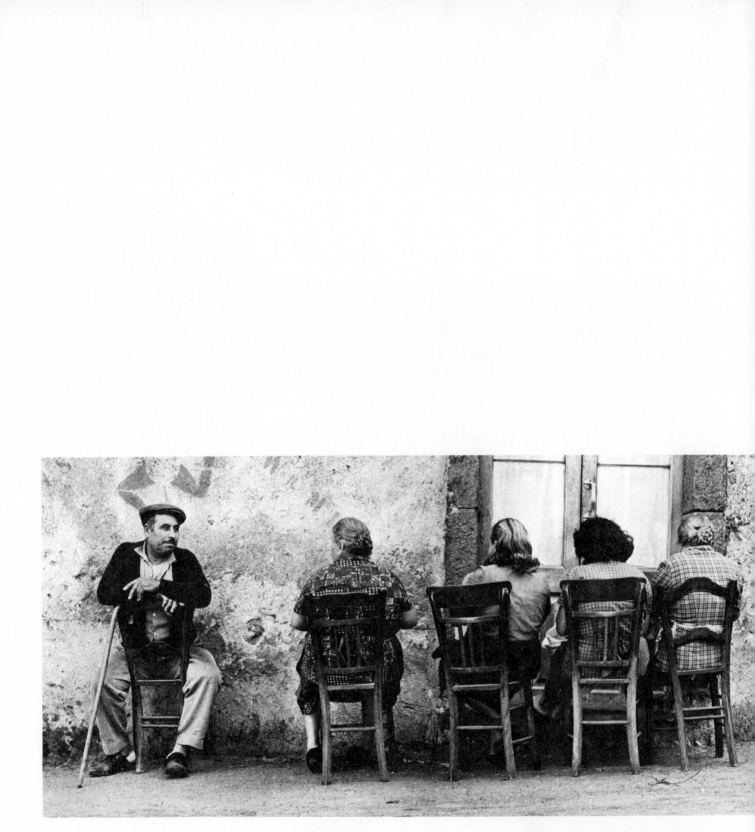

Randazzo, Sicily—Sicilian women take air and do needlepoint while facing a wall so as not to attract attention from men other than their husbands. This photo was most recently used in the book *Women See Woman,* a collection of photographs by women.

SOME REALITIES OF FREELANCING

A freelancer is independent, but along with the pluses of independence goes some insecurity. There is the uncertainty of never knowing where the next job comes from. With the next job comes the next paycheck, so the financial strain of freelancing can be discouraging.

Freelancing can be fraught with terrific highs and lows. It is very easy to highlight the glamour, glory and exotic destinations of our work without stressing the effort that goes into it. On-location shooting with the pressures of time and circumstance is hard work. But usually, getting the assignment is the most difficult aspect of the job.

It Starts With an Idea—If you intend to be a freelancer for newspapers or magazines, *you* must generate original ideas for stories. Later as you become known to editors, they may give you assignments. In the beginning, though, you must carry the burden. You should be able to generate fresh ideas during your whole freelance career if you expect to stay with it.

We evolve ideas after researching publications. We subscribe to 15 newspapers and magazines that have travel sections with current information we can use constructively. Magazines and newspapers we don't subscribe to are read at libraries. But we get *all* the major travel magazines because if they are our potential employer, we must be aware of their needs and editorial content. We familiarize ourselves with a publication's style and look for what has been done, and what might be done next. There is no reason to submit an idea to an editor for a story that was covered less than five years ago.

Another potential source of ideas is people who travel. Talk to friends and acquaintances about their journeys. They may have discovered something by accident that can give you a jump on the assignment.

Now You Have an Idea—Once you have a good idea, do not hesitate to submit it to the editors of the publications of your choice. There are a few ways to do this. If you don't live in the city where the periodical is published, you can send your ideas by letter. The editorial address is on the masthead of every publication. A large list of newspaper travel editors is in *Editor and Publisher Yearbook*—see the appendix for the address.

Brussels, Belgium—
The successful freelancer
continually experiments, tries
varied approaches, and must
work long hours. I often work
around the clock because night
photography is so dramatic.

If you do travel to the city, you may be able to get an interview with an editor. Telephone calls may also work, but they must be done professionally and succinctly. Even if the editor is friendly, he usually won't take time to talk unless you have an idea that interests him. Be articulate, persuasive and brief! Selling yourself on the phone is difficult at first, at least it was for me, but I've learned to get used to it and project cool professionalism.

This approach has worked for me: "Hello, I'm Lisl Dennis, a professional photographer here in New York. I have some ideas I'd like to discuss with you. I would also like to show you my portfolio if I may."

However you contact an editor, be prepared to prove your idea and yourself. Have sample work, the portfolio, ready to send or show, but ideas are top priority. People in publishing, your potential employers, depend on ideas. Editors and art directors cannot generate all publishable ideas by themselves, and they need and want your input.

Business Sense—Your survival as a

freelancer depends on sound business practices as well as gumption. You should have a general idea of what it costs you to be a freelancer. What does your equipment cost? How much money do you need to survive? What are fair rates to charge a client? You can answer these questions and more by reading *ASMP Survey of Trade Practices in Photography*. Order it from the address in the appendix.

This publication tells you about photo rates in both the editorial and advertising marketplace. It also outlines photo-book contracts, gives a sample model-release form and explains aspects of the new copyright law. Day rates for all fields of photography are suggested, and sample contracts for submitting photographs to clients are shown. The book covers all business aspects of freelance photography and is indispensable.

Other books that can help you make it in freelance photography are also listed in the appendix. Learn as much as you can from as many sources as possible.

Istanbul, Turkey—To me, the hat was more interesting than the face of a member of the Royal Ottoman Band.

Brussels, Belgium—These people are part of the annual Meiboome festival in the city's famed Grand Place.

Junkets and the Barter System— Travel writers and photographers often fly to their destinations free. There are a few good reasons for this largess, and a potential freelancer should be aware of them. Many freelancers in the travel industry could not survive any other way.

National government tourist offices located in major cities frequently invite freelancers, both writers and photographers, and staff editors, on familiarization trips to foreign countries and around the U.S. In return, writers publish accounts of what they see and experience. Invited photographers must also get their pictures into print.

Many publications cannot afford to send their correspondents all over the world and must rely on the travel industry to help. If a freelancer has experience and a bona fide assignment confirmed in writing by the editor, the host airline or tourist office is often very cooperative. The catch is that the story or photos must be published. Essentially it is a barter system in which the travel industry gets media exposure of tours, new and old routes, and tourist spots.

The barter system is the *modus operandi* of the travel industry. It works effectively for everyone concerned except sometimes for the public, which may read irresponsible journalism in magazines and newspapers that is no more than an ad disguised as an article. Sometimes, things are reported in glowing terms when the truth is that some bad things should also have been mentioned.

Stock Photos— A principal source of income for a freelance photographer is the stock-photo agency. I could not make a living by photographing exclusively for the travel industry. After my photos have appeared in print, I put practically all of my work in The Image Bank in New York City. It's an international picture source for ad agencies, magazines, design firms and other media interested in using photographs. Stock houses are a source for every conceivable photographic subject from *aardvark* to *zither*.

Image Bank photographers are full-time pros who work on different kinds of assignments. We retain the rights to our work and "lease" a photo to clients. Each of us has thousands of photos in stock. Currently I have 10,000, and they bring me several thousand dollars per year.

One's stock supply can generate income long after the assignment is completed. So it's important for a professional to build a file with a reputable stock-photo agency with outlets world wide.

Advice—The travel industry alone cannot support me and my husband. I only know one person who earns a living strictly on travel photography. So with the freedom of freelancing goes the requirement of flexibility. I have advertising and corporate clients, and Landt is also a general-feature writer. We have also collaborated on books to increase our scope and versatility.

Part of my advice to any potential freelancer is to cultivate versatility. Be able to do more than one facet of photography. Being a specialist is fine if you can make it work, but it is very tough to break into any field as a young, inexperienced specialist. Remember it took us about three years to *begin* to succeed.

Because newspaper experience worked for me, I am quick to recommend it to anyone else interested in an intense photographic learning experience. When you start at the bottom as I did, you learn to test your ambitions and goals constantly. Nobody starts at the top.

Newspaper work also broadened my social scope. When I was shooting for the *Globe,* I sometimes worked with drug addicts in the morning and society ladies in the afternoon. I learned how to deal with all kinds of people to make effective photographs. And my international shooting has benefited from this ability to deal with many different people.

Brussels, Belgium—Another view of the Meiboome festival.

On a newspaper assignment you may have to previsualize a photo according to the demands of the reporter or editor. This calls for an ability to deal with people and events and exert some control over the situation. The opposite side of the same photographic coin requires you to respond instantly to news happenings. They demand dealing with other photographers, crowds and pressure. It is a rare person who works in both modes equally well. Because many assignments require both styles of shooting, newspaper work is the best and fastest way I can think of to develop the attitudes and graces which go into each approach. On a newspaper you also get plenty of practice with the pressures of meeting deadlines. The freelancer who can't regularly deliver on time shouldn't expect regular work.

A successful freelancer must be technically capable with camera, film and lighting. He or she must abound in stamina and body coordination because some of the physcial demands of assignments are extreme.

The photographer must be a shrewd business person who can negotiate terms of agreement and be charming and diplomatic at the same time. The photographer must be a good listener to be able to deal with subjects and clients—and a good talker for the same reason. Most important, the successful freelancer needs to be consistently creative.

It is possible to have all of these traits and achieve personal satisfaction and financial success as a freelance photographer. This is a challenging, competitive business, and if you are sure of yourself and have enough drive and ambition, you may make it as a freelancer.

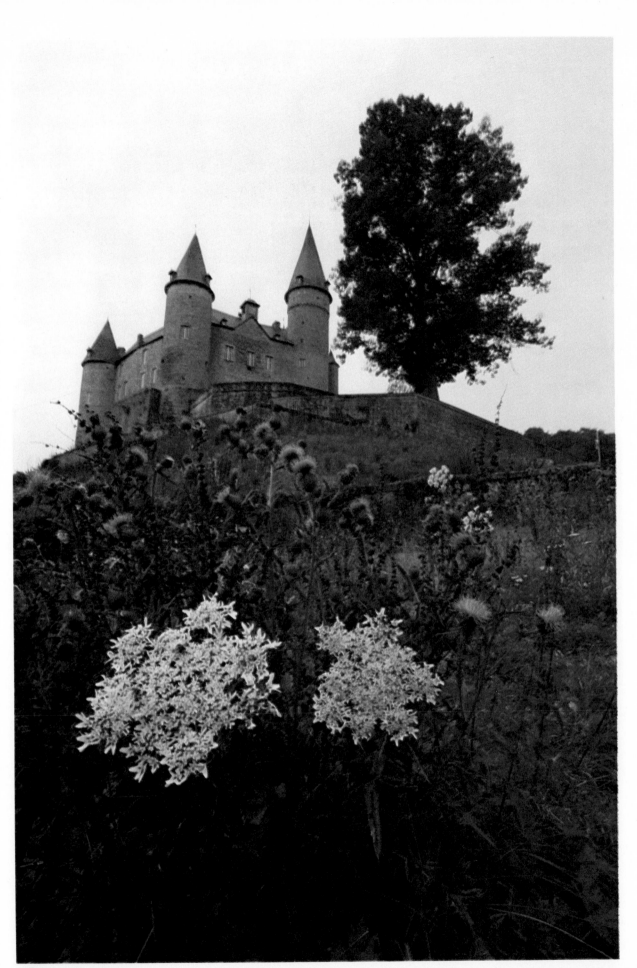

Château de Vevre, Belgium

Brussels, Belgium—Speculoos
cookies are served with every
cup of coffee in Belgium.

This Year's Schedule—I already mentioned that last year was a good one and each new year is better than the last. This year is no exception.

I was in Norway in March for a story on cross-country skiing. In April and May we went on whirlwind familiarization trips to Yugoslavia, Turkey and Germany with magazine assignments for each country. These junkets are also a good way to build up a stock file. In June I continued my writing assignments for various magazines. July was spent in Nantucket, Massachusetts doing a story on the summer lifestyle there.

In August I was in Belgium for the National Government Tourist Office. I photographed the whole country and reveled in lovely countryside, food and people. Then I went to Scotland to cover private clan balls. Back to America in September for more shooting for one of my advertising clients. A well-deserved New England rest stop and final work on this book ended seven months of non-stop activity.

Charlotteville, Tobago—For the pro, one shot may take all day. In fact, it took me six hours to find red paint to touch up the scale, buy fruit at the market, arrange the still life and wait for the sun to peep through the clouds.

Bon Voyage—You may have read this chapter as an amateur curious to learn what being a pro is like. Or you may intend to become a pro. Either way, I hope this book helps you take great travel photographs.

Perhaps our paths will cross. If you see a lot of action in some faraway place, look for me in the middle. That's where I like to be!

APPENDIX

This appendix is in three parts. First is a list of addresses for tourist information offices in many countries of the world. During the planning stage for a trip, you should write to the appropriate offices and ask for three kinds of information. Ask for general information about your destination—brochures, climate, activities or places to stay for instance. Ask for specific answers to any specific questions you may have. And *be sure* to ask about any restrictions on photo equipment and film that you want to take with you.

Many countries don't care how much photo equipment you have, but there are a few with tight restrictions, usually based on an apprehension that you intend to bring equipment into their country and sell it.

If you discover that the amount of equipment you want to take into a country exceeds its limits, don't despair. Write back for advice about how you can get in with your gear even though it does exceed their limit. Explain your purpose and mention that your trip cannot be a success without your photographic equipment. I've found that most countries will make allowances for special cases, provided you write ahead for permission.

Don't expect sympathy or special consideration if you just show up with your equipment and hope for the best. If you haven't done your homework, you'll find that some of the airport and customs officials are the most uncompromising people you will ever meet.

The following list of addresses for various countries of the world sometimes shows more than one address for each country. The city and local zip code or equivalent is listed first, even though you will put it last when you write the address on an envelope. I think it is more useful as a quick reference to find the town or city listed first.

You'll notice that many countries not only have tourist offices within the country, but also in other countries.

Following the list of various countries of the world, you'll find a list of tourist offices for each of the states in the United States of America, too.

After that, I've listed a few books that you may find interesting and helpful.

ADDRESSES OF NATIONAL GOVERNMENT TOURIST OFFICES

AFGHANISTAN

KABUL, Afghanistan
Afghan Tourist Organization
Civil Aviations Authority

NEW YORK, NY 10017, U.S.A.
Afghan Tourist Organization
535 Fifth Ave.

ANTIGUA

ST. JOHN'S, Antigua
Antigua Department of Tourism
Box 363

NEW YORK, NY 10020, U.S.A.
Antigua and Barbuda Information Office
610 Fifth Avenue

ARGENTINA

BUENOS AIRES, Argentina
Direccion Nacional de Turismo
Calle Santa Fe 883

NEW YORK, NY 10036, U.S.A.
Argentina Tourist Office
500 Fifth Ave.

ARUBA

ORANJESTAD, Aruba
Aruba Tourist Bureau
L.G. Smith Blvd.

MIAMI, FL 33137, U.S.A.
Aruba Information Center
2990 Biscayne Blvd.

AUSTRALIA

MELBOURNE, Australia
Australian Tourist Commission
414 St. Kilda Rd.

LOS ANGELES, CA 90010, U.S.A.
Australian Tourist Commission
3550 Wilshire Blvd.

AUSTRIA

NEW YORK, NY 10017, U.S.A.
Austrian Tourist Office
545 Fifth Ave.

VANCOUVER, B.C., Canada V6B 1Y6
Austrian Tourist Office
736 Granville St.

BAHAMA ISLANDS

NEW YORK, NY 10020, U.S.A.
Bahama Islands Tourist Office
30 Rockefeller Plaza

TORONTO, Ontario, Canada M5H 2C9
Bahama Islands Tourist Office
85 Richmond St. West

CORAL GABLES, FL 33134, U.S.A.
Bahama Islands Tourist Office
255 Alhambra Circle

BARBADOS

BRIDGETOWN, Barbados
Barbados Tourist Board
P.O. Box 242

NEW YORK, NY 10017, U.S.A.
Barbados Tourist Board
800 Second Ave.

TORONTO, Ontario, Canada M5H 1A3
Barbados Tourist Board
11 King St. West

BELGIUM

BRUSSELS, Belgium B-1000
Commassariat General au Tourisme
Rue Marche aux Herbes, 61

NEW YORK, NY 10019, U.S.A.
Belgian National Tourist Office
720 Fifth Ave.

BERMUDA

HAMILTON, Bermuda
Old Town Hall
P.O. Box 465

LONDON, England WIM 2BQ
84 Baker St.

NEW YORK, NY 10020, U.S.A.
Bermuda Department of Tourism
630 Fifth Ave.

TORONTO, Ontario, Canada M4W 3E2
Bermuda Department of Tourism
2 Bloor St. West

BONAIR, NETHERLANDS ANTILLES

BONAIRE, Netherlands Antilles
Bonaire Tourist Information Office

NEW YORK, NY 10022, U.S.A.
Bonaire Tourist Information Office
685 Fifth Ave.

BOLIVIA

LA PAZ, Bolivia
Instituto Boliviano de Turismo
Av. Camacho esq. Bueno
Casilla 1868

BRAZIL

RIO DE JANEIRO, Brazil
Embratur-Empresa Brasileira de Turismo
Praca Maua 7-11 andar

BRITISH VIRGIN ISLANDS

NEW YORK, NY 10022, U.S.A.
British Virgin Islands Tourist Office
515 Madison Ave.

TORTOLA, British Virgin Islands
British Virgin Islands Tourist Office
P.O. Box 134 Road Town

BULGARIA

SOFIA, Bulgaria
Balkantourist
1 Lenin Square

NEW YORK, NY 10017, U.S.A.
Bulgarian Tourist Office
50 East 42nd St.

TORONTO, Ontario, Canada M5H 1S3
Bulgarian Trade Mission
10 Adelaide St. West

UNION OF BURMA

NEW YORK, NY 10021, U.S.A.
c/o Permanent Mission of Burma
 to the U.N.
10 East 77th St.

CANADA

OTTAWA, Ontario, Canada K1A 0H6
Canadian Government Office of Tourism
Department of Industry Trade and
 Commerce
150 Kent St.

NEW YORK, NY 10020, U.S.A.
Canadian Government Office of Tourism
1251 Ave. of the Americas

SEATTLE, WA 98101, U.S.A.
Canadian Government Office of Tourism
600 Stewart St.

CAYMAN ISLANDS

CORAL GABLES, FL 33134, U.S.A.
Cayman Islands Department of Tourism
250 Catalonia Ave.

NEW YORK, NY 10017, U.S.A.
Cayman Islands Department of Tourism
420 Lexington Ave.

CHILE

SANTIAGO, Chile
Direccion de Turismo
Ministerio de Edonomia,
 Fomento y Reconstruccion
Catedral 1165

CHINA (People's Republic of)

PEKING, China
6 Chanton Ave.

NEW YORK, NY 10023, U.S.A.
c/o Permanent Mission to the U.N.
155 W. 66th St.

OTTAWA, Ontario Canada K1N 5H3
Embassy-People's Republic of China
411-415 St. Andrews St.

COLUMBIA

BOGOTA, Columbia
Corporacion Nacional de Turismo
Carrera 13A #27-31

NEW YORK, NY 10022, U.S.A.
Columbian Government Tourist Office
140 E. 57th St.

COSTA RICA

SAN JOSE, Costa Rica
Instituto Costarricense de Turismo
P.O. Box 777

CURACAO

WILLEMSTAD, Curacao
Curacao Government Tourist Burea
Concordiastraat 24

NEW YORK, NY 10020, U.S.A.
Curacao Tourist Board
300 Rockefeller Plaza

CYPRUS

NICOSIA, Cyprus
Cyprus Tourist Organization
Th. Theodotou St. #18

NEW YORK, NY 10017 U.S.A.
c/o Consulate General of Cyprus
820 Second Ave.

CZECHOSLOVAKIA

PRAGUE, Czechoslovakia
Cedok
Na Prikope 18

NEW YORK, NY 10016, U.S.A.
Cedok
10 East 40th St.

DENMARK

1570 COPENHAGEN V., Denmark
Danish Tourist Board
Banegaardspladsen 2

NEW YORK, NY 10019, U.S.A.
Danish National Tourist Office
75 Rockefeller Plaza

DOMINICA

ROSEAU, Dominica, West Indies
Dominica Tourist Board
P.O. Box 73

NEW YORK, NY 10017, U.S.A.
c/o Eastern Caribbean Tourist Association
2210 E. 42nd St.

MONTREAL, Quebec, Canada H5A 1B3
c/o Eastern Caribbean Mission
8 Frontenac St.

DOMINICAN REPUBLIC

NEW YORK, NY 10022, U.S.A.
Dominican Republic Information Center
485 Madison Ave.

ECUADOR

QUITO, Ecuador
Ecuadorian Government Tourist Office
P.O. Box 2454

EGYPT

SAN FRANCISCO, CA 94115, U.S.A.
Egyptian Government Tourist Office
3001 Pacific Ave.

EL SALVADOR

SAN SALVADOR, El Salvador
El Salvador Tourist Office
Calle Ruben Dario #619

ETHIOPIA

ADDIS ABABA, Ethiopia
Ethiopian Tourist Office
P.O. Box 2183

FINLAND

SF 00100 HELSINKA, 10
Finland Tourist Board
Kluuvikata 8

NEW YORK, NY 10019, U.S.A.
Finland National Tourist Office
75 Rockefeller Plaza

FRANCE

PARIS, France
Secretariate d'Etat au Tourisme
8 Ave. de l'Opera

NEW YORK, NY 10020, U.S.A.
French Government Tourist Office
610 Fifth Ave.

TORONTO, Ontario, Canada M5H 2W9
French Government Tourist Office
372 Bay St., Suite 610

GALAPAGOS

NEW YORK, NY 10019, U.S.A.
Galapagos Tourist Office
888 Seventh Ave.

GERMANY

FRANKFURT, Germany
Deutsche Zentrale fuer Tourismus
Beethovenstr. 69

MONTREAL, Quebec, Canada H5A 1B8
German National Tourist Office
47 Fundy, P.O. Box 417
Place Bonaventure

NEW YORK, NY 10020, U.S.A.
German National Tourist Office
630 Fifth Ave.

GHANA

ACCRA, Ghana
Ghana Tourist Board
P.O. Box 3106

NEW YORK, NY 10022, U.S.A.
c/o Sontheimer & Co.
445 Park Ave.

GIBRALTAR

GIBRALTAR
Gibraltar Tourist Office
Cathedral Square

LONDON, England WC2N 5EJ
Gibralter Tourist Office
2 Grand Building

GREAT BRITIAN

LONDON, England SW1A 1NF
British Tourist Authority
64/65 St. James St.

NEW YORK, NY 10019, U.S.A.
British Tourist Authority
680 Fifth Ave.

TORONTO, Ontario, Canada M5S 1T3
British Tourist Authority
151 Bloor St. West, Suite 460

GREECE

ATHENS, Greece
Greek National Tourist Organization
2 Amerikis St.

MONTREAL, Quebec, Canada H2B 3C9
Greek National Tourist Organization
2 Place Ville Marie

CHICAGO, IL 60601, U.S.A.
Greek National Tourist Organization
168 N. Michigan Ave.

GRENADA

ST. GEORGE'S, Grenada,
 West Indies 2279
Grenada Tourist Office
P.O. Box 293

NEW YORK, NY 10017, U.S.A.
Grenada Information Office
866 Second Ave.

GUADELOUPE

POINT-A-PINTRE, Guadeloupe,
 French West Indies
Office du Tourisme
Place de la Victoire

NEW YORK, NY 10020, U.S.A.
French West Indies Tourist Board
610 Fifth Ave.

GUATEMALA

NEW YORK, NY 10020, U.S.A.
Guatemalan Tourist Office
c/o Guatemala Consulate General
1270 Ave. of the Americas

GUYANA

NEW YORK, NY 10017, U.S.A.
Guyana Tourist Office
c/o Consulate General of Guyana
622 Third Ave.

REPUBLIC OF HAITI

PORT AU PRINCE, Haiti
Office National du Tourisme

NEW YORK, NY 10020, U.S.A.
Haiti Government Tourist Bureau
30 Rockefeller Plaza

TORONTO, Ontario, Canada M4W 3C7
Haiti Government Tourist Bureau
920 Yonge St.

HONDURAS

NEW YORK, NY 10020, U.S.A.
Honduras Tourist Information Bureau
501 Fifth Ave., 5th Floor

HONG KONG

HONG KONG
Hong Kong Tourist Association
Connaught Rd., C.
G.P.O. Box 2597

SAN FRANCISCO, CA 94104, U.S.A.
Hong Kong Tourist Association
160 Sansome St., Suite 1102

HUNGARY

1052 BUDAPEST, Hungary
Hungarian Council for Tourism
Deak Fu 23

NEW YORK, NY 10020, U.S.A.
Ibusz Tourist Office
630 Fifth Ave.

ICELAND

REYKJAVIK, Iceland
Iceland Tourist Board
Langavegi 3

NEW YORK, NY 10019, U.S.A.
Icelandic National Tourist Office
75 Rockefeller Plaza

INDIA

NEW DELHI, India
Department of Tourism
Ministry of Tourism and Civil Aviation

LOS ANGELES, CA 90010, U.S.A.
Government of India Tourist Office
3550 Wilshire Blvd.

INDONESIA

JAKARTA, Indonesia
Indonesian Tourist Office
Jalan Kramat Raya 81

SAN FRANCISCO, CA 94102, U.S.A.
Indonesian Tourist Board
323 Geary St.

IRAN

NEW YORK, NY 10020, U.S.A.
Iran Information and Tourism Center
10 W. 49th St.

IRAQ

BAGHDAD, Iraq
Ministry of Culture and Information
Summer Resorts and Tourism Service

NEW YORK, NY 10021, U.S.A.
Iraq Tourist Office
c/o Press Information Office
14 E. 79th St.

IRELAND

DUBLIN, Ireland
Bord Failte Eireann
Baggot St. Bridge

NEW YORK, NY 10036, U.S.A.
Irish Tourist Board
590 Fifth Ave.

LOS ANGELES, CA 90014, U.S.A.
Irish Tourist Board
510 W. 6th St.

TORONTO, Ontario, Canada M5C 1A2
Irish Tourist Board
7 King St. East

ISRAEL

JERUSALEM, Israel
Ministry of Industry,
Commerce and Tourism
24 King George St.

NEW YORK, NY 10036 U.S.A.
Israel Government Tourist Office
488 Madison Ave.

TORONTO, Ontario, Canada M5S 1M8
Israel Government Tourist Office
102 Bloor St. West

ITALY

ROME, Italy
Ente Nazionale Italiano per il Turismo
Via Merghera 2

MONTREAL, Quebec, Canada H3B 2E3
Italian Government Travel Office
3 Place Ville Marie

NEW YORK, NY 10020, U.S.A.
Italian Government Travel Office
630 Fifth Ave.

JAMAICA

KINGSTON, Jamaica
Jamaica Tourist Board
77-83 Knutsford Blvd.

MIAMI, FL 33131, U.S.A.
Jamaica Tourist Board
700 Brickell Ave.

TORONTO, Ontario, Canada M4S 2B4
Jamaica Tourist Board
2221 Yonge St.

JAPAN

TOKYO, Japan
Japan National Tourist Organization
Tokyo Kotsu Kaikan Building
10-1 Yurakucho, 2-chome
Chiyoda-Ku

LOS ANGELES, CA 90017, U.S.A.
Japan National Tourist Association
624 S. Grand Ave.

TORONTO, Canada M5H 3B8
Japan National Tourist Organization
165 University Ave.

JORDAN

AMMAN, Jordan
Jordan Tourism Authority

NEW YORK, NY 10017, U.S.A.
Jordan Tourism Authority
c/o Alia, Royal Jordanian Airline
535 Fifth Ave.

KENYA

NAIROBI, Kenya, East Africa
Ministry of Tourism
P.O. Box 30027

NEW YORK, NY 10022, U.S.A.
Kenya Tourist Office
60 E. 56th St.

KOREA

SEOUL, Congro-ku, Korea
Korea National Tourism Corporation
C.P.O. Box 903

LOS ANGELES, CA 90014, U.S.A.
Korea National Tourism Corporation
510 W. 6th St.

LEBANON

BEIRUT, Lebanon
National Council of Tourism
Bank of Lebanon St.

NEW YORK, NY 10022, U.S.A.
Lebanon Tourist Office
405 Park Ave.

LIBERIA

NEW YORK, NY 10017, U.S.A.
Liberian Tourist Office
c/o Liberian Consulate General
820 Second Ave.

LUXEMBOURG

LUXEMBOURG CITY, Luxembourg
Office National de Tourisme
51 Ave. de la Gare

NEW YORK, NY 10024, U.S.A.
Luxembourg Tourist Office
One Dag Hammarskjold Plaza

MACAU

MACAU
Centro de Informacao e Turismo
Palacio do Governo
Rua da Praia Grande

LOS ANGELES, CA 90010, U.S.A.
Portugese National Tourist Office
3250 Wilshire Blvd.

MALAYSIA

KUALA LUMPUR, Malaysia
Tourist Development Corporation
P.O. Box 328

SAN FRANCISCO, CA 94111, U.S.A.
Malaysian Tourist Information Center
Transamerica Building
600 Montgomery St.

REPUBLIC OF MALI

NEW YORK, NY 10021, U.S.A.
Mali Tourist Information Office
c/o Permanent Mission to the U.N.
111 E. 69th St.

MALTA

VALLETTA, Malta
Malta National Tourist Office
The Palace

MARTINIQUE

FORT-DE-FRANCE, Martinique,
 French West Indies
Office du Tourisme
Blvd. Alfassa, B.P. 520

NEW YORK, NY 10020, U.S.A.
French West Indies Tourist Board
610 Fifth Ave.

MEXICO

MEXICO CITY D.F., Mexico
Mexican National Tourist Council
Mariano Escobedo 726

NEW YORK, NY 10020, U.S.A.
Mexican National Tourist Council
405 Park Ave.

SAN DIEGO, CA 92101, U.S.A.
Mexican Government Ministry of Tourism
245 Westgate Plaza Mall

VANCOUVER, B.C., Canada V7Y 1B6
Mexican National Tourist Council
700 West Georgia St.

MONACO

MONTE CARLO, Monaco
Direction du Tourisme
2A Blvd. des Moulins

NEW YORK, NY10021, U.S.A.
Monaco Government Tourist Office
115 E. 64th St.

MOROCCO

RABAT, Morocco
Office National Marocain du Tourisme
22 Ave. d'Alger

NEW YORK, NY 11017, U.S.A.
Moroccan National Tourist Office
521 Fifth Ave.

MONTREAL, Quebec, Canada H5A 1A6
Moroccan National Tourist Office
114 Place Bonaventure

NEPAL

KATMANDU, Nepal
Office of the Directorate
Department of Tourism
Ramshah Path

NETHERLANDS

NEW YORK, NY 11017, U.S.A.
Netherlands National Tourist Office
576 Fifth Ave.

TORONTO, Ontario, Canada M5K 1K7
Netherlands National Tourist Office
T.D. Center, P.O. Box 331
3310 Royal Trust Tower

NETHERLANDS ANTILLES
(Aruba, Bonaire, Curacao)

NEW YORK, NY 10017, U.S.A.
Caribbean Tourism Association
20 E. 46th St.

NETHERLANDS ANTILLES
WINDWARD ISLANDS

PHILIPSBURG, St. Maarten
St. Maarten Tourist Board

ORANJESTAD, St. Eustatius
St. Eustatius Tourist Board

THE BOTTOM, Saba
Saba Tourist Board

NEW YORK, NY 10022, U.S.A.
St. Maarten, Saba and
 St. Eustatius Information Office
445 Park Ave.

TORONTO, Ontario, Canada M2N 1Y5
St. Maarten, Saba and
 St. Eustatius Information Office
243 Ellerslie Ave.

NEW ZEALAND

WELLINGTON, New Zealand
New Zealand Tourist Department
P.O. Box 95

LOS ANGELES, CA 90014, U.S.A.
New Zealand Government Travel
 Commission
630 Fifth Ave.

NICARAGUA

MANAGUA, Nicaragua
Direccion Nacional de Turismo
La Avenida S.O. No. 808

NORWAY

OSLO, Norway
Norway Travel Association
H. Heyerdahlsgate 1

NEW YORK, NY 10019, U.S.A.
Norwegian National Tourist Office
75 Rockefeller Plaza

PAKISTAN

KARACHI, Pakistan
Pakistan Tourism Development
 Corporation
Hotel Metropole, Club Rd.

PANAMA

PANAMA 5, Republic of Panama
Instituto Panameeno de Turismo
Apartado 4421

NEW YORK, NY 10020, U.S.A.
Panama Government Tourist Bureau
630 Fifth Ave.

PARAGUAY

ASUNCION, Paraguay
Director General de Turismo
Ministerio de Industria Y
 Turimo Communicaciones

PERU

LIMA, Peru
Direccion General de Turismo Ministerio
Industria y Turismo
Urbanicacion Corpac

PHILIPPINES

MANILA, Philippines
Department of Tourism
Agrifina Circle

LOS ANGELES, CA 90010, U.S.A.
Philippines Tourist Information Office
3325 Wilshire Blvd.

POLAND

WARSAW, Poland
Polish Tourist Information Center
Warsaw, Mazowiecka 7

NEW YORK, NY 10036, U.S.A.
Polish National Tourist Office
500 Fifth Ave.

PORTUGAL

LISBON, Portugal
Directorate General of Tourism
86, Av. Antonio Augusto de Aguiar

NEW YORK, NY 10036, U.S.A.
Portuguese National Tourist Office
548 Fifth Ave.

PUERTO RICO

HATO REY, Puerto Rico
Tourism Development Company
Banco de Ponce Building
268 Munoz Rivera

NEW YORK, NY 10019, U.S.A.
Puerto Rico Tourism
 Development Company
1290 Ave. of the Americas

TORONTO, Ontario, Canada M5C 1C3
Puerto Rico Tourism
 Development Company
10 King St. East, Suite 501

ROMANIA

BUCHAREST, Romania
Romanian National Tourist Office
7 Blvd. Magheru

NEW YORK, NY 10016, U.S.A.
Romanian National Tourist Office
573 Third Ave.

ST. KITTS-NEVIS-ANGUILLA

NEW YORK, NY 10022, U.S.A.
St. Kitts-Nevis-Anguilla
 Tourist Information Center
39 W. 55th St.

ST. LUCIA

CASTRIES, St. Lucia
St Lucia Tourist Board
P.O. Box 221

NEW YORK, NY 10017, U.S.A.
St. Lucia Tourist Board
220 E. 42nd St.

TORONTO, Ontario, Canada M5S 1S4
St Lucia Tourist Board
151 Bloor St. West

ST. VINCENT AND
THE GRENADINES

KINGSTON, St. Vincent
St. Vincent Tourist Board
P.O. Box 834

NEW YORK, NY 10017, U.S.A.
c/o Caribbean Tourist Association
20 E. 46th St.

TORONTO, Ontario, Canada M4W 2J5
c/o Editorial Services Limited
980 Yonge St.

SAUDI ARABIA

WASHINGTON, DC 20008, U.S.A.
Saudi Arabian Tourist Information Office
c/o Saudi Arabian Embassy
1520 18th St., N.W.

REPUBLIC OF SENEGAL

DAKAR, Senegal
Syndicat des Angences de
 Voyages de Senegal
5, Place de l'Independance
P.O. Box 3126

NEW YORK, NY 10017, U.S.A.
Senegal Tourist Information Office
51 E. 42nd St.

SINGAPORE

SINGAPORE—10
Tourist Promotion Board
Tudor Court
Tanglin Rd.

SAN FRANCISCO, CA 94108, U.S.A.
Singapore Tourist Information Office
251 Post St.

SOUTH AFRICA

PRETORIA, South Africa
South African Tourist Corporation
Arcadia Center
Private Bag X164

NEW YORK, NY 10020, U.S.A.
South African Tourist Corporation
610 Fifth Ave.

TORONTO, Ontario, Canada M4R 1K8
South African Tourist Corporation
20 Eglinton Ave. W.

SPAIN

MADRID, Spain
Direccion General de
 Promocion del Turismo
Azcarraga
Avenida del Generalisimo 39

NEW YORK, NY 10022, U.S.A.
Spanish National Tourist Office
665 Fifth Ave.

TORONTO, Ontario, Canada M4W 3B8
Spanish National Tourist Office
60 Bloor St. W.

SRI LANKA (CEYLON)

COLUMBO 1, Sri Lanka
Sri Lanka Tourist Board
25 Galle Face Centre Rd.

LOS ANGELES, CA 90057, U.S.A.
Sri Lanka Tourist Board
2007 Wilshire Blvd.

**DEMOCRATIC REPUBLIC
 OF THE SUDAN**

KHARTOUM, Sudan
Tourist Section
Sudan Tourist Corporation
P.O. Box 2424

SURINAM

PARAMARIBO, Surinam
Surinam Tourist Development Board
Box 656, Kerkplein 10

NEW YORK, NY 10020, U.S.A.
Surinam Tourist Board
One Rockefeller Plaza

SWEDEN

STOCKHOLM, Sweden
Swedish Tourist Board
Hamngatan 27

NEW YORK, NY 10019, U.S.A.
Swedish National Tourist Office
75 Rockefeller Plaza

SWITZERLAND

ZURICH, Switzerland
Schweizerische Verkehrszentrale
Talacker 42

CHICAGO, IL 60603, U.S.A.
Swiss National Tourist Office
104 S. Michigan Ave.

NEW YORK, NY 10020, U.S.A.
Swiss National Tourist Office
608 Fifth Ave.

TORONTO, Ontario, Canada M5L 1E8
Swiss National Tourist Office
Commerce Court West

TAHITI

LOS ANGELES, CA 90028, U.S.A.
Tahiti Tourist Board
700 S. Flower St.

TAIWAN, REPUBLIC OF CHINA

TAIPEI, Taiwan
Tourism Bureau
280 Chung Hsiao E. Rd.
9th FL Section 4, Taipei 105

SAN FRANCISCO, CA 94108, U.S.A.
Chinese Tourism Bureau
210 Post. St.

TANZANIA

DAR ES SALAAM, Tanzania
Tanzania Tourist Office
P.O. Box 9372

THAILAND

BANGKOK, Thailand
Tourist Organization of Thailand
Mansion II, Ratchadamnoen Ave.

LOS ANGELES, CA 90014, U.S.A.
Tourist Organization of Thailand
510 W. 6th St., Suite 1212

NEW YORK, NY 10048, U.S.A.
Tourist Organization of Thailand
5 World Trade Center

TONGA

LOS ANGELES, CA 90017, U.S.A.
Tonga Visitors Bureau
700 S. Flower St.

TRINIDAD AND TOBAGO

PORT OF SPAIN, Trinidad
Trinidad and Tobago Tourist Board
56 Frederick St.

MIAMI, FL 33131, U.S.A.
Trinidad and Tobago Tourist Center
200 S.E. First St.

NEW YORK, NY 11017, U.S.A.
Trinidad and Tobago Tourist Board
400 Madison Ave.

TORONTO, Ontario, Canada M5N 1J8
Trinidad and Tobago Tourism Center
145 King St. W.

TUNISIA

TUNIS, Tunisia
Office National du Tourism
Avenue Mohamed V

NEW YORK, NY 10020, U.S.A.
Tunisian National Tourist Office
630 Fifth Ave., Room 863

TURKEY

ANKARA, Turkey
Ministry of Tourism
Iskender Cenap Ege

NEW YORK, NY 10036, U.S.A.
Turkish Tourism Office
821 United Nations Plaza

**TURKS AND CAICOS ISLANDS,
 BRITISH WEST INDIES**

GRAND TURK, British West Indies
Turks and Caicos Tourist Board

CHICAGO, IL 60631, U.S.A.
Turks and Caicos Tourist Office
7777 West Talcott

**UNION OF SOVIET
 SOCIALIST REPUBLICS**

MOSCOW, U.S.S.R.
Intourist
16 Marx Ave.

NEW YORK, NY 10017, U.S.A.
Intourist
45 E. 49th St.

URUGUAY

MONTEVIDEO, Uruguay
Direccion Nacional de Turismo
Avenida Agraciada 1409

VENEZUELA

CARACAS, Venezuela
Corpoturismo
Edifico Capriles
Apartado 4301—laza Venezuela

NEW YORK, NY 10022, U.S.A.
Venezuelan Government Tourist Bureau
450 Park Ave.

VIRGIN ISLANDS (U.S.A.)
St. Croix, St. John and St. Thomas

CHARLOTTE AMALIE,
 Virgin Islands 00801
Department of Commerce
P.O. Box 1692

NEW YORK, NY 10020, U.S.A.
U.S. Virgin Island Tourist Office
10 Rockefeller Plaza

MIAMI, FL 33132, U.S.A.
U.S. Virgin Islands Tourist Office
100 Biscayne Blvd.

YUGOSLAVIA

BELGRADE, Yugoslavia
Tourist Association of Yugoslavia
Mose Pjade 8

NEW YORK, NY 10020, U.S.A.
Yugoslav National Tourist Office
630 Fifth Ave.

REPUBLIC OF ZAIRE

KINSHASA, Zaire
Commissariat National du Tourisme
B.P. 1399

KIVU, Zaire
Department of Tourisme
B.P. 2466
Bukava

ZAMBIA

LIVINGSTON, Zambia
Zambia National Tourist Bureau
P.O. Box 342

NEW YORK, NY 10022, U.S.A.
Zambia National Tourist Bureau
150 E. 58th St.

OTTAWA, Ontario, Canada, K1P 5G4
c/o High Commission of the
 Republic of Zambia
130 Albert St.

ZIMBABWE RHODESIA

SALISBURY, Zimbabwe Rhodesia
Zimbabwe Rhodesia National Tourist Board
P.O. Box 8052

ADDRESSES OF UNITED STATES TOURIST OFFICES

ALABAMA
Bureau of Publicity and Information
State Capitol
Montgomery, AL 36130

ALASKA
Alaska Division of Tourism,
Department of Economic Development
Pouch E
Juneau, AK 99811

ARIZONA
Arizona Office of Tourism
1700 W. Washington, Room 501
Phoenix, AZ 85007

ARKANSAS
Arkansas Department of
 Parks and Tourism
149 State Capitol Building
Little Rock, AR 77201

CALIFORNIA
Redwood Empire Association
476 Post. St.
San Francisco, CA 94102

COLORADO
Travel Marketing Section
Colorado Division of
 Commerce and Development
602 State Capitol Annex
Denver, CO 80203

CONNECTICUT
Tourism Promotion Service,
Connecticut Department of Commerce
210 Washington St.
Hartford, CT 06106

DISTRICT OF COLUMBIA
Washington Area Convention and
 Visitor's Bureau
1129 20th St., N.W., Suite 200
Washington, DC 20036

FLORIDA
Division of Tourism,
Florida Department of Commerce
107 W. Gaines St.
Tallahassee, FL 32304

GEORGIA
Tourist Division,
Bureau of Industry and Trade
P.O. Box 1776
Atlanta, GA 30301

HAWAII
Hawaii Visitors Bureau
P.O. Box 2274
Honolulu, HI 96804

IDAHO
Division of Tourism and
 Industrial Development
State Capitol Building, Room 108
Boise, ID 83720

ILLINOIS
Office of Tourism,
Department of Business and
 Economic Development
205 W. Wacker Dr., Room 1100
Chicago, IL 60606

INDIANA
Tourism Development Division,
Indiana Department of Commerce
State House, Room 336
Indianapolis, IN 46204

IOWA
Tourism Division,
Iowa Development Commission
250 Jewett Building
Des Moines, IA 50309

KANSAS
Tourist Division,
Kansas Department of
 Economic Development
503 Kansas Ave.
Topeka, KS 66603

KENTUCKY
Division of Advertising and
 Travel Promotion
Capitol Annex
Frankfort, KY 40601

LOUISIANA
Tourist Development Commission
P.O. Box 44291, Capitol Station
Baton Rouge, LA 70804

MAINE
State Development Office,
 Executive Department
State House
Augusta, ME 04333

MARYLAND
Division of Tourist Development,
Department of Economic and
 Community Development
1748 Forest Dr.
Annapolis, MD 21401

MASSACHUSETTS
Massachussets Department of
 Commerce and Development
Leverett Saltonstall Building,
 100 Cambridge St.
Boston, MA 02202

MICHIGAN
Michigan Tourist Council
P.O. Box 30226
Lansing, MI 48909

MINNESOTA
Tourism Division,
Minnesota Department of
 Economic Development
480 Cedar St., Hanover Building
St. Paul, MN 55101

MISSISSIPPI
Travel and Tourism Department,
Mississippi Agricultural and
 Industrial Board
1504 Walter Sillers Building
Jackson, MS 39205

MISSOURI
Missouri Division of Tourism
P.O. Box 1055
Jefferson City, MO 65101

MONTANA
Travel Promotion Unit,
Montana Department of Highways
Helena, MT 59601

NEBRASKA
Division of Travel and Tourism,
Nebraska Department of
 Economic Development
P.O. Box 94666
State Capitol
Lincoln, NE 68509

NEVADA
Tourism Division,
Department of Economic Development
Capitol Complex
Carson City, NV 89701

NEW HAMPSHIRE
Office of Vacation and Travel,
Division of Economic Development
P.O. Box 856
Concord, NH 03301

NEW JERSEY
Office of Tourism and Promotion,
Department of Labor and Industry
P.O. Box 400
Trenton, NJ 08625

NEW MEXICO
Tourist Division,
Department of Tourism
113 Washington Ave.
Santa Fe, NM 87501

NEW YORK
Travel Bureau,
New York State Department of Commerce
99 Washington Ave.
Albany, NY 12245

NORTH CAROLINA
Travel Development Section
North Carolina Department of Natural and
 Economic Resources
P.O. Box 27687
Raleigh, NC 27611

NORTH DAKOTA
North Dakota Travel Division,
State Highway Department
Capitol Grounds
Bismark, ND 58501

OHIO
Travel Bureau,
Ohio Department of Economic and
 Community Development
Box 1001
Columbus, OH 43216

OKLAHOMA
Tourism Promotion Division,
Oklahoma Tourism and
 Recreation Department
504 Will Rogers Memorial Building
Oklahoma City, OK 73105

OREGON
Travel Information Section
102 State Highway Building
Salem, OR 97310

PENNSYLVANIA
Bureau of Travel Development,
Pennsylvania Department of Commerce
432 South Office Building
Harrisburg, PA 17120

RHODE ISLAND
Tourist Promotion Division,
Department of Economic Development
1 Weybosset Hill
Providence, RI 02903

SOUTH CAROLINA
Division of Tourism,
South Carolina Department of Parks,
 Recreation and Tourism
1205 Pendleton St.
Columbia, SC 29201

SOUTH DAKOTA
Division of Tourism
Joe Foss Building
Pierre, SD 57501

TENNESSEE
Division of Tourism
Andrew Jackson Building, Room 1028
Nashville, TN 37219

TEXAS
Texas Highway Department,
Travel and Information Division
Box 5064
Austin, TX 78763

UTAH
Utah Travel Council
Council Hall, Capitol Hill
Salt Lake City, UT 84114

VERMONT
Office of Information,
Agency of Development and
 Community Affairs
61 Elm St.
Montpelier, VT 05602

VIRGINIA
Virginia State Travel Service
6 N. Sixth St.
Richmond, VA 23219

WASHINGTON
Travel Development Division,
Department of Commerce and
 Economic Development
General Administration Building
Olympia, WA 98504

WEST VIRGINIA
Travel Development Division,
West Virginia Department of Commerce
State Capitol
Charleston, WV 25305

WISCONSIN
State of Wisconsin Vacation and
 Travel Service
205 N. Michigan Ave.
Chicago, IL 60601

WYOMING
Wyoming Travel Commission
2320 Capitol Ave.
Cheyenne, WY 82002

OTHER BOOKS

Here are some books I have found interesting and useful. You can order them from the addresses given. Some are available through bookstores, although you may have to ask your bookstore to order a copy for you.

For information about professional practices in the photography business, both editorial and commercial, order the *ASMP Survey of Trade Practices in Photography*, $14.00 p.p., from the American Society of Magazine Photographers, 205 Lexington Ave., New York, NY 10016, U.S.A.

For a listing of newspaper travel editors in the United States who may be customers for your work, consult the annual *Editor and Publisher Yearbook,* available from *Editor and Publisher,* 575 Lexington Avenue, New York, NY 10022, U.S.A. These people also publish a Syndicate Directory which gives names and addresses of newspaper syndicates in the United States.

You may be interested in reading *Photography for the Professional* by Robin Perry, Livingston Press, Waterford, CT 06385, U.S.A.

For more places to sell your work, check *Photography Marketplace* by Fred W. McDarrah. It's published by R. R. Bowker Co.,

Xerox Education Company, 1180 Sixth Avenue, New York, NY 11036, U.S.A.

Another place to look for potential customers is a book entitled *Artists' and Photographers' Market* published by *Writer's Digest,* 9933 Alliance Road, Cincinnati, OH 45242, U.S.A.

Some of these publications may be available at your local library although possibly not the latest version. Because I am based in the United States, these are the reference sources I use and know about. If you live in another country, you should be able to find similar sources there.

10.51267802465532